PAUL OVERY

157 illustrations, 17 in colour

 Thames and Hudson

for Tag

The author would like to acknowledge the help of the following in researching and writing this book: Herbert Henkels, Evert van Straaten, Binnert Schröder, the late Marjan Schröder, Frank den Oudsten, Lenneke Büller, Bertus Mulder, Monika Buch, Marijke Küper, Sjarel Ex, Ida van Zijl, M. J. H. Willinge, Reyer Kras, Frits Bless, Maria van Berge, Lotje Wouters, Tjarda Mees, Ellen ten Haaf, Kas Oosterhuis, Ilona Lénárd, László Beke, Nadine Lehni, Christian Derouet, Brian Housden, Bernard Gay, Julie Lawson, Adrian Forty, Margaret Dickinson, Jonathan P. Parry, Peter Graham, Ken Garland, T. A. Gronberg. Preliminary research was made possible by a grant from The Elephant Trust.

Printed and bound in Singapore by C.S. Graphics

Paul Overy
was educated at King's College, Cambridge. He lectures
on the history of art, architecture and design at London
University, the London Institute and Middlesex Polytechnic
and has been art critic for *The Times, The Financial Times* and
The Listener. He is the author of *Kandinsky: The Language of
the Eye* (1969) and an earlier volume on De Stijl and is
co-author of *The Rietveld Schröder House* (1988).

WORLD OF ART

This famous series
provides the widest available
range of illustrated books on art in all its aspects.
If you would like to receive a complete list
of titles in print please write to:

THAMES AND HUDSON
30 Bloomsbury Street, London WC1B 3QP
In the United States please write to:
THAMES AND HUDSON INC.
500 Fifth Avenue, New York, New York 10110

Contents

PM '17

1 Piet Mondrian *Composition in Colour B* 1917

Producing De Stijl

Represented as one of the major 'modern movements' since the first attempts to construct histories of early twentieth-century art, architecture and design in the 1920s, De Stijl was not a homogeneous 'group' or an 'ism' like Cubism, Futurism, or Surrealism; nor was it an art and design school like the Bauhaus. Rather, it was a collective project or enterprise, organized and promoted by the Dutch painter, designer, writer and propagandist Theo van Doesburg (1883–1931), between 1917 and 1928. The main elements of continuity in it were the *De Stijl* magazine, edited by Van Doesburg, and his own commitment as a proselytizer and entrepreneur.

Many of those involved in the project barely knew each other, met rarely, if ever, and did not exhibit their work together. There exist no group photographs of 'members' and the only exhibitions to present De Stijl as a group enterprise at the time were held in France in the mid-twenties – and only architecture and interior design were included. Nevertheless, during their association with De Stijl the painters Piet Mondrian (1872–1944), Vilmos Huszár (1884–1960), *1* Bart van der Leck (1876–1958) and Van Doesburg were often aware *2* of the development of each other's work and produced paintings which have stylistic and conceptual characteristics in common. They also shared many aims, as did the architects initially associated with De Stijl, J. J. P. Oud (1890–1963), Robert Van 't Hoff (1887–1979) and Jan Wils (1891–1972), although they worked more independently. They were united by a conviction that the architectural styles of the past were outmoded, a common interest in the works and ideas of the American architect Frank Lloyd Wright, and a belief in the social role of architecture. With the sculptor and painter Georges Vantongerloo (1886–1965), the furniture designer and architect Gerrit Rietveld (1888–1964) and the architect and town planner Cornelis van Eesteren (1897–1988), these were the artists and architects most closely involved with De Stijl.

2 Bart van der Leck
Composition 1918

✳De Stijl means 'The Style' in Dutch – not just 'style', but '*The* Style'. The word *stijl* also has another meaning: a 'post, jamb or support'. In particular it refers to the upright element of a crossing joint in cabinet-making and carpentry. 'Style' as conceived by Van Doesburg and other early De Stijl collaborators was not seen as the surface application of ornament or decoration, but as an essential ordering of structure which would function as a sign for an ethical view of society. The single element, perceived as separate, and the configuration of elements, perceived as a whole, were intended to symbolize the relationship between the individual and the collective (or the universal).

The separating out and combining of such elements into new and

unusual configurations was a crucial part of the formal vocabulary of De Stijl. These elements were used to construct an ideal 'model' for a new world through furniture, sculpture, interior design and architecture, while closely related two-dimensional elements were employed in a similar symbolic way in De Stijl painting and graphic design. ✳[De Stijl activity was not entirely synonymous with the *De Stijl* magazine but the beginnings of the enterprise can be dated from the year of the founding of *De Stijl* in 1917. The magazine was the major 6 means for producing and validating stylistic and ideological links between the artists and architects, and in promoting De Stijl as an ideology and stylistic project. While it is easy to exaggerate the importance of an avant-garde magazine which never sold more than about three hundred copies, its influence was widespread both in Holland and abroad.] By the time the work of the early twentieth century avant-garde was being institutionalized as 'the modern movement' or 'modernism', in the 1930s, De Stijl was accorded a central role.

In the first years between 1917 and 1921 – before Van Doesburg had begun to travel and promote De Stijl extensively outside Holland – this can be seen as an attempt to construct a new, modernizing, 'national' style in a country isolated by its neutrality, caught between powerful neighbouring countries in conflict during the First World War. At the same time many of the pronouncements by Van Doesburg and other early De Stijl contributors invoked the notion of a 'new internationalism'. [In its earliest years De Stijl inscribed a national identity not in terms of traditional cultural chauvinism,[but in opposing the War and constructing new concepts of Dutchness, grounded in an international outlook, that would have an important mediating role in European culture.]

[It was possible to produce De Stijl in Holland during the war years largely because of the presence there of a number of artists and architects mostly, but not exclusively, Dutch, who had certain ideas and ideals in common](or were persuaded that they had by Van Doesburg – sometimes for only a very brief period). Some, like Vantongerloo, who was a refugee from the German invasion of Belgium, or Mondrian and Van 't Hoff, who had lived and worked in Paris and London before 1914, would not have been in The Netherlands but for the War.

To leave Holland or to make contact with other European countries was not easy at this time. Consequently, Dutch artists and

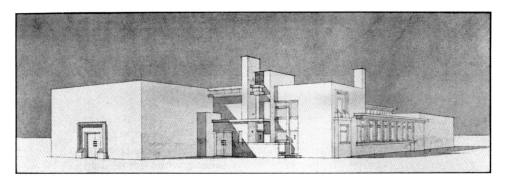

3, 4 J. J. P. Oud, factory at Purmerend, drawing, *c.* 1919; Gerrit Rietveld, Buffet, *c.* 1919, and High Back Chair, *c.* 1919. In the notes to these illustrations published in *De Stijl* (vol. 3, no. 5) March 1920, Van Doesburg compared them with a painting by Mondrian (*1*) and a sculpture by Vantongerloo (*46*): 'All four display in themselves – quite independently of each other – an identical yet distinct way of working.'

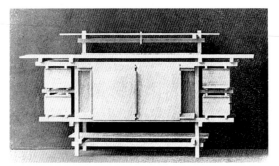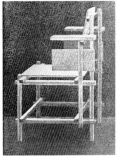

intellectuals began to look inward and re-appraise their own traditions and culture, re-examining and re-defining the role that their small, industrious country could play in a modern Europe and the position which they could construct for themselves within modern European culture. By astutely taking advantage of this situation, Van Doesburg was able to organize and promote De Stijl as 'the Dutch contribution to modernism'. However, although in many ways De Stijl could be regarded as an entrepreneurial operation, it cannot be reduced to an idea constructed single-handedly by Van Doesburg, or to a loose association of individual artists and designers. Nor can the works be conflated as products of what their authors themselves often characterized as the 'collective will' or Zeitgeist (*Tijdgeest* in Dutch).

The stylistic characteristics most commonly represented by means of articles, illustrations and comparisons in the *De Stijl* magazine and elsewhere were:

● A stripping down of the traditional forms of architecture, furniture, painting or sculpture into simple 'basic' geometric components or 'elements'.

● The composition from these separate 'elements' of formal configurations which are perceived as 'wholes', while remaining clearly constructed from individual and independent elements.

● A studied and sometimes extreme asymmetry of composition or design.

● An exclusive use of 'orthogonals' (horizontal and vertical lines or 'elements') and the 'pigment primary' colours ('pure' red, yellow and blue), plus the 'neutral' colours or tones (white, grey and black).

These principles were rarely consistently adhered to in De Stijl work, even in the first years, and were often later changed or modified. Thus, many works produced while their authors were involved with De Stijl are composed of diagonal lines, 'secondary' colours (such as green, orange and violet) or are symmetrical in form.

The 'orthogonal' principle and whether this might be 'compromised' by the addition of diagonals was the subject of a bitter quarrel between Mondrian and Van Doesburg, which was to be one of the main reasons for Mondrian quitting De Stijl in the mid-twenties. Around 1925, when De Stijl was beginning to be included in early modernist accounts of the development of twentieth-century art and architecture, Van Doesburg attempted retrospectively to suggest that there had been greater stylistic unity or adherence to De Stijl 'principles' than was the case: he retouched black-and-white photographs of earlier designs (which had originally been executed in secondary colours) with primary colours, for reproduction in an influential French architectural magazine, *Architecture Vivante*, and 67 back-dated the founding of *De Stijl* to 1916.

One of the main functions of the *De Stijl* magazine in its early years was constantly to circulate images of 'key' works, to draw attention to and ratify stylistic similarities. It was also intended to link such common formal characteristics to the theoretical ideas promoted through the magazine. Not only were the illustrations in *De Stijl* designed to display – and indeed to produce – this stylistic unity, the 3,4 magazine was also intended to validate the work of De Stijl

collaborators by providing a forum where the contributors constantly and incestuously wrote about each other's work.

However, in the later 1920s Van Doesburg began to suggest that the new art would be style-*less*, in line with the increasing internationalism of the De Stijl enterprise and the orientation of his own work and theories. The elimination of style was, of course, an impossibility. But Van Doesburg seems to have regarded the reductivist, geometric forms of the so-called International Style in architecture and its equivalent manifestation in painting and sculpture in the late twenties and early thirties (into which the work of many of the former and current collaborators of De Stijl were being assimilated) as coming close to this ideal of a style-less style.

De Stijl was never seen by those associated with it as merely the production of a common style. It also involved the construction of theoretical positions and beliefs which were perceived as of equal importance to the production of art objects or buildings. The artists and architects were almost all deeply engaged with new and evolving ideas about the production and consumption of art and design and the relationship of these to modern society and social life. These may be summarized as:

- An insistence on the social role of art, design and architecture.
- A belief in a balance between the universal and collective and the specific and individual.
- A utopian faith in the transforming qualities of mechanization and new technology.
- A conviction that art and design have the power to change the future (and also the lives and life-styles of individuals).

These were close to beliefs held by other avant-garde artists and designers at the time in other parts of Europe – for example, in Soviet Russia in the first years after the Revolution, and at the Bauhaus design school in Germany (see Chapter 9). However, the immediate origin of these ideas was in the specific conditions of Dutch society and cultural production in the early twentieth century.

In the early twenties, when Van Doesburg had fallen out with most of his original collaborators, he tried to involve other artists and designers, many of them from outside Holland. Some of those named De Stijl 'collaborators' at this time, such as the young Dutch painter César Domela (born 1900), produced work stylistically very similar to Mondrian's or Van Doesburg's own painting. Some, like the

Russian artist and designer El Lissitzky (1890–1941) and the Romanian sculptor Constantin Brancusi (1876–1957), were included more because Van Doesburg admired their work and ideas. Other artists with whom Van Doesburg worked in collaboration, and apparently respected, such as the Swiss painter Sophie Taeuber-Arp (1889–1943), were never formally described as De Stijl collaborators, although their work was in many ways more closely related to De Stijl. (The only woman named by Van Doesburg as a De Stijl collaborator was Truus Schröder-Schräder, 1889–1985, the client and co-designer with Rietveld of the Schröder house.) Although the works of these and others close to De Stijl will sometimes be described and illustrated, extended discussion has been confined mainly to that of the nine artists and architects who were most closely associated with the enterprise during its first six or seven years – that is, before it became almost exclusively the projection and construction of Van Doesburg's personal obsessions.

Van Doesburg described those who contributed to the *De Stijl* magazine as *medewerkers*. 'Collaborators' or 'contributors' is the nearest English equivalent. This terminology will be followed here rather than referring to 'members of De Stijl'.

The work and ideas of these artists and architects did not automatically cease to be related to De Stijl once they had formally severed their connection, and a number of works undertaken afterwards will be discussed in the following chapters.

Like the Bauhaus, with which it was almost contemporary, the *De Stijl* magazine promoted a common aim to bring together painting, sculpture, applied art, architecture and design. From the first issues the works and writings of painters were presented alongside those of architects. A particular emphasis was placed on the evolution of a collective style and on collaboration between painters and architects, both through illustrations and manifestos in *De Stijl*, and also by means of articles and reproductions of collaborative works in newspapers, cultural journals and specialist art and architectural magazines. De Stijl artists and architects had very different ideas on how this collective style might be achieved and the degree of independence each needed to retain when undertaking collaborative work. These differing conceptions of their mutual roles and self-images were often the source of bitter arguments. Fuelled by conflicts over specific collaborations and the roles assigned to each within these, such differences caused many early divisions in De Stijl.

13

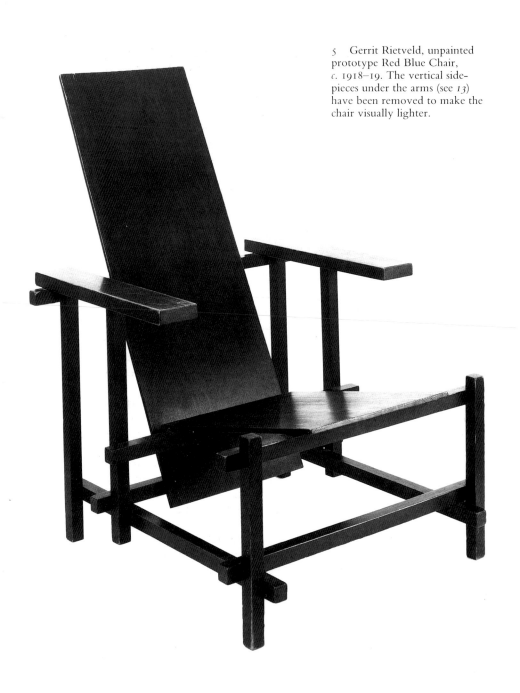

5 Gerrit Rietveld, unpainted
prototype Red Blue Chair,
c. 1918–19. The vertical side-
pieces under the arms (see *13*)
have been removed to make the
chair visually lighter.

An oversimplified picture of De Stijl has been constructed in many modernist accounts by circulating and illustrating a small number of often-reproduced paintings, artifacts or designs for buildings which have thus been accorded iconic status: Rietveld's Red Blue Chair and *93-6,98* Schröder house, Mondrian's asymmetrical paintings of the 1920s, *34* Oud's Café de Unie facade, Van Doesburg and Van Eesteren's *100* coloured axonometric architectural drawings. Their constant repro- *104* duction and recycling has tended to produce a narrow and static view of De Stijl.

These works by different artists and designers cannot be regarded unproblematically as fixed images of De Stijl, separated from the particular conditions of their production and reception. Many were in fact produced either before or after their authors were involved with De Stijl. For example, Rietveld's so-called Red Blue Chair was first made in a slightly different and unpainted form in 1918 before its *5* designer came in contact with De Stijl in 1919. It was not painted in its familiar livery of red, blue, yellow and black until around 1923 – four years after. Between 1918 and 1923 Rietveld also produced a number of variants, unpainted, stained, or painted black or white, with differing dimensions and specifications. The chair was a design which evolved and Rietveld constantly experimented, often revising or incorporating earlier ideas. He never thought of his artifacts or buildings as unchanging.

In the latter half of the 1980s, a number of well-known works by De Stijl artists and architects were reconstructed or restored. In 1986 Oud's Café de Unie – completed in 1925 and destroyed during the German bombing of Rotterdam in 1940 – was rebuilt a few hundred yards from its former site in the centre of the city. Between 1985 and 1987, after Mrs Schröder's death, the interior of the Schröder house in Utrecht was restored as closely as possible to its 1925 state and opened to the public as a museum. In 1989 work began on the reconstruction of the interior of the two main rooms at the Aubette, a vast entertainments complex in Strasbourg, decorated with huge abstract wall paintings by Van Doesburg between 1926 and 1928 and *144-5* destroyed during the 1930s – generally regarded as his most complete realized achievement as an artist and designer. Such restorations and reconstructions of early modernist works demonstrate and re-affirm the status which has been bestowed on them as 'monuments' of the modern movement.

In the period when the first histories of modernism were being

produced from the 1920s onwards, artists' and architects' written and verbal statements were often given as much weight as their art works, artifacts or buildings. As the estates and archives of those associated with De Stijl have become available after their deaths, historians and critics have also drawn on their correspondence. Like published statements and essays, letters from one artist or architect to another, or to critics, dealers, curators, collectors and art historians, are often carefully calculated to construct a self-image. Van Doesburg kept most of the letters he received from De Stijl contributors and collaborators, sympathizers and enemies. He also kept drafts or carbon copies of his own letters. These were preserved with many other papers and manuscripts by his widow Nelly van Doesburg. In the modernist era artists' widows have often played the role of guardians and creators of their husband's reputations. With Nina Kandinsky and Sonia Delaunay, Nelly van Doesburg was one of the most assiduous of these *grandes veuves* of modernism. After her death in 1975, the Van Doesburg archives passed to her niece Wies van Moorsel, the wife of Jean Leering, who as director of the Stedelijk van Abbemuseum in Eindhoven had organized the major post-war retrospective of Van Doesburg's work. She donated these with a large number of paintings, drawings and designs to the Rijksdienst Beeldende Kunst (Netherlands Office for Fine Arts) in The Hague.

Mondrian never married, but he did have an American disciple, the painter Harry Holtzman, who invited him to New York in 1940. Holtzman helped to find him a studio and introduced him to artists, critics and collectors. After Mondrian's death in 1944 Holtzman photographed, filmed and wrote in detail about his New York studio, became the artist's executor and spent the rest of his life promoting and controlling his reputation, including the editing and translation (with the art historian Martin James), of his collected writings into English.

The letters written to Mondrian by his De Stijl colleagues and other correspondents were destroyed after he had read and replied to them. However, he almost certainly counted on his own letters being preserved by their recipients, as most of them were. He also kept very few books, disposing even of some which had been inscribed to him by their authors. This was part of a strategy to produce his self-image as an artist of austere habits and minimal personal effects. His studio and life-style were publicized by means of 'authorized' photographs and written descriptions by the select circle of friends, clients,

curators, critics, journalists and fellow artists who were permitted to visit it. Mondrian's studio has been accorded an almost mythical *147* position in recent writings about the artist and De Stijl in general, and he himself has for long occupied a dominant place in modernist art-historical accounts and international museum collections as one of the 'masters of modern art'. Like a number of Dutch artists of earlier eras such as Rembrandt, Hals, Vermeer and Van Gogh, Mondrian's paintings have often been represented in ways which sever them from their conditions of production and from the contemporary work of the artists with whom he was associated.

Debates about post-modernism in art, architecture and design have focused critical re-appraisal on the variety of formal invention manifested in the early years of modernism, before it was absorbed and homogenized into the International Style and subsequently debased into a consensus modernism after the Second World War. De Stijl remains of interest today because it can still be a fertile source of ideas and visual invention, not merely a series of iconic images constantly reproduced and recycled as 'classics of modernism'. During the 1980s revisions in art, architectural and design history, the challenge of post-modernist theory and practice, and the availability of new material on the artists and architects associated with De Stijl have made a new introduction to the subject essential.

Every history of an enterprise such as De Stijl inevitably represents a different charting of the terrain, mapping new information or interpretations onto what is already known. But each history is grounded in its own time. There is no 'real' De Stijl which can be uncovered, if only we could go back to the primal (or primary) source. Each account of De Stijl, including this one, produces a new 'De Stijl' which is itself historically located and constructed.

6 Vilmos Huszár (attributed), lettering for *De Stijl* 1917

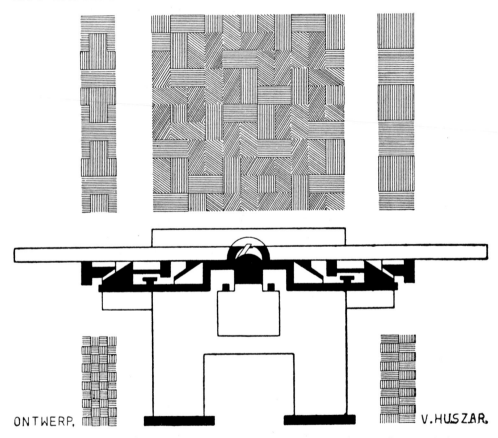

7 Vilmos Huszár, advertisement for the Bruynzeel Company, from *De Stijl*
1917–18

a return to the sobriety and industry of seventeenth-century Holland. Rivalry between the two cities over their commercial and cultural centrality was encouraged and promoted through magazines like *De Nieuwe Amsterdammer* (The New Amsterdamer) and the Rotterdam periodical *Holland Express*, which had strong religious and nationalist affiliations. European commentators, particularly in Germany, wrote about Rotterdam as symbolizing the 'modernity' of contemporary Holland.

Many smaller Dutch towns and cities also underwent rapid expansion and economic development at this time. The city of Utrecht had particular connections with De Stijl. It was the birthplace of Van Doesburg, Van der Leck and Rietveld. The last spent his working life there as a furniture designer and architect, and it is the site of his first building, the Schröder house, the most frequently cited example of De Stijl architecture. Utrecht had been an important node of communications in the Middle Ages but had stagnated when economic power moved to Amsterdam and other coastal cities in the seventeenth century. Occupying a key position at the meeting-point of overland routes from Europe, it became a major centre of communications and trade again with the arrival of the railway and the internal combustion engine. The location of the Catholic archbishopric in Utrecht after Catholicism was re-legalized in the nineteenth century attracted prosperous Catholic business and professional families. The important international trade fair, the Utrecht Jaarbeurs, was first held in 1917. By 1925 an article in the French magazine *Art et Décoration* was describing Utrecht as 'a city in full renaissance'. The same year the Dutch architectural magazine *Bouwbedrijf* devoted a special issue to modern architecture there.

The artists and architects associated with De Stijl implicitly presented their work and ideas as an attack on the hegemony of Amsterdam, which had traditionally dominated Dutch cultural life. The Amsterdam School of architects and designers – whose work had elements in common with European Art Nouveau but which was more deeply inscribed with exotic and orientalist symbolism – particularly aroused their antagonism and scorn. Such symbolism is by no means entirely absent from the work and thought of De Stijl artists and architects, but it is masked by the codes of abstract geometric representation which they adopted. They wished to oppose, to what they considered baroque, overblown and decadent developments, a plain style imbued with spiritual purity and moral

fervour. They believed that their simplified geometric paintings, sculptures and designs for furniture, interiors and buildings could also convey meaning – and indeed more clearly – by simple but 'universal' juxtapositions of horizontal and vertical lines, with evenly applied areas of black, white, grey and pure primary colours.

In the early years of the twentieth century Holland was seeking a new European role as a trading state on the model of Sweden or Switzerland. Adopting a policy of neutrality in the conflicts between the great European powers, it was becoming a modern social democracy whose main concern was the prosperity and welfare of its bourgeois citizenry but which also exhibited a strong ethical concern for social justice and human rights extending beyond its borders. This was promoted through the establishment in The Netherlands of internationalist institutions such as the International Peace Conference, the Court of Arbitration and the Court of International Human Rights in The Hague. In 1933 the well-known Dutch historian J. J. Huizinga, author of *The Waning of the Middle Ages* and *Homo Ludens*, published a lecture entitled 'The Netherlands as Mediator between Western and Central Europe'. Theo van Doesburg clearly saw De Stijl as occupying a similar role of cultural mediation. In the June 1919 issue of *De Stijl* he quoted a tribute by the German critic F. M. Huebner to the internationalist position adopted by the magazine: 'Today, when international understanding of cultural problems is so impeded, it seems to me that your country is the obvious intellectual mediator among the new groups of artists, poets and philosophers on all sides.'

Van Doesburg was attacked in The Netherlands for his internationalism and his interest in German thought. Shortly before the first issue of *De Stijl* appeared, the artist Dirk Roggeveen claimed, in a letter published in September 1917 in *Holland Express*, that the De Stijl artists were in the pay of the Austrians and Germans and that Van Doesburg was the champion of Germanic ideas and culture. Oud replied, denying that any foreign financial support for *De Stijl* had been sought or received. He pointed out that the work and writings of collaborators from abroad would be included not in order to promote nationalist ideas but on the contrary, 'to advance the *international* character of modern art *in the most general sense*' and claimed that it was 'remarkable that *this movement originates in Holland*'.

In the seventeenth century the work of Dutch artists had been internationally known and sought. With the commercial and

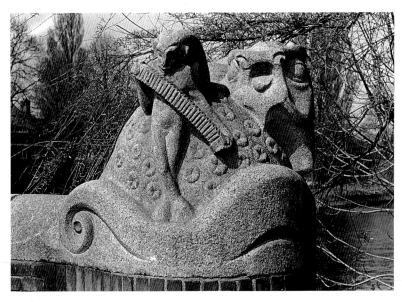

8, 9 Hildo Krop, bridge sculpture, Amsterdam, 1926 (detail); Michel de Klerk, Spaarndammerplantsoen estate, Amsterdam, *c.* 1915–17. Sculptors like Krop and Amsterdam School architects like De Klerk introduced exotic decorative or symbolic elements from Dutch East Indies' art, as well as from traditional Dutch sources like ship design. Trained as a pastry-cook, Krop was appointed city sculptor of Amsterdam in 1916 and designed works for bridges and housing blocks.

economic decline of the eighteenth century the fortunes of Dutch painting had declined too. In the second half of the nineteenth century the Hague School established a certain reputation outside Holland. However, by the early twentieth century Paris had become the European centre where Dutch artists had to make and ratify a reputation – at home as well as abroad – particularly if they wanted to be regarded as 'modern' and 'progressive'.

In 1907 Van der Leck had planned to work in Paris but had returned after only two weeks, appalled by the social conditions. Huszár had spent some months there between 1907 and 1908. When Mondrian settled in Paris in 1912 an established group of progressive artists from Holland was living and working there, including Peter Alma, Kees van Dongen, Conrad Kikkert, Otto van Rees and Lodewijk Schelfhout.

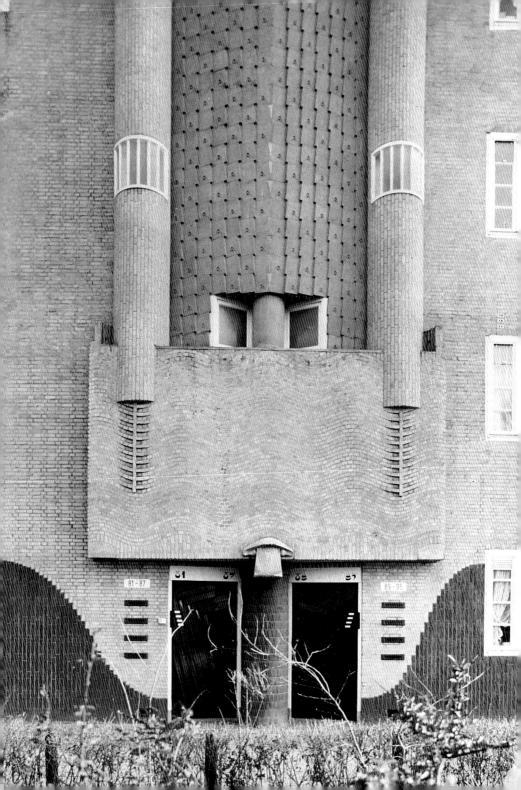

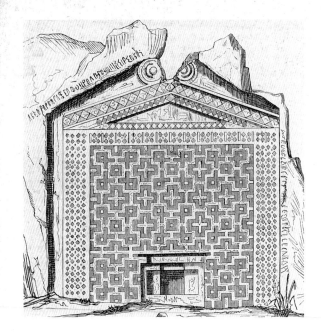

10, 11 Tomb of Midas, illustrated in Gottfried Semper *Der Stil* 1860–63; H. P. Berlage, interior of the Henny house, The Hague, 1898. Semper argued that the form of the wall came from the hanging carpets of nomadic tribes; he considered it a coloured plane rather than a solid structure. For Berlage, brick symbolized the relationship of the individual to society. He used plain unplastered brick for the walls of some of his domestic interiors.

In the construction of a new, 'modernizing' image of The Netherlands at the end of the nineteenth century, architecture had a more dynamic role than painting. H. P. Berlage (1856–1934), the most influential Dutch architect of his time, worked to create a modern architectural style in keeping with the new ideals of Dutchness. This was to be marked by restraint in ornament, sobriety, lack of ostentation and above all a dependable solidity, as displayed in his most famous building, the Amsterdam Beurs (Stock Exchange, 1903). Berlage was also much concerned with social housing – a pressing issue in Holland, the most densely populated country in Europe. His socialist beliefs led him to the conclusion that collective values rather than excessive individuality should be emphasized in housing blocks and public buildings, while retaining the elements of plurality and tolerance which were held to have characterized Dutch society. He described this as *eenheid in veelheid* (unity in diversity or unity in plurality).

Given Berlage's socialist ideals it was an ironic paradox that his best-known buildings should have been the Amsterdam Beurs and the London office of the Müller shipping company, Holland House (1914). Although he built some pioneering housing blocks himself, his ideas about social housing were more completely realized by a

younger generation of architects who had been influenced by his example. Wils had worked in Berlage's office between 1914 and 1916. Oud – the architect most closely involved with Van Doesburg in the initial establishment of De Stijl – had been helped and encouraged by Berlage at the beginning of his career.

The name 'De Stijl' probably originated from the interest they shared in the work and ideas of Berlage. In 1904 Berlage had published a book entitled *Over stijl in bouw- en meubelkunst* (Concerning Style in the Art of Architecture and Furniture Making), where he introduced to Dutch readers ideas derived from the writings of the German architect and design theorist Gottfried Semper. Semper's monumental two-volume study of form in the applied arts, *Der Stil*, 10 had originally been published in Germany between 1860 and 1863. Berlage developed and adapted Semper's ideas in terms of his own utopian socialist beliefs. Following Semper, he placed great emphasis on the wall as both plane and definer of space. This was to be absorbed into De Stijl architectural theory where 'unity in plurality' was represented by the configuration of individual elements from which De Stijl buildings, furniture, sculpture and paintings were constructed, perceived simultaneously both as complete wholes and as assemblages of individual elements.

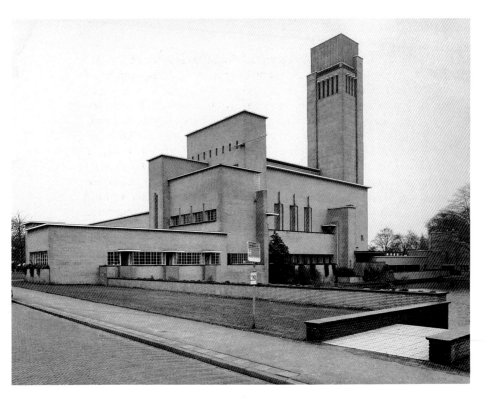

12 Willem Dudok, Town Hall, Hilversum, 1924–31

Other elements of Berlage's utopian socialist ideology can be found in De Stijl, and there were initial suggestions that he might contribute to the magazine. However, Berlage remained opposed to De Stijl ideas, and this was exacerbated by a number of later attacks on him by Van Doesburg, although Mondrian rallied to his defence in a letter to Van Doesburg of February 1921: 'Did you think it was necessary to attack Berlage? Do you think he is really the representative of our enemies? I always saw him as the only architect, the only artist, the only personality, but – old fashioned.'

At the first Congrès International d'Architecture Moderne (CIAM) in 1928, the recently formed international pressure group of modernist architects and urban planners, Rietveld asked Berlage: 'Why do you not join us, you belong with us, don't you?' To which Berlage replied: 'You people are demolishing everything that I have

built up.' Nevertheless, Berlage's last building, the Gemeentemuseum (Municipal Museum, 1919–35) in The Hague, reveals the impact of De Stijl aesthetics in its long horizontal lines, 'elementary' composition, and the use of colour in the interior. However, this is filtered through 'vernacular' modifications, such as the use of yellow brick, similar to those employed by the Hilversum municipal architect Willem Dudok in public buildings like the Town Hall (1924–31), to produce a modern style more acceptable to conservative Dutch taste. *12*

Berlage had drawn attention in Europe to the architecture and ideas of Frank Lloyd Wright through lectures and writings after visiting America in 1911. The two publications on Wright's work, published by Ernst Wasmuth in Berlin in 1910 and 1911, would also have been known in Holland. Wright's architecture presented a 'modernized' transatlantic re-interpretation of Arts and Crafts ideology suitable for re-importation to Europe. With the traditional emphasis in Holland on domesticity and family life, Dutch architects were particularly open to Wright's ideas about the sacral nature of the interior and the hearth as the mythic centre of the home. Although it was not so much this aspect of Wright's architectural philosophy as his ideas about modernity and technology which attracted the architects associated with De Stijl, his mystical opposition of horizontal and vertical, outside and inside, nature and culture, had much in common with the interpretation of this by both them and other Dutch modernists.

The introduction at the end of the nineteenth century of machine methods into craft practices was not considered to be as disruptive in Holland as in England a century earlier. The lack of specialization which characterized Rietveld's early career was not untypical. He *13,14* worked for his father as a cabinet-maker and shop-fitter from the age of eleven, then as a draughtsman in a jewelry firm, finally setting up as a furniture-maker and designer on his own some years before turning to architecture in the mid-1920s. However, in the early twentieth century industrialization had produced enormous upheavals of population in Holland as workers moved from the countryside to find work in the new manufacturing centres, particularly in Rotterdam. This resulted in severe overcrowding and very bad housing conditions in many Dutch towns and cities. The Housing Act of 1902 made public intervention on a major scale in social housing possible, with planned expansion of communities over a certain size compulsory. Such improvements were introduced relatively slowly during

the first two decades of the century, although often in advance of the rest of Europe. (In 1917 fewer houses were built in Holland than during any year since the passing of the new Housing Act.)

The social concern which characterized Berlage's own practice and writings influenced a whole generation of architects in Holland. Whereas modernist architects in France or Germany eschewed official positions with local authorities, in Holland Berlage, Oud, Dudok, Van Eesteren and many others served either directly as municipal architects or planners or worked with local authorities. Oud obtained a job with the Municipal Housing Authority in Rotterdam shortly after the founding of De Stijl. Van Eesteren held a post as a city planner in Amsterdam from the late 1920s until the 50s and was the co-author of the influential and important Amsterdam Expansion Plan of 1934. Nevertheless, many of the buildings, interiors, art works, designs and artifacts produced by De Stijl architects and artists were commissioned by, or sold to, private clients. It was largely for this reason that Van 't Hoff, who held extreme socialist and later anarchist views, was to cut himself off from De Stijl and eventually give up architecture altogether.

At the turn of the century a number of showrooms and workshops devoted to the creation of the 'designed interior' and to encouraging collaborative and applied art work by artists and designers had been set up in Holland. Arts and Crafts, a shop in The Hague, promoted the Art Nouveau style and was based on the model of Liberty in London and Bing in Paris. 'T Binnenhuis (The Interior) in Amsterdam, founded by Berlage and other designers who were opposed to Art Nouveau, promoted plainer and simpler furniture and fabrics. These were often displayed in both 'T Binnenhuis and Arts and Crafts in complete 'designed interiors'. 'T Binnenhuis also attempted to produce affordable mass-produced designs for the working classes. Another showroom and workshop, De Woning, founded in Amsterdam by the furniture designer Willem Penaat, was organized on similar lines but aimed to produce designs even more cheaply. However, the furniture designed by Penaat for workers was purchased mainly by primary school teachers, while the customers who bought their furniture and fabrics at 'T Binnenhuis seem to have been largely artists and intellectuals.

The most important retail outlet and sponsor for De Stijl artists and designers was the firm of Metz. Originally a drapery store in

13, 14 Gerrit Rietveld and assistants outside his furniture workshop in Adriaen Ostadelaan, Utrecht, c. 1918; portable electric machines, illustrating an article in *Bouwbedrijf* 1 October 1926. As electricity became more available it enabled Rietveld's and other small workshops to continue alongside large furniture factories by using portable or hand-held wood-working machines.

TIMMERWERKEN EN MACHINALE HOUTBEWERKING BIJ DE UITVOERING VAN BOUWWERKEN
door Ir. J. G. Wiebenga

Afb. 1. Handgereedschapsmachine voor zagen, schaven, boren, sponningzagen enz.

VERHOOGING van de arbeidsprestatie per timmerman is van urgent belang. Op twee wijzen kan dit worden nagestreefd: 1o. door bestudeering van de bewegingen van den timmerman; 2o. door het invoeren van machines. Bij de studie van de bewegingen van den timmerman maakt men van stopwatch en zelfs stereo-fotografische reproductie gebruik, om in onderdeelen van seconden de gemaakte tijden en bewegingen vast te leggen. Vervolgens moeten deze waarnemingen worden verzameld en geanalyseerd, om daaruit conclusies te trekken, waarvan de bruikbaarheid moet worden gecontroleerd. Deze methode, waarvan Taylor de grondlegger was, is geschikt voor timmerwerkplaatsen werkende met vast personeel, waarbij sprake is van dezelfde telkens terugkeerende werkzaamheden.

De aannemer echter schrijft in en de hem gegunde werken komen in telkens andere plaatsen voor. Bij elk nieuw werk

Afb. 2.

Amsterdam whose success had depended on holding the Liberty concession in Holland, Metz began to commission and manufacture furniture after the First World War in order to produce a more 'modern' image for itself. Initially, the main designer was Penaat, who designed simple white lacquered furniture. At the end of the 1920s Metz began to manufacture and sell furniture designed by Rietveld. He also designed a number of model rooms, a spectacular glass and metal roof-top showroom for the Amsterdam store, and a branch in The Hague. Although Metz was an exclusive shop selling mainly to the well-off, educated middle classes, much of their furniture designed by Rietveld was cheap and self-assembled, promoted as suitable for children's and teenagers' rooms and for summer-houses.

The company commissioned fabrics from Huszár and Van der Leck, who collaborated with Rietveld on room designs for display in Metz's showrooms. Oud also designed furniture for them in the 1930s as, paradoxically, did many of the more extreme left-wing Dutch architects and designers such as Mart Stam.

The interior has traditionally occupied a special role in Dutch culture, belonging to both the private and the public realm – the privileged site of family life and the base from which Dutch mercantile capitalism was organized. Prosperous merchants and professional men often lived above their business premises, as small shopkeepers did elsewhere. The curtains of the living-rooms of Dutch houses, which traditionally face onto the street, are often left undrawn and the rooms brightly lit. The private realm is symbolically projected into the public, while the public city café has something of the privacy and comfort of the domestic interior, and is often furnished in a similar manner to the traditional bourgeois home, with 'oriental' carpets on the tables, dark brown décor and a large central stove.

Since the seventeenth century the window had played an important role as a signifier of wealth for the Dutch bourgeois, who lived in standardized canal houses very similar to those of their neighbours. The municipal tax in The Netherlands was partly based on the amount of glass and thus the size of the windows proclaimed the householder's wealth and status. Because the frontage on the canal or street was extremely expensive, houses in towns and cities were very narrow and deep. Large windows also allowed the maximum penetration of light into the deep interiors of the buildings. In the

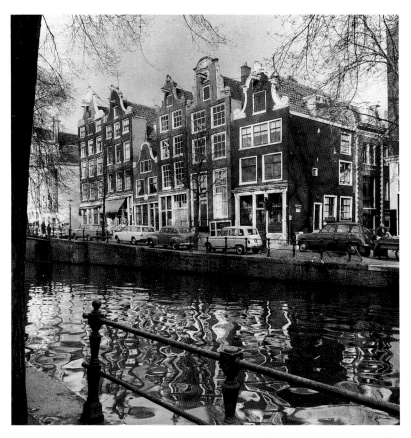

15 Canal houses, Amsterdam, 17th century

traditional Dutch town-house the front room or *mooie kamer* (literally, beautiful room), represented the symbolic presentation of the home to the street.

Today this can be seen even in lower middle-class, or working-class houses or apartments in Holland. Glass is no longer so expensive, but this presentation of the interior to the public gaze remains important. The passer-by is invited to see how comfortable the furniture looks, how many lights are blazing in the interior irrespective of the cost of electricity, how many exotic house-plants or elaborate sets of china figurines can be crowded onto the window-sill.

De Stijl artists and designers attempted to open up the interior, as in the Schröder house. The interior was to be the model of the future, a symbol of new ways of living which, it was hoped, would later be transferred into the public realm. Like the traditional Dutch interior, with light streaming into it from large windows by day and brightly lit at night with curtains undrawn, the De Stijl interior depended on the window as the proscenium which divided the outer from the inner, the private from the social. The De Stijl artists and architects wished to replace the image of the seventeenth-century canal-house with that of the twentieth-century workers' dwelling designed to a basic specification, or 'existence minimum', of which the middle-class house would be a scaled-up version, rather than vice versa.

To the comfortable bourgeois interior as painted by De Hooch was opposed the ascetic environment of Mondrian's studio and the spare, transformable interior of the Schröder house, itself not so far removed from Oud's designs for municipal housing at Kiefhoek and Hook of Holland. The closing of the gap between social classes represented by the convergence of different life-styles in such relatively similar buildings was producing, and was itself produced by, *nivellering*. This – the 'equalizing' of society – was the avowed aim of all but the most conservative elements in Dutch society in the first decades of the century.

During the period when De Stijl was taking shape the Dutch evolved a system known as *verzuiling* (literally, pillarization) or 'denominational segregation'. Each religious community – and some non-religious, such as the Social Democrats – developed its own schools, hospitals, old people's homes, building societies, newspapers and even radio stations. Until the last quarter of the nineteenth century the political parties in the Netherlands were organized according to religious allegiances. This policy aimed to achieve the 'unity in plurality' which Berlage had advocated and which was to underlie the essential aesthetic and social ideology of De Stijl, to create a modern Dutch nation which was separate and individual yet retained a coherent identity.

The majority of artists and architects associated with De Stijl were sympathetic to socialism, anarchism or communism, particularly immediately after the First World War. Profiteering by the mercantile and manufacturing bourgeoisie during the War had caused shortages of materials and created deep resentment. Social unrest was at its height in 1919 and mass demonstrations brought

Holland to the verge of revolution. Huszár, Wils and Van 't Hoff (who was briefly a member of the Dutch Communist Party) were the most involved at this time. Rietveld remained close to the Dutch Communist Party during the twenties. He was secretary of the Utrecht branch of the Filmliga, the radical film society formed by the documentary film-maker Joris Ivens and other Dutch left-wing intellectuals to show the films of Soviet directors like Eisenstein and Pudovkin, whose works were banned from public showing in The Netherlands. An attack in 1927 by Mart Stam on designers who produced 'one-off' pieces of furniture or interiors for wealthy clients, 'Away with the Furniture Artists', may well have been instrumental in turning Rietveld to designing furniture for multiple production at this time. Mrs Schröder's sister, An Harrestein, was married to a left-wing doctor in Amsterdam. In 1926 Rietveld and Mrs Schröder redesigned the Harresteins' Amsterdam apartment. This was the centre of a circle of artists and intellectuals in Amsterdam close to the Dutch Communist party. Rietveld became a member of this circle and was a frequent visitor at the Harresteins.

Oud refused to join any party or to sign any manifesto, including the first De Stijl manifesto in November 1918, perhaps because of his new official position as an architect with the Rotterdam Municipal Housing Authority. (His brother Pieter Jacobus Oud was a well-known Liberal Democrat politician who became mayor of Rotterdam and leader of the opposition in the Dutch parliament.)

In 1919 Van Doesburg joined the League of Revolutionary-Socialist Intellectuals whose members included a number of artists and architects such as Berlage. He celebrated the second anniversary of the Russian Revolution in a letter to his friend and early De Stijl contributor, the poet Antony Kok, in December 1919 and rejoiced in the failure of the Western military intervention. However, he dissociated himself from the Dutch Communist Party, believing that 'art should not be subordinated to political beliefs'.

Mondrian shared this view, writing to Van Doesburg in October 1919: 'Bolshevism in itself seems to me ideal; but the term is already contaminated by misapplication. I very much approve of the way you are making the De Stijl movement quite objective and not linking it with Bolshevism or any other political branch, despite the fact that it may possibly be necessary to do this.'

Before his involvement with De Stijl, Van der Leck painted 16
subjects from working-class life in a stylized, figurative manner.

However, he avoided joining any political party and believed that an artist should embody his social ideals through his art and not by direct political action.

The traditional burgher class or civic bourgeoisie, which had gained political, economic and social dominance in The Netherlands with the development of mercantile capitalism in the seventeenth century, had opposed industrialization and modernization and the integration of the Dutch provinces into a centralized economy during the nineteenth century. These were the traditional patrons of culture in Holland, their tastes represented from the 1860s to 1900 by the work of the Hague School which invoked a rural, pre-industrial past. It was only at the end of the nineteenth century that a new bourgeoisie of manufacturers and financiers emerged as private patrons of the arts. Initially they followed the taste of the traditional bourgeoisie, patronizing the Hague School artists, whose production multiplied enormously in response. However, the more 'progressive' members of this new class wished to patronize work which would promote a more modernizing image of themselves. The patrons and clients of the De Stijl artists and architects were mainly from this new manufacturing class, or from the professions, or other architects and artists. Their patronage was usually on a domestic scale, commissioning paintings or interiors for their own homes. Among these was the wood product manufacturer Cornelis Bruynzeel, who commissioned stained glass and colour designs for his house in Voorburg by Huszár and Wils, as well as designs for his business.

7

Exceptional among the patrons of De Stijl were Saloman B. Slijper and Helen Kröller-Müller, whose patronage was on quite a different scale. Slijper, a stockbroker, purchased nearly two hundred paintings and drawings by Mondrian, produced between 1908 and 1921. These are now, through his bequest, the foundation of the collection at the Gemeentemuseum in The Hague, which also contains many other important De Stijl works.

The Kröller-Müllers were ship-owners, who also had extensive mining interests in Spain and north Africa. Advised by the art critic H. P. Bremmer, Mrs Kröller-Müller built up one of the finest modern art collections in the world, including 250 paintings by Van Gogh. Her exemplary collection is now the basis of the Kröller-Müller Museum on what was once part of the family estates at Otterlo near Arnhem. Mrs Kröller-Müller bought the work of Mondrian and Van

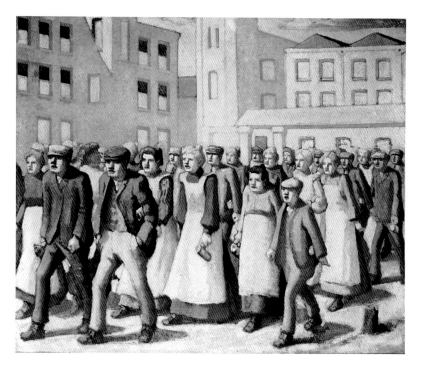

16 Bart van der Leck *Leaving the Factory* 1910. See also *24*

der Leck in large quantities, and the latter was for some years under contract to the Müller company and then to Mrs Kröller-Müller personally. Bremmer arranged these contracts and others for himself with Mondrian and Van der Leck, by which they received monthly sums in return for paintings. Bremmer also helped Huszár, although he does not seem to have bought his paintings.

31

Van Doesburg, Oud and Mrs Schröder all came from the manufacturing classes but only the last seems to have inherited substantial wealth. Van Doesburg sold little work and lived largely by writing cultural journalism for small-circulation magazines in Holland. Although his third wife, Nelly van Doesburg, inherited a small amount of money from her father, a subscription had to be raised by friends and other artists shortly before his death in 1931 to send him to be treated for acute asthma at a Swiss sanatorium.

Van 't Hoff, who came from a comfortable middle-class professional background, married a wealthy heiress and helped subsidize

De Stijl for a short time. Mondrian's father was a junior-school headmaster. Van der Leck and Rietveld were both from working-class families and left school early – Rietveld at eleven, Van der Leck at fourteen to be apprenticed to a stained-glass maker.

Most of the Dutch artists and architects associated with De Stijl were from Protestant backgrounds but equally important was the interaction and opposition of Catholic and Protestant ideas, which was a major feature of Dutch life in the late nineteenth and early twentieth century: Van Doesburg converted to Catholicism at the end of his life; Mrs Schröder was from a Catholic family; both Rietveld and Oud were from strict Calvinist ones. Although he had a Protestant background, Van der Leck worked as a young man for a workshop producing stained glass exclusively for Catholics. Mondrian, on the other hand, helped his Calvinist father paint religious wall-paintings for his school, and during his early years as a student in Amsterdam in the 1890s drew images to illustrate Calvinist publications. Van Doesburg came to believe that the aesthetic and social ideas at the basis of De Stijl could become an alternative to religion, a kind of spiritual positivism. In a letter of 1922, he wrote, 'that which the + represented to the early Christians, the □ represents to us', and to another correspondent the same year, 'The □ will conquer the + .'

Many of those associated with De Stijl refer frequently in their writings to 'the spiritual'. The Dutch word *geestelijk*, like the German *geistig*, has different connotations from the English 'spiritual', for it also conveys the idea of the mental or intellectual, which they opposed to the positivism and materialism of nineteenth-century scientific thought.

Both Mondrian and Van Doesburg had an interest in Theosophy and Rudolf Steiner's Anthroposophy at the time when they were beginning to formulate De Stijl ideas. Their concept of 'the spiritual' was partly derived from the theories of the Russian painter Vasily Kandinsky whose treatise *Concerning the Spiritual in Art* (1912) was widely read in Holland. From about 1920 Van Doesburg shifted his interest to scientific and quasi-scientific notions like the fourth dimension. He did not abandon the use of the term 'the spiritual', although he does seem to have become sceptical about Theosophy. It is one of the most characteristic aspects of De Stijl, as of other modernist movements, that an intense fascination and admiration for modern technology and science should be combined with a belief in their redemptive and spiritual qualities.

Writing De Stijl

Dutch is not a language which has a wide currency outside Holland. The cultural identity of The Netherlands has to a large extent been represented internationally as visual, produced by architecture and painting rather than by literature. Nevertheless, De Stijl gave great importance to the written word. Van Doesburg and Mondrian considered De Stijl a literary movement as well, and one of the original De Stijl collaborators was the poet Antony Kok. Almost all the De Stijl artists (particularly Van Doesburg, Mondrian and Oud) wrote at length about their own work and contributed theoretical articles about art and architecture to the pages of *De Stijl* and other magazines. They regarded the word as an important support and as a necessary adjunct to their visual work. They were well aware of the strength of the Dutch visual tradition and how their own works and those of a like-minded group of artists and architects might be produced within it. They were equally well aware of the limitations of working within what had, by the early twentieth century, become a small social-democratic country, and of writing in a language which was little known outside Holland.

When Mondrian returned to France after the First World War he wrote and published in French (and later, when he moved to London and New York, in English). His writings were also translated into German. Oud, who had worked in Germany before the First World War, also published in German. Van Doesburg published in German and French, living in Germany in 1921 and 1922, and settling permanently in Paris in 1923. This may partly explain why the work of Van der Leck, who wrote seldom and always in Dutch, made little international impact after he had left De Stijl and was working on his own in Holland after 1919. However, even when Van Doesburg was in Germany and France, the majority of articles published in *De Stijl* were in Dutch. Despite its increasing international range after 1920, this continued to be so until the last issue edited by Van Doesburg in 1928, the special number on the design of the Aubette, the only one

37

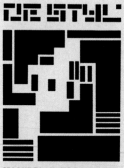

DE STIJL

MAANDBLAD VOOR DE MO-
DERNE BEELDENDE VAKKEN
REDACTIE THEO VAN DOES-
BURG MET MEDEWERKING
VAN VOORNAME BINNEN- EN
BUITENLANDSCHE KUNSTE-
NAARS. UITGAVE X. HARMS
TIEPEN TE DELFT IN 1917.

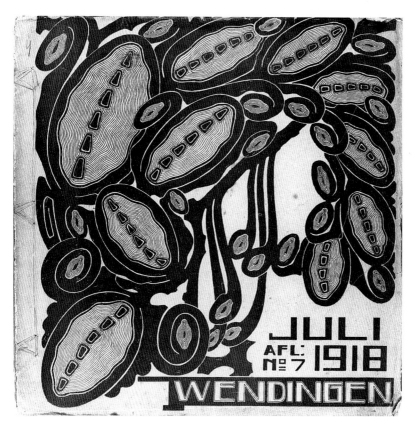

17, 18 Vilmos Huszár, cover of early issue of *De Stijl*; cover of *Wendingen* July 1918. The geometric austerity of *De Stijl* was in marked contrast to its rival, *Wendingen*, with de luxe paper and printing and exotic covers using organic imagery.

not to have a single article in Dutch. This tenacious holding to the Dutch language in *De Stijl*, even in its most international years, can perhaps be explained by a passage from the essay by Huizinga cited earlier. 'The Dutch, precisely because they have their own language, that ancient symbol of their national identity and independence, can assimilate foreign influences evenly and quite freely. Without a language of their own, the Dutch could never have become the great mediators they are.'

Van Doesburg and Mondrian believed that the modernist artist must also be a critic and theorist. In the first issue of *De Stijl* Van Doesburg wrote that it was part of the modernist artist's dual role to write about his or her own work in order to make it more easily understood by the public. 'Today I looked at my work and was so struck by its lucidity that I wrote another article', Mondrian wrote to Van Doesburg, around 1919. Such strategies were related to continuing critical discourses since the last decades of the nineteenth century in Dutch cultural journals like *De Nieuwe Gids* (The New Guides) and *De Nieuwe Amsterdammer*, where the work of the critic was considered comparable to the production of the work of art. From about 1912 the role of the writer–artist, or artist–critic, began to appear and be validated in art journals and daily newspapers in Holland. By the time of the First World War, artists' statements and writings were being published in exhibition catalogues. Artists were also writing criticism and reviews in magazines. *De Stijl* and the Amsterdam School magazine *Wendingen*, founded in early 1918, were both edited by artist- or architect-critics, and primarily published writing by artists and architects, rather than by professional critics.

17
18

These critical activities helped to establish artists and architects as 'personalities', to build their reputations in Holland and later in other European countries and the United States. This has often been regarded as a typical modernist strategy, yet it was also adopted by the Amsterdam School architects and artists who contributed to *Wendingen*, whose work has generally been represented as anti-modernist, although eclectic would be a more accurate description.

Published in Dutch, English and German editions, issues of *Wendingen* were devoted to single subjects, ranging from social housing, the theatre, masks, marionettes, Hungarian illustration, to Jan Toorop, Lloyd Wright, Diego Rivera (with a cover designed by Huszár), Lyonel Feininger, Soviet theatre design, Eric Mendelsohn, and the contemporary architecture of Denmark, Sweden and Austria. It also published many articles and a number of special issues on the art of the South-East Asian countries which formed the Dutch colonies. Van Doesburg had originally thought of calling *De Stijl The Straight Line*; had he done so, the difference between the two would have been even clearer, for *wendingen* means 'turnings' in Dutch.

In modernist art-historical narratives artists' writings have often been quoted or cited uncritically. However, at the time when these

writings first began to appear they were not received in this way. When the first issue of *De Stijl* was reviewed in the Dutch architectural magazine *Bouwkundig Weekblad* in 1917, its editor J. P. Mieras wrote: 'In *De Stijl*, clear argument gives way to the introduction of several fancy phrases, vague generalizations which are for the thinking man not simply to be accepted without question. . . . What is plastic consciousness? What is the "tijdgeest" [Zeitgeist]? What does this all mean? Is there no material to explain these particular terms, such as exists in legal and mathematical language?' This is very similar to the complaints of revisionist critics and art historians in the 1980s. The Dutch art historian Carel Blotkamp claimed in *De Stijl: The Formative Years, 1917–1922* (1986) that 'even we Dutch authors sometimes have not the slightest idea, after half a century, of the meanings of certain statements made by these elated men.' The writings of De Stijl artists cannot be viewed as logical or rational explanations of their work. Van Doesburg claimed in the introduction to his *Grundbegriffe der neuen gestaltenden Kunst* (Principles of Neo-Plastic Art), originally published in Dutch in 1919 and as a Bauhaus Book in 1925, that, 'Artists do not write *about* art, they write *from within art*.' Both paintings and writings are 'texts' which can be submitted to critical consideration but artists' writings cannot be regarded as statements open to logical verification, any more than paintings can be analysed according to scientific principles or mathematical laws.

After returning to Holland from Paris in 1914 Mondrian painted relatively little until 1917 (probably only one painting between 1915 and 1916). Instead, he began to write his first theoretical essays from earlier notes. These were later published in *De Stijl* in twelve instalments as 'De Nieuwe Beelding in de Schilderkunst' (Neo-Plasticism in Painting). He wrote them while living in Laren, a village north-east of Amsterdam favoured by artists and writers. Here he met Van der Leck, the modernist composer Jacob van Domselaer, whom he had known in Paris before the War, and the writer Matthieu Schoenmaekers, a former Catholic priest who called himself a Christosophist because he combined Christianity with Theosophy. Schoenmaekers had recently published two influential books, *Het Nieuwe Wereldbeeld* (The New World Image, in 1915) and *Beginselen der Beeldende Wiskunde* (Principles of Plastic Mathematics, in 1916). The impact of Schoenmaekers' writings on Mondrian's ideas has been

over-emphasized. Mondrian very quickly became suspicious of Schoenmaekers and later considered him to be a charlatan. As early as 21 May 1917, he wrote to Van Doesburg that he regarded him as a 'miserable fellow' and doubted his sincerity. However, Mondrian did take over some of Schoenmaekers' terminology. The terms *beeldend* and *nieuwe beelding* have caused more problems of interpretation than any others in the writing of Mondrian and other De Stijl contributors who adopted them. These Dutch terms are really untranslatable, containing more nuances that can be satisfactorily conveyed by a single English word. *Beeldend* means something like 'image forming' or 'image creating', *nieuwe beelding* 'new image creation', or perhaps 'new structure'. In German, *nieuwe beelding* is translated as *neue Gestaltung*, which is close in its complexity of meanings to the Dutch. In French, it was rendered as 'néo-plasticisme', later translated literally into English as 'Neo-Plasticism', which is virtually meaningless. This has been further confounded by the editors of the collected English edition of Mondrian's writings, who adopted the absurd term 'the New Plastic'.

Although Van Doesburg was also influenced by Theosophy and by occult writers like Schoenmaekers, his theoretical writing is more closely grounded in the Hegelian philosophical tradition. This was popularized in Holland in the early years of the century through the teaching and publications of G. J. P. J. Bolland, who was professor of philosophy at the University of Leiden. Both Mondrian and Van Doesburg knew Hegel largely through secondary sources like Bolland's books. Mondrian, however, is more discursive in his writing than Van Doesburg and draws heavily on Theosophy and the Anthroposophy of Steiner. His oppositions of universal/individual, horizontal/vertical, nature/spirit, masculine/feminine, abstract/real, determinate/indeterminate are an amalgam of Hegel, Theosophy, Steiner and Schoenmaekers.

Although he also sometimes used similar sources, Van Doesburg was more in touch with current ideas in art history and was familiar with the recent works of German art historians like Wilhelm Worringer and Heinrich Wölfflin. He absorbed Worringer's ideas about abstraction, although where Worringer considered abstraction and 'empathy' with nature to be opposite poles between which art oscillated, Van Doesburg saw the whole of art history moving inexorably towards abstraction. From Wölfflin, whose *Kunstgeschichtliche Grundbegriffe* (Principles of Art History) had been published

in 1915, he derived the notion of essential 'elements' which form the basis of the individual arts and of architecture. Van Doesburg drew further on Wölfflin's ideas in *Klassiek-Barok-Modern*, a lecture delivered in 1920 in Antwerp and published in Dutch and French versions. Here he extended Wölfflin's concept of the duality of the classic and baroque, through Hegel's idea of thesis, antithesis and synthesis. The 'thesis' of classicism and its 'antithesis' baroque are reconciled in the 'synthesis' of the modern.

In his lectures and essays written between 1916 and 1919, Van Doesburg proposed a typically modernist, 'developmental' history of art. He saw the whole of Western art from Giotto to the early twentieth century as a gradual evolution from the representation of 'natural reality' to that of 'spiritual reality'. He illustrated one of his early publications with a series of reproductions beginning with palaeolithic art and ending with De Stijl. Van Doesburg and Mondrian eventually came to disagree over this. Mondrian believed that the developmental process culminated in *nieuwe beelding*, having attained the highest plane of art. Beyond that, he claimed, art would disappear altogether. Van Doesburg, on the other hand, argued that the developmental process continued indefinitely.

As in the Epilogue to the 'First Futurist Manifesto' where Marinetti had foreseen the Futurists hunted down by the next generation of avant-gardists, Van Doesburg believed that *nieuwe beelding* would in turn be overtaken by a new modernist development. Hence his introduction of the diagonal in the mid-1920s when he had come to believe that *nieuwe beelding*, or at least Mondrian's interpretation of it, was a return to classicism – a thesis which in turn must be ruptured by a new antithesis, the baroque of what he called 'Elementarism' or 'Counter-Composition', in which diagonal elements predominated.

After returning to Paris in the summer of 1919, Mondrian continued to contribute to *De Stijl* and to propagate De Stijl ideas in France, while at the same time stimulating and enlarging the horizons of the Dutch contributors with whom he was in contact. He kept Van Doesburg informed about what was happening in the post-war Parisian art world, and urged him to move to Paris himself, reiterating this when Van Doesburg visited him there in 1920 and 1921.

However, Mondrian remained rather isolated by comparison with the years 1917 and 1918 in Holland, when he had found himself at the centre of an admiring group of younger artists. The post-war French

19

43

art world was essentially unsympathetic to radical abstraction and much more chauvinistic than in the years immediately before 1914. In 1921 Mondrian thought of abandoning art for market gardening, and began to produce flower paintings for Dutch clients in order to survive financially.

The immediate post-war years were a crucial time of change for Van Doesburg, as well as for De Stijl, both in his work and in his personal life. When he visited Mondrian in Paris early in 1920 it was the first time he had ever been outside Holland. This trip widened his horizons and gave him a taste for travel. At the end of the same year he made his first visit to Germany. In early 1921 he left his second wife Lena Milius in Leiden and travelled via Belgium, France and Italy to Weimar with Nelly van Moorsel, later his third wife. He was to live and work in Germany, on and off, for almost two years.

During the next ten years Van Doesburg travelled continuously in France, Germany, Austria, Belgium, Italy, Spain, and Czechoslovakia. He made contact with modernist artists and architects in every country he visited, promoting his own work and the idea of De Stijl as vigorously as Marinetti had promoted Futurism throughout Europe in the years before the War. Between 1920 and 1924 he gave up painting and became preoccupied with architecture and the role of colour in architecture. Restless and rootless, frequently on the move, he began to use two pseudonyms to supplement the already pseudonymous persona of Theo van Doesburg – he was baptized Christian Emil Marie Küpper – a Dadaist poet and novelist, I. K. Bonset, and a Futurist/Dadaist persona, Aldo Camini. In 1923, having decided to settle permanently in France, he began to spell his first name Théo in the French manner. (Mondrian had dropped the second 'a' from his original surname, Mondriaan, on first moving to Paris before the First World War.)

Van Doesburg increasingly came to see the future development of De Stijl in European terms and the magazine became the main agent in promoting this. Its title, *De Stijl*, had Berlagean connotations for Dutch readers (German readers would have been reminded of Semper). It also had the advantage of being easily comprehensible in French, German, English or Italian. Nevertheless, from 1926 it

19 Theo van Doesburg, design for the cover of the Dutch edition of *Klassiek-Barok-Modern* 1920. By the mid-20s Van Doesburg had come to see the diagonal as a 'modern' rather than a 'baroque' element.

THEO VAN DOESBURG

KLASSIEK

BAROK

MODERN

DE SIKKEL·ANTWERPEN

appeared in translation as well on the cover: 'Le Style, Der Stil, The Style, Il Stile'.

Although dated October 1917, the first issue probably appeared in early November, with sixteen pages of text plus separate inserted reproductions. It contained an editorial by Van Doesburg, the introduction to Mondrian's 'Neo-plasticism in Painting', 'Modern Painting and its Relationship to Architecture' by Van der Leck, 'Modern Painting in the Interior' by Kok, and Oud's 'The Monumental City and its Image'. There were reproductions of *32,91* Composition 1917 by Van der Leck and Oud's design for a sea-front housing block at Scheveningen, with commentaries on these by Van Doesburg. The choice of contents was clearly intended to emphasize the preoccupation with the relationship between painting and architecture.

Van Doesburg had written to Van der Leck in May 1917 that the new magazine would be 'unpretentious', typographically and aesthetically austere, 'without any trappings'. In its first years *De Stijl* was austere and unpretentious to the point of plainness. It was printed on cheap paper with inserted loose illustrations reproduced rather *17* poorly on coated paper, in a small upright format with covers in light green or grey, which continued until the end of 1920 when the *22* magazine was redesigned by Van Doesburg and Mondrian.

In 1918 the publisher of *De Stijl*, Harms Tiepen of Delft, wanted to appoint a separate editor for architecture. Not surprisingly, this was unacceptable to Van Doesburg, who decided to publish the magazine himself. Financial support was provided by Van 't Hoff, until he and Van Doesburg fell out in the autumn of 1919.

It is unlikely that sales were ever more than 300 copies, although *De Stijl* attracted considerable critical attention in Holland and abroad. In March 1918 there were 120 subscribers, by October, 200; in 1920–22 there were 250. Probably some extra copies were printed to sell in bookshops and galleries. This was close to the average for avant-garde magazines of the period. The figures for the Amsterdam-based *i10*, for instance, published between 1927 and 1929, are comparable. However, the distribution of *De Stijl* was quite wide, with a surprisingly large number of subscribers in Japan.

The first number of the second volume of *De Stijl*, published in November 1918, coincided with the end of the First World War and *20* contained the 'First De Stijl Manifesto' in Dutch, French, English and German. Its message was clearly aimed at extending De Stijl into the

46

MANIFEST I OF „THE STYLE", 1918.

1. There is an old and a new consciousness of time.
The old is connected with the individual.
The new is connected with the universal.
The struggle of the individual against the universal is revealing itself in the world-war as well as in the art of the present day.
2. The war is destroying the old world with its contents: individual domination in every state.
3. The new art has brought forward what the new consciousness of time contains: a balance between the universal and the individual.
4. The new consciousness is prepared to realise the internal life as well as the external life.
5. Traditions, dogmas and the domination of the individual are opposed to this realisation.
6. The founders of the new plastic art therefore call upon all, who believe in the reformation of art and culture, to annihilate these obstacles of development, as they have annihilated in the new plastic art (by abolishing natural form) that, which prevents the clear expression of art, the utmost consequence of all art notion.
7. The artists of to-day have been driven the whole world over by the same consciousness, and therefore have taken part from an intellectual point of view in this war against the domination of individual despotism. They therefore sympathize with all, who work for the formation of an international unity in Life, Art, Culture, either intellectually or materially.
8. The monthly editions of „The Style", founded for that purpose, try to attain the new wisdom of life in an exact manner.
9. Co-operation is possible by:
I. Sending, with entire approval, name, address and profession to the editor of „The Style".
II. Sending critical, philosophical, architectural, scientific, litterary, musical articles or reproductions.
III. Translating articles in different languages or distributing thoughts published in „The Style".

Signatures of the present collaborators:
THEO VAN DOESBURG, Painter.
ROBT. VAN 'T HOFF, Architect.
VILMOS HUSZAR, Painter.

ANTONY KOK, Poet.
PIET MONDRIAAN, Painter.
G. VANTONGERLOO, Sculptor.
JAN WILS, Architect.

MANIFEST I VON „DER STIL", 1918.

1. Es gibt ein altes und ein neues Zeitbewusztsein.
Das alte richtet sich auf das Individuelle.
Das neue richtet sich auf das Universelle.
Der Streit des Individuellen gegen das Universelle zeigt sich sowohl in dem Weltkriege wie in der heutigen Kunst.
2. Der Krieg destruktiviert die alte Welt mit ihrem Inhalt: die individuelle Vorherrschaft auf jedem Gebiet.

20 'First De Stijl Manifesto' (English version), *De Stijl* (vol. 2, no. 1) November 1918. Oud declined to sign and Van der Leck had already cut his links with De Stijl.

international arena after the War. This was seen, as it was by many of the European avant-garde, to have destroyed the 'old world', clearing the way for the construction of 'the new'. The 'old' was the individual, the 'new' the universal. The War had destroyed the domination of the individual. The new art was creating the 'content of the new consciousness' – an equilibrium between the individual and the universal. The manifesto ended by inviting the readers to co-operate by sending their names, addresses and professions to the editor, by contributing critical, philosophical, architectural, scientific, literary and musical articles, or by sending reproductions, translating articles into other languages and 'disseminating the ideas published in *De Stijl*'. In a note Van Doesburg added that as soon as normal communication between Holland and other countries was re-established the manifesto would be issued separately in a large edition and distributed in the main art centres abroad. He was no doubt thinking of Marinetti's methods of distributing Futurist manifestos. However, this did not happen, presumably because he did not possess the Futurist leader's unlimited funds.

Although the 'First De Stijl Manifesto' was not as aggressive as those of the Futurists, it was unmistakably couched in manifesto form with its numbered propositions and exhortatory tone. Van Doesburg clearly believed, now that *De Stijl* was directing itself towards an international audience, that the well-tried strategy of the manifesto form would gain maximum attention. This proved to be effective. The initial response from abroad came from Italy, in early 1919. The Italian magazine *Valori Plastici* was the first foreign magazine to respond and discuss *De Stijl* in detail.

During the next two years Van Doesburg tried to establish as many contacts as possible with artists and architects outside Holland. At first this had to be done entirely by correspondence, and by arranging exchanges between *De Stijl* and other European avant-garde magazines, as can be seen from the 'Books and Magazines Received' column which appeared at the end of the early issues. The first artist from outside Holland to contribute to *De Stijl*, and the only contributor writing from abroad until the end of the War, was the former Futurist painter Gino Severini, who worked in Paris. His articles, which began to appear from the second issue in December 1917, had originally been published in *Mercure de France*. Relatively few works by non-Dutch artists were illustrated in the magazine during the early years. It was only in 1921, when Van Doesburg was

RUITER

Stap

Paard

STAP

PAARD

Stap

Paard.

STAPPE	PAARD	
STAPPE	PAARD	
STAPPE	PAARD	
STAPPE PAARD	STAPPE PAARD	
STEPPE PAARD	STEPPE PAARD	
STEPPE PAARD	STEPPE PAARD	
STIPPE PAARD STIPPE	PAARD STIPPE PAARD	
STIP	PAARD	
STIP	PAARD	
	STIP	

WOLK

162

VOORBIJTREKKENDE TROEP

Ran sel

Ran sel

Ran sel

Ran-sel

Ran-sel

Ran-sel

Ran-sel

Ran-sel

BLik - ken - tr**o**mmel

BLik - ken - tr**o**mmel

BLikken TRommel

RANSEL

BLikken trommel

BLikken trommel

BLikken trommel

RANSEL

21 Spread from *De Stijl* (vol. 4, no. 11) November 1921. Van Doesburg had begun to publish experimental poems under his Bonset pseudonym, laid out typographically with great variations in the letter sizes, in the May 1920 issue. In 1921 these increased in visual invention.

in Weimar, that *De Stijl* became more truly 'European' in its contents, publishing more articles in German and French, although still retaining its primarily Dutch character.

In 1920 the lay out of *De Stijl* was radically redesigned. In place of the upright format, a squarer page was adopted with a new cover designed by Mondrian and Van Doesburg, consisting of 'NB' (Nieuwe Beelding) in tall red letters, overprinted with 'De Stijl' in black. Van Doesburg decided to wait until the New Year of 1921 before launching the magazine in its new format. On receiving the January issue, Mondrian wrote to him and Lena Milius: 'This morning, to my joy, came *De Stijl* in her new dress. I find this perfect, and still enjoy the conversations about it when Does was here. You did it exactly as I intended. How nice that our aims are growing together.'

22

The new design used already existing type (grotesques) in unusual combinations, rather than employing a specially designed alphabet, as Huszár had done for the early covers. The lettering was in a plain, well proportioned sans-serif type, carefully and asymmetrically spaced across a 'landscape'-format cover in white or cream. The combination of red and black type balanced asymmetrically in this way was to become a commonplace of avant-garde typography in the twenties, from Russia to Switzerland. *De Stijl* was one of the earliest publications to adopt what became known as 'the New Typography' in its cover design, although there were precedents for the asymmetric use of typographical elements in Futurist and Dadaist publications.

A sheet of De Stijl notepaper and a postcard using similar typographical combinations to the magazine cover were illustrated in Jan Tschichold's seminal *Die Neue Typographie* (1928), which took its epigraph from Mondrian. This was intended as a handbook for typographers and included an appendix with the names and addresses of sixteen 'New Typographers', among whom Van Doesburg was included.

The text of the re-designed magazine was printed in two columns numbered as separate pages so that it could be folded for reading or

10 JAREN ~~STIJL~~ 1917 - 1927

Voor nieuwe tijdschriftjes hebb... ...niet erg bemoedigend scepticisme. Zoo gaat ook nu we met
eenige aarzeling schrijven ov... ...maandblad, voor de moderne beeldende kunsten onder de redactie
van Théo van Doesburg. Di... ...eet « De Stijl ». De naam wordt de lezer een raadseltje van blokken
op den omslag opgegeven,n onze zetterij geprobeerd heeft hierboven ... nabootsinkje te maken.

(Haarl. Dagblad 1917).

Les artistes du « Stijl » so... ...cubistes purs, des cubistes qui en certain ...ns, veulent aller plus loin
que les cubistes français, te... ...le maître Pablo Picasso entre autres, dont ...re garde un certain carac-
tère de plasticité.

Le « Stijl » n'admet pas cel...

Le cubisme, qui a bien fait r... ...core en certains milieux, n'en demeure pas moins fort vivace en dépit
des attaques dont il est l'objet... ...mérite l'attention. Il n'entre pas dans notre idée de l'analyser ici. Nous
voulons simplement constater q... cette interprétation moderne de la vie, donne déjà, — en architecture par
exemple — des résultats que ...ne une profane (sans parti pris) saurait apprécier. Ceci également mérite
l'attention.

Lumière. Nov. 1919.

Dat kunstenaars zich vermaken met, of zich vergeten in het opstellen en verkondigen van theorieen is de
dwaasheid van den krompoot. d... zich op glad ijs waagt, maar het brengt nog humor in de wereld. Dat ze
echter waarachtig probeeren om in lijn en kleur en in beeldende en bouwende plastiek hunne philosophie-
tjes te verwerkelijken is een dwaasheid, die niet beminnelijks meer heeft, omdat het 't aanzien geeft van een
pretentieuse propagandakunst, waarvan de onmacht van het woord nog eens dik onderstreept wordt door die
van het kunnen.

Ook deze strooming is een teeken van onzen tijd vol van tijdelijkheden, een tijd, waarin niets duurzaams
schijnt, en ook deze mode zal tijdelijk blijken en zelfs bij personen, die thans met haar proi ...en, zal ze voor-
bijgaan. hopenlijk om ze te ontwikkelen, want voor is bij deze rechtlijnige geaardheid no ruimte, zoo ze
althans voor sommigen geen einde beteeken...

C. J. Blaauw in « De Telegraaf 1920. »

Das Triumphgeschrei der Stilgruppe Architektur und Malerei aus ihren eigentlichen Mitteln : ehrlich, ein-
fach und sachlich, erscholl voll Widerhall in europäischen Ländern. Die rasche Verbreitung der konstruk-
tivistischen Erkenntnisse ist wohl hauptsächlich eine Folge Doesburgscher Taten, dessen philosophische Gründ-
lichkeit die neue Bewegung mächtig geholfen liess, Hinzu kam der Umstand, dass diese Erkenntnisse gewis-
sermassen in der Luft lagen, wie das gleichzeitige parallele Vorgehen z. B. russischer Künstler beweist. Eine
Zeitschrift « De Stijl » die von Theo van Doesburg geleitet wurde und ein von ihm verfasstes Werk :
« Grundbegriffe der neuen Kunst » haben seine ...ig verstärkt. Theo van Doesburgs Theorien, welche
m. e. viel schärfer umrissen sind als die Meinung... B. Mondrians, haben trotz und wegen einer gewissen
Einseitigkeit — stark gewirkt.

Harry Scheibe, in « Form » (1926).

Wir haben hier nur die Konstatierung zu u... ...hen, dass die Stellungnahme Doesburgs unbeirrt und früh
erfolgte : 1917 — also zu einer Zeit, in ... in Deutschland etwa das Poelzigsche Schauspiel plante.

Dr. Giedion, Zürich in « Cicerone » (1927).

DE STIJL
LE STYLE
DER STIL
THE STYLE

1917 1918 1919 1920 1921 1922 1923 1924 1925 1926 1927 1928

22 Cover of *De Stijl* (vol. 4, no. 1) January 1921. Huszár cancelled his
subscription after his original cover (*17*) and lettering (*6*) were replaced with this
design by Mondrian and Van Doesburg.

23 Theo van Doesburg, cover of *De Stijl*, Tenth Anniversary issue, 1928. A
highly sophisticated design, with lettering in light blue over a photograph of Van
Doesburg.

carrying. The typography of the text remained fairly conventional although Van Doesburg made a number of experiments with letter sizes even before the re-design. The 'Second De Stijl (Literature) Manifesto', which advocated a 'constructive unity of form and content', was published in the April 1920 issue without capital letters, one of the hallmarks of early modernist typography, as also were some of his Bonset and Camini contributions.

Under the NB/De Stijl logo on the new cover, Van Doesburg began to print the names of the cities in which De Stijl had a significant following. Over the next few years Brussels, Berlin, Vienna, Warsaw, Hannover, Antwerp, Brno, New York and Tokyo were at various times added, although never all at once.

The magazine appeared more or less regularly each month until the Fifth Anniversary issue in December 1922. Undoubtedly it sometimes appeared late, particularly while Van Doesburg was living and working in Weimar, although some issues were printed in Germany. There was a three-month break between December 1922 and March 1923 while Van Doesburg went on a Dada tour of Holland (see Chapter 9). After this the publication of the magazine became more and more irregular, as Van Doesburg was increasingly involved with major collaborative projects such as the exhibition in autumn 1923 at Léonce Rosenberg's Galerie de l'Effort Moderne in Paris and the Aubette in Strasbourg.

The burden of writing the magazine increasingly fell by default upon him. Apart from reprinted comments from the local press, Van Doesburg wrote the whole of the final, Aubette issue himself. As Van Eesteren pointed out to him in 1926, '*De Stijl* has become a totally personal expression of Van Doesburg, with all the consequences that entails. *De Stijl* is a kind of private correspondence between yourself and your readers. As such it is important, but it has with that ceased to be the organ of the so-called De Stijl group.'

For the Tenth Anniversary issue (which came out in 1928), the names of all cities were replaced by a map of the world on the back cover above which was printed 'Le Néo-plasticisme', while diagonally across the middle of the globe (slicing through the continent of Africa) 'Elémentarisme' appeared in large type. This was repeated in the Aubette issue, the implication being that De Stijl had now achieved complete global domination and cultural colonization. In fact, by this time its impact was on the decline and the original contributors and collaborators had all withdrawn.

52

When *i10* appeared in Holland with Oud as architecture editor and nearly all the former (and some of the current) De Stijl collaborators among its contributors, Van Doesburg was, not surprisingly, displeased. Stung by the defection, he lashed out in the Tenth Anniversary issue. 'We surely have no need of *i10* (the contents of which, for the main part, is the same as the contents of my dustbin)', he wrote. Mondrian, by then estranged from Van Doesburg, was particularly incensed at this. However, on 18 November 1929 (when *i10* had already ceased publication for six months and *De Stijl* for a year) Van Doesburg wrote to Oud, suggesting that the two magazines might combine in order to appear again. Nothing came of this, nor of the negotiations Van Doesburg apparently started earlier that year with a 'large publisher in Germany'. The Tenth Anniversary and Aubette issues, printed in Strasbourg with good quality paper and reproductions, had left him too exhausted and too much in debt to publish further numbers himself. 142

Van Doesburg's editorship was often eccentric but *De Stijl* pursued a remarkably straight line from start to finish – from the first issue, with its call for co-operation between the different visual arts, to Van Doesburg's last number celebrating the completion of the Aubette, where he was finally to put this into practice within a complete environment designed in collaboration with Hans Arp and Sophie Taeuber-Arp. The line had taken a sharp turn or two – almost always a right angle, or sometimes a forty-five degree turn – but it remained consistent. Van Doesburg's method was dialogic or dialectic, not discursive. In this sense *De Stijl* stayed relentlessly modernist in character to the end.

In the last year of his life Van Doesburg published a manifesto in a new magazine which had only one issue, *Art Concret* (1930). The manifesto's third article proposed the 'self-referential' quality often represented as one of the key elements of modernism: 'The picture must be entirely constructed with purely plastic elements, i.e. planes and colours. A pictorial element signifies nothing but itself; consequently, a picture signifies nothing but itself.' The idea of the self-referentiality of art had already appeared in Van Doesburg's *Klassiek-Barok-Modern* of 1920, although not stated as categorically as this. This and the absolute 'flatness' which Mondrian, Van der Leck and Huszár strived after in their early De Stijl works became key elements in later modernist painting. 19

53

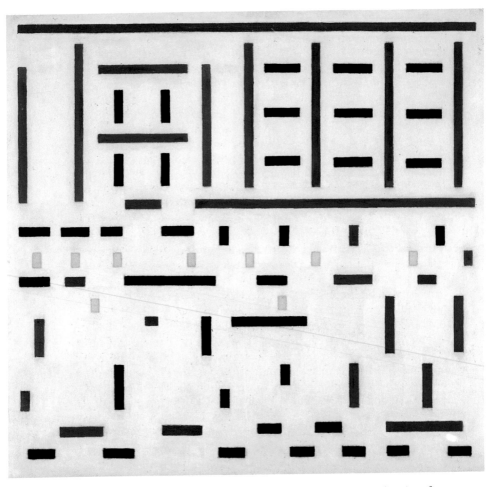

24 Bart van der Leck *Composition 3* 1917, 'decomposed' from drawings for one of his early paintings, *Leaving the Factory* (*16*). It seems entirely abstract but when compared with *16* traces of the motif can just be discerned.

Painting

The phrase 'De Stijl painting' probably evokes for most people Mondrian's work of the 1920s: abstract, geometric, asymmetric, yet carefully and consciously balanced, composed of black lines on a white background with rectangles of pure primary colour. But this was arrived at towards the end of his engagement with De Stijl. Because of the pre-eminence of Mondrian's reputation as a modern master, and because these particular works seem stylistically quite similar to other De Stijl artifacts such as Rietveld's Red Blue Chair or *98* Oud's Café de Unie, they have been frequently used to represent De *100* Stijl painting in popular or encyclopaedic accounts of modernism.

Yet, from 1917 to 1919 the four painters initially associated with De Stijl were experimenting in ways which had largely ceased to interest Mondrian by the 1920s. Some of the issues raised during these years became important much later in the history of what, for want of a better name, is called abstract painting ('non-figurative', 'non-objective', or Van Doesburg's own coinage 'concrete' never really caught on). And much of the later work of these artists, even when they had returned fully or partly to figurative painting, like Van der Leck and Huszár, retained characteristic elements from their De Stijl years.

Between 1917 and 1919 the work of Mondrian, Van der Leck, Huszár and Van Doesburg developed in a symbiotic relationship. It is often assumed that Mondrian always took the initiative in these developments but the truth is rather more complex. Mondrian was forty-five in 1917. His career had developed slowly and unpromisingly at first. His early work had been relatively traditional and he became known in Holland only in his late thirties, with paintings which combined expressionistic and symbolist elements in geometricized but still representational forms. In early 1912 he moved to Paris where he lived until the summer of 1914, painting in an idiosyncratic and original Cubist-derived style. He exhibited his work at the Salon des Indépendants (as did many other Dutch artists), where it was

25, 26 Piet Mondrian *Composition in Line* 1917 (right); photographed in an early state (left). In the final version Mondrian thickened and separated many of the elements after seeing Van der Leck's paintings where the thicker individual elements were kept discrete.

favourably reviewed in 1913 by the poet and art critic Guillaume Apollinaire.

Geometric tendencies had begun to appear in Mondrian's painting as a result of his interest in Theosophy. His contact with Cubism confirmed and strengthened this interest and geometrical elements occur increasingly in the paintings and drawings he produced in Paris and after his return to Holland in 1914. Visiting his family that summer, Mondrian was forced by the outbreak of war to stay there for the duration, remaining comparatively isolated until 1916 when he met many of the artists and architects who were to be associated with De Stijl. He began a series of paintings and drawings based on his observation of the flat Dutch coastline. The sea, the shoreline, the horizon and a pier or groyne jutting out into the water provided the visual data which he progressively 'abstracted' into geometric elements.

These works are usually known as the 'Pier and Ocean' series, although they have also sometimes been called 'Plus and Minus' paintings. The two names emphasize different aspects of the works: 'Pier and Ocean' their origins as representations of a particular landscape (or more correctly seascape); 'Plus and Minus' the formal elements from which they are constructed. These elements, which he also derived from studying the facades of buildings, were to be the

25,26

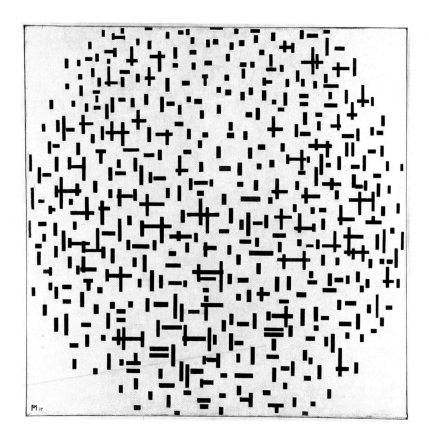

basis of what Mondrian called his *nieuwe beelding* style. Similar formal elements were to appear in the work of other De Stijl artists, designers and architects, although often these were arrived at independently from Mondrian.

Mondrian was not the earliest Dutch artist to produce 'abstract' paintings. Jacob Bendien, Jacoba van Heemskerck, Janus de Winter, Johannus van Deene and Erich Wickman (and possibly even Van Doesburg) were painting purely abstract works earlier, although in an informal and expressionistic style, from which Mondrian attempted to distance his own painting.

Van Doesburg's work remained relatively unadventurous until after the beginning of the First World War. In late 1914 or early 1915 he began to paint in an amorphic, abstract and expressionistic manner, reminiscent of the pre-war paintings of Kandinsky whose work and

57

AN OBJECT AESTHETICALLY TRANSFIGURED
Fig. 5: Photograph. Fig. 6: Form preserved but relationships accentuated. Fig. 7: Form abolished. Fig. 8: Image

27, 28 Photographs and sketches relating to Theo van Doesburg's *The Cow* 1917 (right), illustrated in his Bauhaus book *Principles of Neo-Plastic Art* (1925). In *The Cow*'s balanced, asymmetric composition, the forms remain separate, except where the cow's 'tail' joins its body and where its 'head' and 'tongue' touch the ground as it eats, wittily re-interpreting one of the traditional themes of Dutch painting. The sequence of photographs and drawings purports to show the process of abstraction.

writings he had come to admire. He was also probably influenced, as Kandinsky had been, by the coloured diagrams and illustrations of 'thought forms' which appeared in Theosophical publications. By 1916 he was working on a series of more tightly constructed works with crystalline geometric forms related to those in later Cubist painting.

62　　Although they were still derived from a figure motif, Van Doesburg's designs for stained-glass windows of 1916 and 1917 were often more accomplished and confident, and also more abstract, than the paintings he was producing at the time (see Chapter 6) and many

of the ideas employed in his early De Stijl paintings were initially developed in his stained glass and other applied art works. It was here that he first introduced rectangular 'elements' similar to those in the paintings of Mondrian and Van der Leck, and compositional devices of 'rotation' and 'reversal' to create fugue-like variations from combinations of simple geometric forms and colours.

Some time after he met Mondrian and Van der Leck in 1916, Van Doesburg began to 'abstract' his work in a much more self-conscious manner, starting from realistic sketches which he progressively geometricized until in the final versions the motif is unrecognizable. He did not attempt to conceal the origins of these works and published didactic sequences showing a development from realistic sketches or photographs to the final abstract geometric paintings.

In early 1916 Mondrian had met Van Doesburg, Van der Leck, and a little later Huszár. The contact with artists thinking and working along similar lines clearly stimulated him to produce many more paintings between 1917 and 1918 than during the previous two years. Discussions and correspondence with Van Doesburg helped him

29

27,28

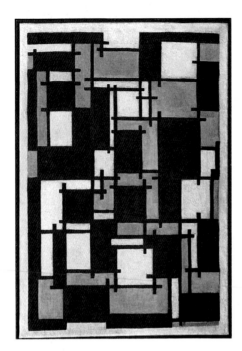

29　Theo van Doesburg *Composition X* 1918. Although Van Doesburg had not seen any of Rietveld's work at this time, the deliberately abrupt and crude execution is closer to the way in which Rietveld joined rectangular elements in his early furniture than to Mondrian's 'Plus and Minus' paintings.

30, 31　Bart van der Leck *Dock Work* 1916; poster for the Batavier shipping line, 1915. The painting was based on sketches for the poster commissioned by the owners of the line, the Müller company.

clarify his ideas, and get these into publishable form. (Van Doesburg constantly tried to persuade him to write more clearly and accessibly, not always successfully.) Van der Leck, who was painting in flatly applied primary colours, had a more direct impact on Mondrian's work. Later he recalled, 'Van der Leck, though still figurative, painted in flat planes and pure colours. My more or less cubistic technique – then still more or less pictorial – was influenced by his exact technique.' In 1916 Van der Leck had begun to use pure, unmixed primary colours, juxtaposed with white and black in paintings, such as *Storm* and *Dock Work*, where he increasingly formalized and abstracted his flat, emblematic figurative style. He was probably working on these two paintings when Mondrian visited his studio in the first half of 1916.

 Van der Leck was himself impressed by Mondrian's recent paintings such as the 1916 *Pier and Ocean*, and began to call his own works 'Compositions', as Mondrian did. He developed a method of abstraction where he progressively covered over a figure study with white paint until it was reduced to a geometric pattern of rectangular

30

24,32

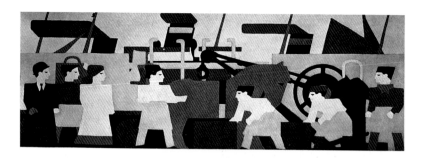

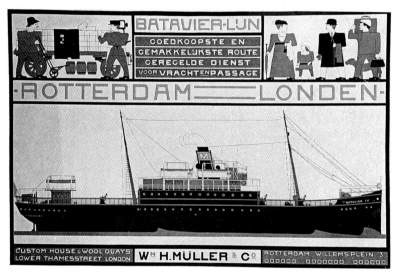

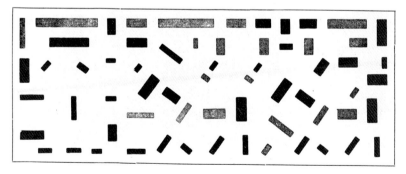

32 Bart van der Leck *Composition 1917 No. 5*, from the first issue of *De Stijl*,
October 1917.

elements, a process he called 'decomposing' or 'decomposition'. In his paintings the elements never cross or touch one another, as they do in many of the works of Mondrian and Van Doesburg. He often 'decomposed' his De Stijl works from earlier figurative paintings or drawings. Some of these were based on sketches and drawings made in north Africa in 1914 while researching themes for a commission for a stained-glass window for the Müller company's headquarters in The Hague.

32 *Composition 1917 No. 5* was the only painting reproduced in the first issue of *De Stijl*. This was abstracted or 'decomposed' from *Arabs*, a painting of 1915 also known as *The Donkey Riders*. From his published commentary on the illustration, Van Doesburg clearly thought Van der Leck's composition highly successful. Mondrian disagreed, complaining that one could 'still see the donkeys'. It was one of a series

33 Vilmos Huszár *Still Life Composition (Hammer and Saw)* 1917. The frame is also included in the work. Van Doesburg wrote about it in the January 1918 *De Stijl* (vol. 1, no. 3), illustrating it in colour but so crudely that it became an independent work, flatter and more abstract than the painting.

34 Piet Mondrian *Composition in Red, Yellow and Blue* 1922

of eight 'paired' works, the only paintings Van der Leck produced in 1917. In each pair one painting was constructed with thin rectangular elements and the other with thicker, planar elements. The 'thin' versions were arrived at first. In the 'thick' versions he filled the elements out into rectangles and sometimes squares. These works are the most assured and confident paintings by any of the De Stijl artists at this time: by comparison Mondrian's were still quite tentative.

In his paintings of 1917 Van der Leck sometimes placed his squares and rectangles on the diagonal. Then in 1918 he began to produce paintings which contained 'lozenge' forms or parallelograms as well as rectangles and squares. Diagonal elements become increasingly important in his work, creating a dynamic balance with the horizontal and vertical elements. Again, Van der Leck initiated something which was to be crucial in the formal aesthetics of De Stijl, when the admissibility or inadmissibility of the diagonal was to be hotly debated by Mondrian and Van Doesburg in the mid-1920s.

Probably none of Van der Leck's De Stijl works were ever entirely abstract, but were ultimately 'decomposed' from naturalistic subjects, as his paintings of 1917 had been. Until 1921 he alternated paintings in which subjects are quite easily recognized with others which appear almost completely abstract. After this his work was always based on the subject, although highly formalized and geometricized, apart from a brief period shortly before his death in 1958 when he produced abstract paintings.

Like all the painters associated with De Stijl, Huszár painted figurative works concurrently with more abstract paintings and in the later 1920s adapted the formal mannerisms of his earlier abstract work to produce stylized figurative paintings not unlike those of Van der Leck. Although he had spent some months in Paris between 1907 and 1908, his work has more in common with abstract tendencies current in art and design in Central Europe (where he had studied in the first years of the century in Budapest and Munich). The use of geometric forms in his paintings and prints is often closer to the work of the Hungarian avant-garde than to that of his French or Dutch modernist contemporaries, employing figure and ground reversals and effects of transparency. Huszár also worked in graphic design and applied art, particularly stained glass. As with Van Doesburg, his works in these media were often more abstract and simplified than his paintings between 1916 and 1917. Designing stained glass with its underlying structure of lead glazing bars probably suggested ways of making his painting more abstract and geometric.

17 The logo Huszár designed for the cover of *De Stijl* may have been abstracted from an image of an embracing couple. The four almost identical horizontal bands can be read as representing hands, and the stepped forms the hair of the lovers. This was a common subject in late nineteenth-century and early twentieth-century art. Brancusi used a rather similar motif of stylized human heads and hands in his increasingly abstracted sculptures entitled *The Kiss*. (Van Doesburg was to illustrate Brancusi's work in *De Stijl* and name him as a De Stijl 'collaborator' in the mid-1920s.) For the logo Huszár attempted to create a balanced abstract composition in which black and white had equal value, rather than the black geometric forms being perceived as figure against the white ground. In the second part of 1917 he
33 produced several paintings in which the forms are even more closely
35 interlocked. Here he was trying to achieve an effect of greater flatness, and to avoid any illusion of depth. This preoccupation with

35 Vilmos Huszár *Composition VI*, linocut from *De Stijl* (vol. 1, no. 6) April 1918, his first surviving purely abstract work, perhaps based on a lost painting. The forms are even more reductive than in the *De Stijl* logo (17).

36 Vilmos Huszár *Composition* 1918

37 Piet Mondrian *Chequerboard with Light Colours* 1919. It was probably this or a similar work in dark colours which Mondrian described to Van Doesburg as 'a reconstruction of a starry sky' done 'without recourse to nature'.

equalizing figure and ground and achieving as complete a flatness and absence of depth as possible was shared by Mondrian and Van der Leck at the time – it seems to have been less important for Van Doesburg.

Most of the works of Huszár, Van der Leck, Van Doesburg and even Mondrian were still based on abstractions from figure or landscape motifs. Around 1917 Mondrian abstracted his work almost exclusively from landscape or architectural subjects, while the paintings of the other De Stijl artists were nearly always abstracted from the figure or still lifes. However, around 1918 Huszár produced a few paintings, now lost and known only from photographs, which seem to have no external starting point. Here he used what appear to be brightly coloured shapes in a rather different way from Mondrian's paintings of this year. In one of these pictures, small coloured squares jostle one another on a black or dark background, so nearly filling this that it appears like mortar between bricks. Huszár used an overall, regular grid in at least one painting of 1918, as Mondrian did between 1918 and 1919. The two painters seem to have arrived at this way of working independently, for Mondrian wrote to Van Doesburg in June 1918: 'I too was just working on something which I showed to Huszár, and which he judged to be good. I had also been using a regular subdivision, without knowing what he was doing. However, I am still doing a lot of reworking on that subdivision, and I do think that it will look different from Huszár's work.'

Mondrian had begun to divide his canvases into a pattern of horizontal and vertical lines, filling the planes formed between these with different colours. At first he arranged the grids intuitively, but from about the middle of 1918 he began to divide his canvases by means of a simple mathematical system.

A few of these works, such as *Diamond with Grey Lines*, 1918, were almost entirely symmetrical and uniform. In some the grids were placed diagonally to the canvas. Indeed, Mondrian may have done this to distinguish them from Huszár's works. When he exhibited at the Hollandsche Kunstenaarskring Exhibition at the Stedelijk in Amsterdam early in 1919 he turned some of them on their ends to form diamond-shaped compositions, perhaps to avoid diagonal forms within the paintings. Shortly before he moved back to Paris in June 1919 he painted two works in which the canvas is divided into identically sized squares, like a chequerboard. Between 1920 and 1921 he produced a series of paintings which are organized asymmetrically

36

37

38 Georges Vantongerloo *Composition* 1918. Vantongerloo both painted and sculpted, working rather separately from other De Stijl artists: he returned to Belgium after the War and moved permanently to France in 1920.

but with a close relationship between the individual rectangles, rather like elements in a well-ordered room. Many works painted between 1922 and 1928 were even more asymmetric, with large blank areas of white left in the middle of the canvas like a white wall, or the oiled paper sliding screens of a Japanese interior. The colours were often reduced to a few narrow planes and strips at the edge of the canvas bordering large central expanses of white. *34*

Before 1922 Mondrian frequently mixed his colours with grey, achieving a rather neutral effect which displeased Van Doesburg, who believed that the addition of grey 'polluted' colours. Van Doesburg himself was using 'pure' unmixed colours, but introducing secondary colours such as green, violet and orange, as well as the primaries.

Most of the artists associated with De Stijl were interested in ways of codifying and ordering colours systematically. In August 1918 Huszár had written in *De Stijl* about the German scientist Wilhelm Ostwald's system of classifying colours, and an essay by Ostwald was published in the magazine in May 1920. Vantongerloo seems to have devised his own system for dividing colours. He used pure primaries in his paintings of 1918, such as *Composition*, applying rectangular *38*

67

planes of colour to a white ground. In 1919 he began to mix primary colours with white to produce pastel shades and in 1920 was using the full seven colours of the spectrum.

After meeting Vantongerloo in Paris in April 1920, Mondrian wrote to Van Doesburg that he found his use of purple and all the colours of the spectrum 'a bit premature'. He was still using grey in his paintings, sometimes as a separate component, sometimes mixed into the primary colours. It was only in 1922 that he began exclusively to use the 'pure' primary colours, white and black that have come to be associated both with his own mature work and with De Stijl.

Apart from the paintings of 1918 that he had re-orientated as diamond-shaped canvases, Mondrian painted only one or two more paintings in diamond format before 1925, when he produced five or 42 six, and several more over the next few years, such as *Composition with Two Lines*, 1931. These have exerted a fascination for critics and historians out of all proportion to their number. Some commentators have suggested precedents in the diamond-shaped escutcheons for the dead hung on the columns inside seventeenth-century Dutch churches. Others have argued that one need look no further than Mondrian's desire to avoid a diagonal orientation of forms within the painting in order to explain his adoption of the diamond format – a simpler and more convincing explanation. It has been proposed that Mondrian's works of the mid-20s each represent a fragment of a 39 greater whole extending beyond the canvas edges, particularly the later diamond-shaped paintings. This is also a quality implicit in Van Doesburg's *Counter-Compositions* of 1924–5.

Between 1920 and the end of 1924 Van Doesburg abandoned painting for architectural work and applied art. When he began to paint again at the end of 1924 or the beginning of 1925, he started on a series of works incorporating diagonal elements, which he called *Counter-Compositions*. At first these were sketched out as diamond-40 shaped canvases composed of horizontal and vertical forms (*Counter-Composition VIII*). There was a precedent for this in his earlier work – 62 five identical stained-glass windows designed for a schoolteacher's house at Sint Antoniepolder by Wils in 1917, where a diamond shape was imposed over the orthogonal form of the window by means of thick wooden glazing bars.

Van Doesburg soon began to re-orientate his new paintings from a diamond shape to a square orthogonal format containing diagonal elements, the opposite of what Mondrian had done in 1918–19. Later

68

39 Theo van Doesburg *Composition XVIII*
1920. After seeing how Mondrian had
arranged his Paris studio with rectangles of
cardboard and canvas on the walls, Van
Doesburg began work on this triptych,
intended to suggest that the individual parts
were fragments of a larger work whose
centre was the empty space between the
3 canvases.

40 Theo van Doesburg *Counter-Composition
VIII* 1924–5. This black-and-white work was
his only one to be hung as a diamond:
Counter-Composition V (1924–5) was
originally intended to be hung like this but
was later re-orientated as a square painting
with diagonal elements.

works in the series, like *Counter-Composition of Dissonance*, 1925, and
Counter-Composition XV, 1925, were painted directly in an orthogo- *136*
nal format as square or rectangular canvases. This may have been in
response to Mondrian's return to the diamond-shaped format at this
time. Mondrian may himself have responded to the initiative of Van
Doesburg, who had been using the diagonal in his architectural and
interior designs since 1923. By 1925 the two men had become
intensely competitive and their different views about the admissibility

of the diagonal led to their estrangement as Van Doesburg countered the balanced horizontals and verticals of *nieuwe beelding* with the unstable and dynamic diagonals of what he called Counter-Composition or Elementarism.

41

In the early aesthetics of De Stijl, as defined in the writings of Mondrian, the horizontal line is a schematic representation of the earth, the horizon. The vertical line is the impingement of man on his environment. Vertical and horizontal lines also represented for Mondrian the traditional equation of the female and the male with respectively nature and culture. For Mondrian the orthogonal

42,43

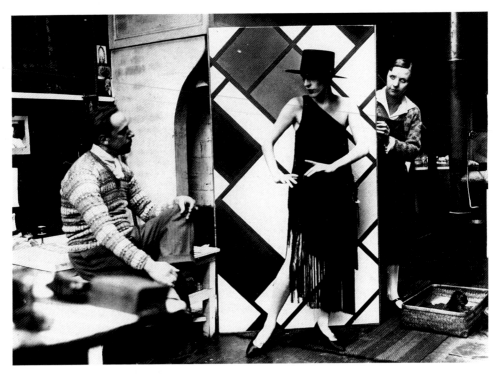

41 The dancer Kamares posing in front of Van Doesburg's *Counter-Composition XVI* in his studio at Clamart, near Paris, 1925. Van Doesburg's designs for the Ciné-dancing at the Aubette in 1927 (*105*) used similar diagonal colour planes to suggest the human body's vigorous movement in contemporary jazz dances such as the Charleston or the Black Bottom.

70

42, 43 Piet Mondrian *Composition with Two Lines* 1931; Willem Dudok, Town Hall, Hilversum, 1924–31: period photograph of the council chamber. Mondrian's black-and-white painting, his most simplified diamond composition and most minimal work, was purchased for this room but never placed in it, although Dudok hung it temporarily in his office there. After seeing photographs of the building, Mondrian wrote that it was 'quasi-modern . . . the old in a new form'.

relationship embodied a balanced configuration, a harmonious equilibrium. Into this balance Van Doesburg introduced the diagonal. By the mid-twenties he had come to believe that it could represent the human body in movement by purely abstract means and the experience of the speed of modern mechanized life, as a symbol of natural power harnessed by man. At the same time he believed that diagonal relationships more completely realized 'the spiritual', because they opposed the gravitational stability of the natural and material structure of horizontals and verticals. He intended to convey this by using the term Counter-Composition. The example of Russian avant-garde artists like Malevich, Rodchenko and Lissitzky, whose work and ideas he had come to know while working in Germany in the early twenties, had persuaded him that the diagonal could be used in modern as opposed to what he had earlier termed baroque painting.

Through his diagonal *Counter-Compositions* Van Doesburg believed he could construct a non-reductivist abstract painting capable of a convincing representation of the variety and vitality of life. This embodied a schematic rendering of the dynamics of the human experience of movement and changing relationships instead of the static balancing of 'universals' found in earlier De Stijl theory and practice.

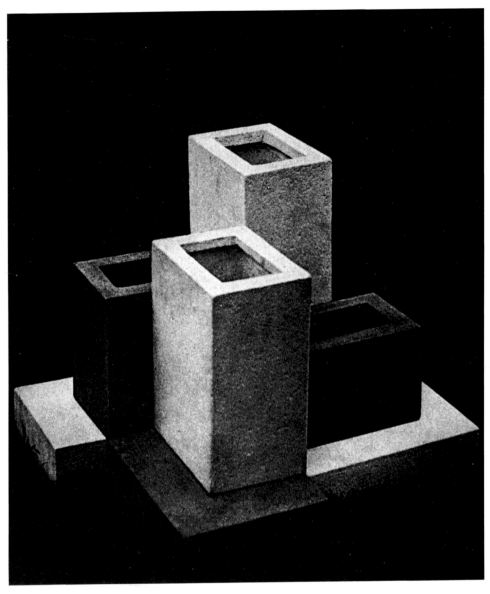

44 Theo van Doesburg *Garden Sculpture* 1919. The pots were glazed in different greys. In an architectural magazine article Van Doesburg imagined the sculpture placed on a green lawn and filled with red, yellow, blue and white flowers.

Sculpture and Furniture

Van Doesburg clearly felt it necessary to produce a De Stijl sculpture if the aim of uniting all the visual arts in a common effort was to be achieved. He himself designed a number of three-dimensional works, including a stylized, geometricized head carved in oak for a newel post for a house by Wils at Alkmaar in 1917, curiously close in style to the work of Amsterdam School sculptors like Hildo Krop and John Radecker. In late 1917 and early 1918 he designed a monument for an architectural competition for the station square in the Friesian city of Leeuwarden, in collaboration with Wils, of which only a maquette was made. He also designed a garden sculpture in 1919. Both these *44* were abstract works. However, needing a De Stijl sculptor to hold the balance between the painters and architects, who tended to be mutually suspicious of one another, he approached Vantongerloo, who had been working in Holland since 1914.

Vantongerloo was presented solely as a sculptor in *De Stijl*, where illustrations of his work and selections from his writings appeared from July 1918. He seems to have had little contact with the other De Stijl artists, although he eventually became quite close to Mondrian, whom he met in the early twenties when Mondrian had returned to Paris and he himself was living in France. *Composition starting from an* *45* *Oval*, 1918, quite closely resembles a three-dimensional De Stijl painting. Two tiny sculptures of 1919, both entitled *Construction of* *46* *Volume Relations*, are generally considered to be Vantongerloo's most important contribution to the De Stijl aesthetic, with their positive and negative interaction of mass and void. They are close to contemporary De Stijl designs like Oud's drawing for a factory at *3* Purmerend of 1919, with which they were compared by Van Doesburg in a note in *De Stijl* in March 1920.

As early as 1919 Van Doesburg had described Rietveld's furniture in *De Stijl* as providing 'a new answer to the question of what place sculpture will have in the new interior'. Rietveld also sometimes wrote of his furniture as if it were sculpture. Yet at the same time even

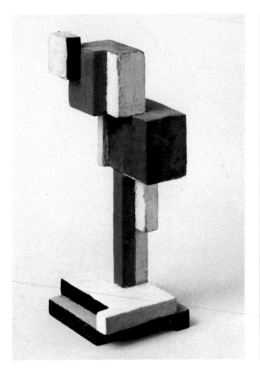

45, 46 Georges Vantongerloo *Composition starting from an Oval* 1918;
Construction of Volume Relations 1919, reproduced in *De Stijl* (vol. 3, no. 2)
December 1919, which also showed the other work of the same title, now lost.

overtly sculptural pieces like the End Table and Berlin Chair of 1923
have at least symbolic functions.

Rietveld was probably working on his early experimental
furniture a year or so before his first contact with De Stijl in 1919. Van
't Hoff drew this to the attention of Van Doesburg who represented it
as embodying De Stijl principles in three-dimensional form in the
September 1919 *De Stijl*. He wrote: 'Our chairs, tables, cabinets and
other objects of use are the (abstract-real) images of our future
interior.' Rietveld's furniture seemed to exemplify what a three-
dimensional De Stijl artifact ought to look like, for in their
construction from individual elements (which at the same time are
perceived as wholes), these pieces could be taken to embody the
Berlagean idea of 'unity in diversity'. They also acted as a prototype
for the future interior. When he came to design the Schröder house

with Mrs Schröder in 1924, nearly all Rietveld's early experimental 94,98
pieces were used to furnish the house, with the exception of the Buffet 4
(or sideboard), 1919.

In modernist accounts of design history Rietveld has often been presented as an intuitive but untutored craftsman. This is inaccurate. Although he left school at eleven, he studied design and architecture at evening classes. He was also the pupil of the Utrecht architect and designer P. J. C. Klaarhamer, whose furniture he sometimes executed. Klaarhamer's circle was well informed about contemporary issues in art and design.

Early historians of modernism like Sigfried Giedion interpreted this furniture, such as the Red Blue Chair, the Child's High Chair, 1918, and the Buffet, as absolutely new. However, as more recent commentators have pointed out, the stripped simplicity of the Red Blue Chair and the angled boards which form the back and seat can be parallelled in earlier chairs by Wright, Berlage and Klaarhamer (and no doubt other designers). Rietveld was asked by J. N. Verloop, the owner of a bungalow designed by Van 't Hoff at Huis ter Heide (see Chapter 7), to copy some of Wright's furniture. Verloop showed Rietveld illustrations of pieces designed for the Cooley house in the second of the two Wright volumes published by Wasmuth. There seems to be no modern precedent, though, for Rietveld's use of elements which extend beyond their junction to create the characteristic Rietveld 'crossing joint' or so-called Cartesian node. As Frampton has argued: 'Its structure enabled Rietveld to demonstrate an open architectonic organization that was manifestly free from the influence of Wright.'

The Red Blue Chair and the Buffet resemble traditional chairs stripped down to their basic structural skeletons, or constructional diagrams that suggest 'deconstructions' of a conventional armchair or buffet into the individual elements from which they are made. Rietveld regarded such pieces as experiments or studies which, he wrote to Oud, 'at most could influence one's regular work a little'. He told Van 't Hoff that the unpainted prototype of the Red Blue Chair 5 had been designed for himself, and he kept an early example.

In 1920 Oud furnished a show apartment in one of his early blocks of municipal flats at Spangen in Rotterdam with some of Rietveld's experimental pieces. But Rietveld doubted whether these would be popular with the tenants (as proved to be the case), telling Oud, 'Above all, do not let it be forced on *anyone*.'

Rietveld often designed furniture and toys for his six children and for those of friends and clients. The open, yet containing, cage-like structure of high chairs, cots and play pens was particularly suited to the method of construction he developed in his early furniture. This has a 'ludic' quality and often resembled the educational and constructional toys which were fashionable among middle-class parents throughout Europe, following the ideas of Froebel and Montessori. (The Schröder house was briefly used as a Montessori school in 1936.) A belief in the 'specialness' of the experience of childhood was common in advanced middle-class circles in Holland at the time, as elsewhere in Europe. Huizinga elaborated a theory of games and play, based on the behaviour of children, ideas developed in his writings from 1903 and published in book form as *Homo Ludens* in 1938.

Possibly it was while designing furniture for babies and young children that Rietveld conceived the idea of producing pieces for adults on similar principles. Rather as his children's furniture and toys provided a 'play-element' for the children of his friends and family, his early pieces like the Red Blue Chair and the Buffet were meant to be a form of fantasy, play or active relaxation for adults.

It was in his children's furniture and toys that Rietveld first

48 introduced colour. The Child's High Chair, made in 1918, was probably his first piece of furniture to incorporate colour. It was

49 painted green with red leather straps. The Wheelbarrow and Child's Cart may have been the earliest of Rietveld's works painted in the pure De Stijl primaries. Recent research has shown that they were probably first made around 1923 (although often dated earlier). The Red Blue Chair was almost certainly painted about the same time, shortly before Rietveld began work on the Schröder house – for a widow and her three young children – where he used colour most freely and uninhibitedly.

It was once thought that the Red Blue Chair was not manufactured in quantity until Rietveld's heirs sold the rights to the Italian firm of

50,51 Cassina in 1971. However, a hand-drawn price list of Rietveld furniture was discovered in the Rietveld-Schröder Archives, after Mrs Schröder's death in 1985, with the chairs drawn in coloured crayon in schematic form. The Red Blue Chair was advertised in two versions, a cheaper and a better quality one. The cheaper version, no doubt made in small batch-production runs, was manufactured by the firm of Cvt Hullenaar. The more expensive version, available from

morgenstern

**wenn ich sitze, möchte ich nicht
sitzen, wie mein sitzfleisch möchte
sondern wie mein sätzgeist sich,
säsze er, den stuhl sich flöchte.**

47 Label from the Red Blue Chair, 1930s. Rietveld glued this verse from the
German writer Christian Morgenstern's poem 'Der Aesthet' (The Aesthete) under
the seats of some of these chairs: 'When I sit, I do not care/ just to sit to suit my
hindside:/ I prefer the way my mind-side/ would, to sit in, build a chair.'

48, 49 Gerrit Rietveld, Child's
High Chair, 1918, from *De Stijl*
(vol. 2, no. 9) July 1919. This
was his first piece to be
reproduced in *De Stijl*, with a
commentary by him about its
construction. Toy Wheel-
barrow, 1923, first made for
Oud's son Hans. In May 1925
Rietveld asked Oud for the
dimensions: 'I would like to
have a number of them made
this season for the beach, but I
am not sure about the
measurements.'

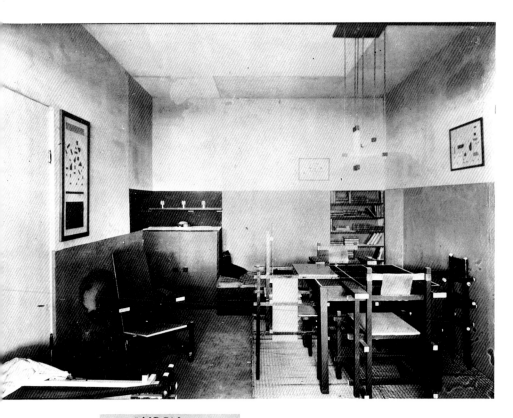

50, 51 Gerrit Rietveld, furniture in a model living-room, probably for an exhibition, and a coloured drawing for the price list, *c*. 1923. Some of the furniture and children's toys are advertised as 'sold to Dr Müller, gynaecologist', for whose children Rietveld designed a nursery with furniture.

52 The components from which the Red Blue Chair is made. Rietveld reduced its parts to a series of easily sawn elements of similar dimensions, which could be produced in batches or longer runs using machine-saws.

Kunsthandel (Art Dealer) Gerbrands, was probably a hand-made version constructed in Rietveld's workshop by his assistant Gerard van de Groenekan. This would have been similar to the arrangements for the manufacture and sale in the 1930s of the Zig-Zag Chair, which was batch-produced in deal by the furniture firm Metz, but could also be obtained hand-made in hardwood from Rietveld and Van de Groenekan.

The versions of the Red Blue Chair made by Rietveld and Van de Groenekan over the years differ considerably in dimensions. Only when produced in quantity by Cassina since 1972 has there been any uniformity. However, although the dimensions and finish varied, the chair was rationalized and standardized, which made it suitable for batch or quantity production. Of perhaps equal importance was that its construction from separate elements clearly symbolized and announced its standardization.

Rietveld wished to design furniture which would not be a drudgery to produce, either through repetitive machine-work or through repetitive hand-work, both of which he regarded as soul-destroying. When describing the Child's High Chair in De Stijl in July 1919 he stressed the pleasure to be had from assembling the piece and fixing its parts by the dowel or 'peg and hole' construction.

Machine methods of wood-cutting were being introduced and the old methods and traditions of the craftworker were being challenged when Rietveld began to design and produce his early furniture. This accounts for its ambiguity. The pieces are designed to be machine-cut and assembled in quantity but at the same time retain a look of the hand-made.

Although Rietveld has always been represented as *the* De Stijl furniture designer, Wils, Oud and Vantongerloo also designed furniture. However, this was mostly produced after their De Stijl period, while Van Doesburg continued to illustrate Rietveld's furniture in De Stijl in later years.

52

53–6

79

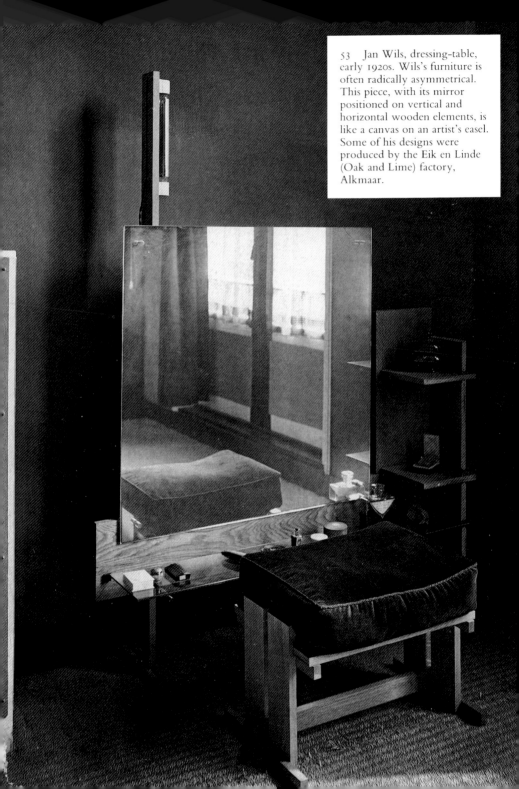

53 Jan Wils, dressing-table, early 1920s. Wils's furniture is often radically asymmetrical. This piece, with its mirror positioned on vertical and horizontal wooden elements, is like a canvas on an artist's easel. Some of his designs were produced by the Eik en Linde (Oak and Lime) factory, Alkmaar.

55 (right) J. J. P. Oud, furniture in the Villa Allegonda, c. 1928, adapted from designs for his terrace housing at the Weissenhofsiedlung, Stuttgart, 1927 (*112*).

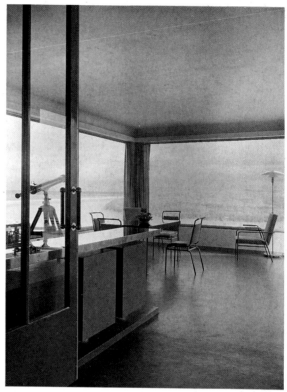

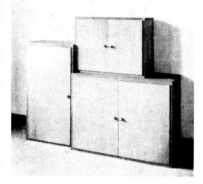

54 Robert van 't Hoff, furniture, c. 1920, designed for his own house at Laren, from *De Stijl*, Tenth Anniversary issue, 1928.

56 Gerrit Rietveld, GZC (Gold and Silversmiths Company) jewellers, Kalverstraat, Amsterdam. Van 't Hoff's cupboard was made by Rietveld, who may have used them as a starting-point for some of his own designs, like this shop (1921) and the stacking cabinets for the Schröder house (1925). The metal frames of the large glass windows of GZC were painted white, black and grey. In 1923–4 he repainted them in primary colours, adding the diamond light.

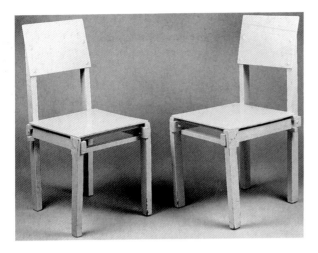

57 Gerrit Rietveld, 2 Military Chairs, 1923. The rails supporting the seats are let into grooves in the legs and secured with large metal bolts, which remain visibly part of the design. This was probably to facilitate quantity production.

In order to have more time for interior commissions and architectural work, Rietveld handed over his furniture workshop to Van de Groenekan in 1924. Although he continued to design furniture, he no longer made it himself. In 1923 he received a commission to supply a series of pieces in quantity for the Catholic Military Home in Utrecht. The order was too big to be made by Van de Groenekan in the workshop and was executed by an independent supplier – but individual pieces ordered later by private clients were made by him. These pieces, consisting of chairs, dining-tables and occasional tables, were constructed according to a modified version of the techniques used in Rietveld's early furniture. The wooden rails of the supporting framework extend past the point of juncture, but do not project as far as in the Red Blue Chair or the Buffet. The way in which the so-called Military furniture was designed for batch production anticipates Rietveld's furniture of the late twenties and early thirties, which was produced and sold in quantity by Metz. Rietveld regarded commissions such as this as his regular or ordinary work into which his more experimental designs could feed.

Before starting work on the Schröder house Rietveld embarked on new designs for furniture which can be seen as studies for the spatial ideas and formal devices used in the house. These were also among his 'experiments'.

The End Table and the Berlin Chair (named after the Juryfrei Kunstschau [Juryless Art Exhibition] in Berlin in 1923 for which it was originally designed) were highly asymmetric, whereas the Red

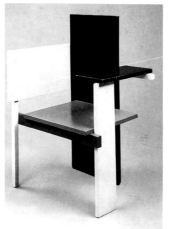

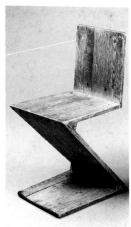

58 Gerrit Rietveld, Berlin Chair, 1923. It came in 2 versions, a left- or right-hand model, with armrest positioned accordingly, painted in black or black and greys.

59 Gerrit Rietveld, Zig-Zag Chair, *c.* 1932–4. Rietveld experimented with different materials, including fibreboard, bent plywood and chrome steel. The first hardwood version was made for Mrs Schröder. A softwood version was produced by Metz from 1934.

Blue Chair and the Buffet, despite their experimental qualities, remained symmetrical designs. Where the earlier furniture was composed of linear elements through which space flows freely, the Berlin Chair and End Table are both composed of planes, the arrangement of which in the chair is formally quite close to those in the exterior of the Schröder house. The table resembles an abstract sculpture. However, it also has a quite practical function. Its cantilevered construction enables it to be moved close to a chair or couch. A contemporary critic compared it to the 'clear architectonic of Japanese buildings and interiors, typewriters and motor cars'. The Berlin Chair has only three 'legs', the rear one being merely the continuation of the back of the chair. With both pieces of furniture sculptural and architectural qualities appear to predominate over the functional. Many years later Rietveld said in an interview, 'To me, De Stijl represented a unit of construction which I considered of prime importance. A practical realization was not always feasible. Function was for me a thing by itself which I never overlooked, it is true, but it did not come into play until the construction and spatial exercises in De Stijl had been completed.'

The Zig-Zag or Z chair, *c.* 1932, was perhaps Rietveld's most 59 extraordinary design after the Red Blue Chair. It has the form of a crouching figure ready to spring up. Four separate planes of wood are ingeniously joined together to make a structurally daring and visually dynamic whole. There is an inspired wilfulness about the design in which one can also see a kinship with Van Doesburg's notion of the

dynamic diagonal and what he called 'the track of man in space'. (The words 'Zig-Zag' had appeared in the typographic poem 'X-Beelden' [X-Pictures], which Van Doesburg published under his Dadaist pseudonym I. K. Bonset in *De Stijl* in 1920.)

After a period when Rietveld's architecture and furniture had approached the International Style of functionalist design promoted throughout Europe and the USA in the late 1920s and early 30s, the Zig-Zag Chair brought his work close again to the De Stijl aesthetic. It represented a move away from the rationalism and internationalism of his designs of the late 1920s towards a constructional manner of design like his early furniture, although more sophisticated in conception. At this time tubular and bent plywood chairs proliferated throughout Europe (Rietveld himself having designed several). He must have come to the conclusion that the rationalist or functional chair had become a cliché which itself needed to be 'deconstructed' – as he had deconstructed the conventional armchair into the prototype Red Blue Chair in 1918.

Zig-Zag chairs were available either hand-made to order from Van Groenekan in hardwood (usually elm) or batch-produced from Metz in softwood, where they were available until the 1950s (and from Cassina since the 1970s).

60

In 1934 Rietveld designed the Crate furniture, a series of utility

61

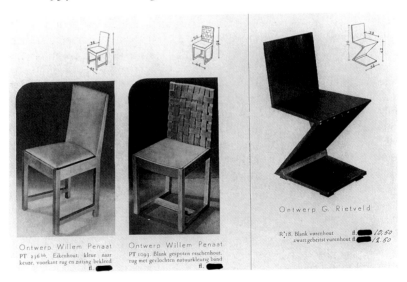

Ontwerp Willem Penaat
PT 236 bb, Eikenhout, kleur naar keuze, voorkant rug en zitting bekleed
fl. ●

Ontwerp Willem Penaat
PT 1093. Blank gespoten esschenhout, rug met gevlochten natuurkleurig band
fl. ●

Ontwerp G. Rietveld
R'18. Blank vurenhout fl. ● 10,50
zwart gebeitst vurenhout fl. ● 12.50

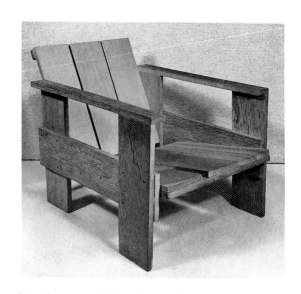

60, 61 Metz catalogue, c. 1935;
Gerrit Rietveld, Crate
Armchair, 1934. The Crate
furniture was sold for week-end
houses and teenagers' rooms.
Purchasers could choose their
own colours at extra cost.
Although Metz was a rather
exclusive shop, most of
Rietveld's designs for them
were cheap compared with, for
example, Penaat's pieces: the
Crate Armchair cost 5.95
guilders.

pieces marketed by Metz, delivered flat for assembly by the purchaser. The wood was cheap red spruce of the kind used for making packing-cases and crates, hence the name. The wooden boards were fixed together with steel nuts and bolts. The range included an armchair which could be purchased plain, or with cushions covered with fabric designed by Van der Leck. There were also an upright version, a stool, two small occasional tables (one with a lower shelf for magazines or books), a bookcase and a desk with bookshelves. In these later designs there is no extension of the elements past the point of junction. The 'Rietveld joint' as such had long since disappeared from his formal vocabulary. But the boards are overlapped in a way reminiscent of the planes of the Berlin Chair, and the method of assembly and fixing by metal bolts is a simplification of the system first tried out in the Military furniture. These were probably Rietveld's most popular pieces. They were cheap and had a quality, shared by most of his furniture, of looking as though one could assemble them oneself. In this case one could. He undoubtedly took into account the pleasure the purchaser might have in putting the pieces together. In the 1950s he also made drawings for an exhibition entitled 'Furniture to Make Oneself', and many years after his death a book of drawings was published in English and Dutch entitled *How to Make Rietveld Furniture*.

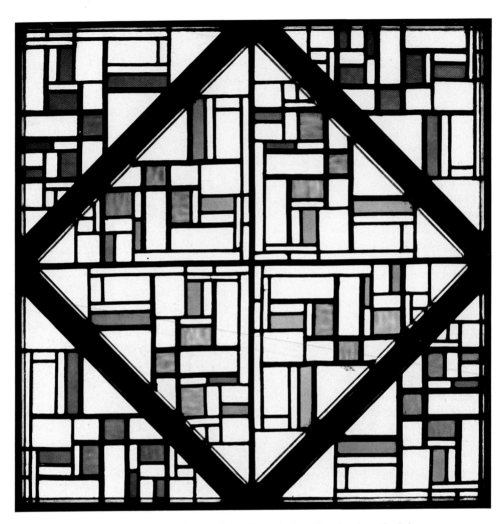

62 Theo van Doesburg, stained-glass window for school-teacher's house
designed by Wils, St Antoniepolder, 1917. One of 5 identical windows that lit the
hall and stairwell, whose motif was abstracted from skating figures.

Colour Designs and Collaborations

One of the most important and frequently stated aims of De Stijl was collaboration between architects and artists in the application of colour to buildings and interiors. Because of the ephemeral nature of such work, most of it was later destroyed. However, when the estates of the artists and architects associated with De Stijl began to pass into the public domain in the 1970s and 80s, documentation of these designs was made available and published. In later projects artists and architects often extended their own practice to embrace both architectural elements and the use of colour, as did Mondrian in his Paris studio, Van Doesburg in the Aubette and Rietveld in his interior designs, sometimes in collaboration with Mrs Schröder.

147
105
81,82

Berlage's ideas about the collective and the individual, and the ideological importance of the wall surface, had promoted an interest among artists in 'monumental' or mural art and stained glass at the end of the nineteenth century. This was also encouraged by the currency of Ruskin's and Morris's ideas in Holland and by the development of socialist ideals among many Dutch artists and architects, favouring a communal or public art rather than private commissions – although most De Stijl commissions were for private individuals.

The revival of stained glass in Holland from the 1850s onwards was initially a response to the need for applied art to decorate the interiors of newly built Catholic churches. However, this soon created a domestic demand which was not confined to Catholic clients. The evolution of an abstract, geometric style of stained glass in the early years of the twentieth century produced a non-figurative decorative art which also accorded with strict Calvinist principles.

The first collaborations by De Stijl artists on colour designs for the exterior and interior of buildings usually involved choosing colours for window-frames and doors, designing abstract decorations for stencilled friezes, stained-glass windows and arrangements of floor and fireplace tiles. As they became more ambitious, they began to

62–5

design colour planes for walls, similar to the colour planes and
rectangular 'elements' in their abstract paintings. At first these areas
of colour were positioned on individual walls. Later they were
sometimes placed so that they overlapped from one wall to another,
'destroying' their boundaries. This was often to be a cause of
differences between architects and artists, for most of the architects did
not much appreciate their architectural designs being 'visually
destroyed' or 'deconstructed'. Only Van Doesburg ventured into
collaboration with architects on exterior colour schemes. This proved
to be even more dangerous ground and led to the break with Oud
over Van Doesburg's 'deconstructive' colour schemes, 1920–21, for
his second set of municipal housing blocks at Spangen in Rotterdam.

Earlier, in 1918, Van Doesburg had collaborated with Oud on
decorative schemes for the exterior and interior of the vacation hostel
De Vonk (The Spark) at Noordwijkerhout. This was designed for a
charitable foundation to provide young girls working in factories in
Leiden with holidays in the countryside close to the sea. The director
Emilie Knappert was a Christian socialist and a friend of Berlage, who
had recommended Oud for the commission. The motifs Van
Doesburg chose for the brick wall decorations and floor tiles were
based on simple interlocking geometric shapes. The standardized
elements of yellow, grey and black glazed bricks and tiles imposed a
structural grid which Van Doesburg exploited skilfully. These were
reversed and rotated to produce constantly changing arrangements of
identical elements and colours, symbolizing in abstract form ideas
about the relationship of the individual to society similar to those
characterized by Berlage as 'unity in diversity'.

The doors leading off the hall and upstairs landing were painted to
harmonize with the floor tiles, using the three colours in different
combinations on door surrounds, mouldings and central panels. Van
Doesburg also planned the colour schemes for the exterior wood-
work and the shutters, which were probably painted blue, green and
orange-yellow to match the colours of the glazed brick facade
decorations. The fence around the garden was later painted in similar
colours. The hostel was officially opened on 8 February 1919.

De Vonk was the only example of his early work with architects
that Van Doesburg reproduced and discussed in *De Stijl*. He clearly
regarded it as his most important collaboration up to that time and
this valuation has generally been accepted by critics and historians.
The hall and staircase were illustrated in the November 1918 issue –

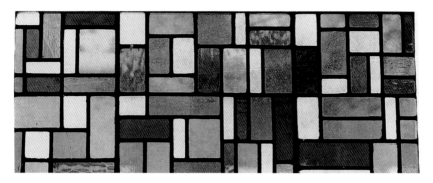

63 Theo van Doesburg, stained-glass window from Oud's first Spangen blocks, Rotterdam, 1918–19. Each apartment had one of two designs above its front door (97). The motifs, from sketches of ships and port activities, are so abstracted that not even the inhabitants, most of whom worked in the port, could have recognized them.

which contained the 'First De Stijl Manifesto' where collective values and collaboration were particularly emphasized, and an important essay, 'Notes on Monumental Art'. Here Van Doesburg wrote that by developing a 'monumental' painting in conjunction with architecture it would be possible 'to place man within painting instead of in front of it and thereby enable him to participate in it'. This was the ultimate role – derived from his study of Kandinsky's writings – that Van Doesburg envisaged for painting in his own lectures and writings on art. He was able to realize this more completely at the Aubette in Strasbourg some ten years later. *105*
144–7

In 1918 Van Doesburg began to collaborate with Oud on colour designs for his first municipal blocks at Spangen and designed small stained-glass windows for the apartments, most of which are still in place. This must be the only example of working-class housing where each apartment contained an applied art work designed by a major modernist artist. He made colour schemes for the exterior woodwork of the windows, guttering and doors, which served to break up the solidity and regularity of Oud's rather heavy, brick-built blocks. He also selected the colours for the tile surrounds of the fireplaces and the coloured plaster of the interior walls. *63*

Oud asked Van Doesburg to produce colour schemes for the second set of blocks for Spangen in autumn 1920. His designs for the exteriors, which he worked on in Weimar in 1921, were bolder and more 'destructive' than those for the two earlier blocks. Oud was at

64, 65　J. J. P. Oud, De Vonk vacation hostel, Noordwijkerhout, 1917. The hall
with its colour scheme and tiled floor was designed in 1918 by Van Doesburg
who used 10 cm square commercial tiles in black, white and cream yellow. The
brick decoration above and on either side of the front doorway was also designed
by him.　66, 67 Theo van Doesburg, interior for Bart de Ligt, Katwijk. Van
Doesburg gave a new spatial quality to the room by painting it with rectangles of
different sizes and colours, probably blue, green, orange, white and black, as in
the 1919 drawing. In 1925 he sent *L'Architecture Vivante* this monochrome
photograph from the November 1920 *De Stijl*, retouched with the primary
colours that by 1925 had become the De Stijl hallmark, for reproduction in the
special De Stijl issue of the magazine.

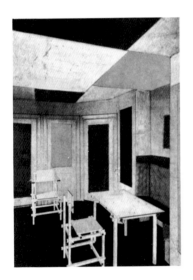

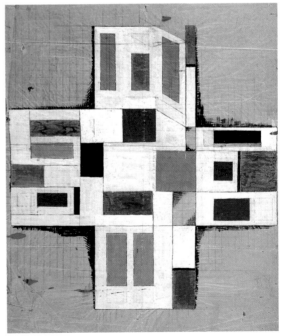

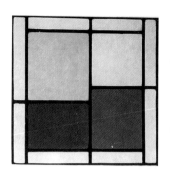

68, 69 Theo van Doesburg, stained glass for secondary school, Drachten, 1922–3; terrace housing at Drachten, Friesland, designed by Cornelis de Boer, colour by Theo van Doesburg, 1921. The painted exteriors were unpopular and were altered within a year, although the area continued to be nicknamed 'papegaaienbuurt' (parrot district). Nevertheless, such designs soon created a fashion in Holland for interiors, exteriors and abstract stained glass in primary colours. In 1988 the exterior of the terrace was restored and the interior of one house repainted according to Van Doesburg's schemes.

first enthusiastic but later had second thoughts, perhaps as the result of criticism about the bright colours from his superiors at the Rotterdam Housing Department. Van Doesburg reacted violently, declaring intransigently in November 1921 that he would not allow any alterations to his designs: 'Either this way – or nothing.' A few weeks later he wrote to Oud: 'A cautious man and a daredevil cannot play together without falling out.' The resulting bitterness led Oud to cease contributing to *De Stijl*.

In 1921 Van Doesburg obtained a commission for stained-glass *68,69* windows and interior and exterior colour schemes for an agricultural school and a terrace of middle-class houses opposite it designed by Cornelis de Boer, in the small Friesian town of Drachten. The architecture of both the school and the houses was rather traditional in red brick with pitched roofs. Van Doesburg unsuccessfully tried to persuade De Boer to have the brickwork painted white. His designs were intended to enliven the architecture with colour schemes which were not limited to a single building or block but related the two different architectural complexes on either side of the street. Van

Doesburg employed primary colours for the housing and the complementary triad of secondary colours (violet, orange and green) for the school. His aim was to create a 'contrapuntal' effect as in a Bach fugue, although the colours for the school were probably not carried out as he had intended.

Van Doesburg produced quite complex colour schemes for the interiors of the houses. He also planned the gardens, which were laid out according to carefully coloured geometric planting patterns, which he drew up after consulting Kok, who was a gardening expert. 44 Van Doesburg incorporated his garden sculpture of 1919 into the plans, although whether these were actually installed is not certain as the gardens have been changed.

Neither the Spangen nor the Drachten schemes were illustrated, or even mentioned, in *De Stijl*, apart from a reproduction of one of the designs for the Spangen stained glass in the June 1921 issue. Van Doesburg presumably considered these ultimately a failure or too much of a compromise, the architecture to which they were to be applied not sufficiently 'modern'.

Van der Leck had collaborated with Berlage on the colour for interior designs for Mrs Kröller-Müller between 1916 and 1917. He found himself constricted and overborn by the architect. In two articles published in early issues of *De Stijl*, he wrote that collaboration was only possible if both the architect and artist retained the integrity of their own domains. He proposed that the painter should use colour to 'destroy' (or deconstruct) architecture, an idea which, as we have seen, Van Doesburg elaborated himself after Van der Leck had left De Stijl.

Between 1918 and 1919 Van der Leck made colour designs for his own house at Laren, which were executed, and for an unknown house and client, which probably were not. He does not seem to have collaborated with an architect again until the 1930s when he worked 71 with Rietveld on model interiors for Metz, and with Piet Elling, who had been one of the earliest purchasers of Rietveld's experimental furniture. He made colour schemes for the interiors of some of the International Style villas Elling designed in the 1930s and 40s and the Vara broadcasting studio at Hilversum in the 50s. Although done long after Van der Leck's brief De Stijl period, these collaborations were very much in its original spirit.

However, Van der Leck generally preferred to work directly with commercial firms rather than with architects, designing rugs, wall-

METZ & CO

AMSTERDAM DEN HAAG

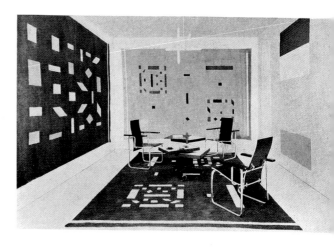

70, 71 Bart van der Leck, lettering for Metz, 1930s; wall hangings and carpet, with furniture by Rietveld, for Metz, from *Mobilier et Décoration* July 1930. Their work was widely illustrated in catalogues and magazines and helped to create Metz's 'house style' in the 1930s.

hangings, ceramics and tiles, and even packaging and carrier bags for Metz in the late 1920s and 30s, in which he used abstract and stylized figurative motifs. In the 1930s he designed ceramics for a company in Delft, and furnishing fabrics which were used for furniture by Rietveld and Oud, and by other designers such as Penaat and W. H. Gispen. Van der Leck's first carpet had been made in 1918 and he continued to use motifs drawn from his paintings of the De Stijl period in his Metz carpet and wall-hanging designs.

70

Huszár stopped painting between 1919 and 1921 to concentrate on abstract colour schemes for interiors. Many of these were collaborations with De Stijl architects or designers, or those like Klaarhamer or Piet Zwart who had connections with De Stijl. During this period Huszár designed at least thirteen interiors. Few seem to have been executed and those that were have disappeared. Some are known from reproductions in *De Stijl* and other publications, and from photographs kept by Huszár.

72,73

In 1919 Huszár collaborated with Klaarhamer on the interior of the Bruynzeel family's Arendshoeve House at Voorburg near The Hague, for which he had earlier designed stained glass. Together they remodelled the bedroom of the Bruynzeel's two young sons, for which Klaarhamer designed simple but rather solid furniture. Huszár had large, coloured squares and rectangles painted on the walls, doors and ceilings of the room, while similar elements were repeated in the upholstery of the furniture.

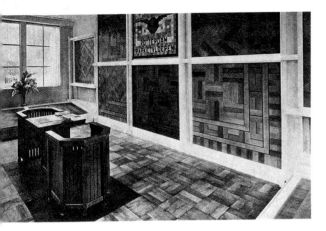
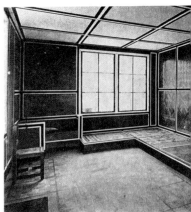

72, 73 Trade stands for the Bruynzeel company, Utrecht Jaarbeurs: P. J. C. Klaarhamer and Bart van der Leck, 1919; Vilmos Huszár, 1918. In Huszár's design at the recently instituted Nederlandsche Jaarbeurs (Netherlands Trade Fair) the walls of the stand were divided into rectangles separated by white and black bands on which were displayed specimens of Bruynzeel's parquet flooring. The 1919 stand, designed by Klaarhamer in collaboration with Van der Leck, was looser and less formal, constructed of thin, white or light-coloured wooden battens to set off the parquet samples.

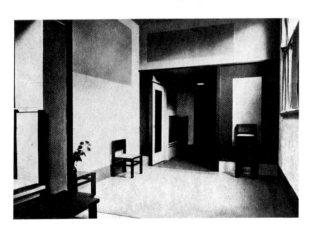
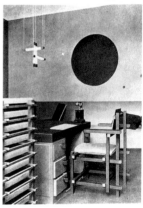

74 Jan Wils and Vilmos Huszár, Berssenbrugge photographic studio, The Hague, 1921. Huszár used rectangles of raspberry red, blue and ochre on the white walls, some surrounded by grey borders. Red, blue and black rugs formed horizontal planes on the floor, painted in two shades of grey. Wils designed alcove and window seats as well as the freestanding furniture. 75 Gerrit Rietveld, surgery for Dr Hartog, Maarssen, 1922. The interior was destroyed just before the Second World War; only the desk survives.

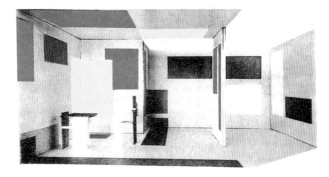

76–8 Vilmos Huszár (colour) and Gerrit Rietveld (furniture), maquette for exhibition room, Berlin, 1923, from *L'Architecture Vivante* autumn 1924. The room was not realized and only this model was exhibited. The original colours may have been subtler than the rather crude primaries of the magazine reproductions.

There was symmetry in the forms but not in the arrangement of colours, which included blue, red, yellow and black, and employed left-right reversals of colours and grounds. The colours were painted on a white background in deep tonal variations rather than as pure primaries. In the middle of the floor was a square carpet, deep blue, with a black square in the centre. Between the beds was a small rectangular rug with the colours reversed (black framing a blue rectangle). The interior was destroyed in the early 1960s but the colour scheme was documented and the furniture acquired by the Gemeentemuseum in The Hague, where the interior has been partially re-created.

74 In 1921 Wils reconstructed and extended a studio for the photographer Henri Berssenbrugge. Huszár drew up the colour schemes for the interior of the studio, while Wils designed the sparse furniture: chairs for the photographer's clients (including a high chair for children) and low tables in black-stained oak. After its completion Berssenbrugge opened the studio to the press for several days and it was widely reviewed and favourably discussed in a number of magazines. He also made it available to the Haagse Kunstkring (Hague Circle of Artists) association for a temporary exhibition at the end of the year.

In 1922 Rietveld obtained his most important early commission for a
75 complete interior: the surgery for Dr A. M. Hartog, a general practitioner in the prosperous little riverside town of Maarssen, near Utrecht. Rietveld designed the colour scheme himself, without the collaboration of an artist. He articulated and visually extended the space, dividing it into discrete areas by means of different colours and neutral tones. The walls, floor and ceiling were divided into a series of planes in different tones of grey, white and black. The fuse boxes, light switches and the rectangular door-plate were picked out in primary colours.

Hartog wanted to hang a painting on one of the walls but Rietveld told him he would do 'something' himself and painted a large red circle on the upper part of the wall, creating a dramatic focal point in the room. He also used some of his experimental furniture, including a Red Blue chair and two High Back chairs, and a filing cabinet built according to the same structural principles. Perhaps at Dr Hartog's insistence he also designed a rather solid-looking and more traditional desk, over which hung the first version of the hanging lamp used in

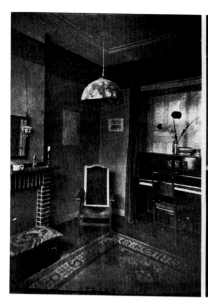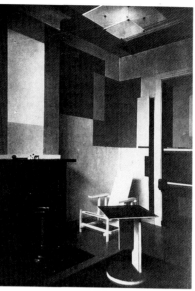

79, 80 Vilmos Huszár (colour) and Gerrit Rietveld (furniture), music room for
Til Brugman, c. 1924; before and after the redesign. Although designed as a music
room – the piano is visible in both photographs – it was later used as a studio by
the German artist Hannah Höch, who lived with Brugman in the late 1920s.

the Schröder house. This consisted of four standard Philips incan-
descent lighting tubes to which small black blocks of wood were
attached at either end, suspended by transparent rods from the ceiling.

In 1923 Rietveld collaborated with Huszár on the design for a
room for the Juryfrei Kunstschau held in Berlin in October. For the
Bruynzeel boys' room and the Berssenbrugge studio Huszár had kept
his planes discretely within the boundaries of the walls. Here they
sometimes extend across the corners or overlap one another to create a
disorientating, 'deconstructive' design complemented by Rietveld's
asymmetric furniture, which included the model for the Berlin Chair.

Huszár was commissioned to redesign a music room for the Dutch
author Til Brugman, probably in 1924. Brugman wrote experimen-
tal 'sound' poetry which had brought her in contact with De Stijl and
the international avant-garde. In this interior the planes form new
tones as they overlap with each other, creating an effect of

76–8

58
79,80

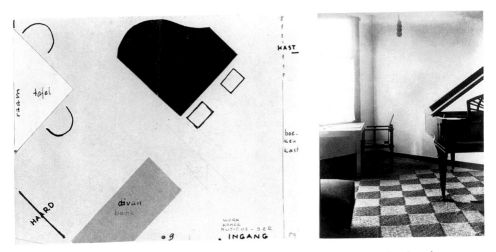

81, 82 Gerrit Rietveld, music room for Piet Ketting, *c.* 1927; sketch and photograph. The drawing indicates how primary colour was used. The divan is shown as red, the bookcase (bottom right) yellow and the cupboard (top right) blue. The table (top left) and fireplace (bottom left) are white, the piano black.

transparency. The furniture was again by Rietveld, although he did not make special designs as he had for the Berlin interior but supplied some of his experimental pieces.

81,82 Rietveld designed a music room for a young musician, Piet Ketting, in Utrecht in about 1927, probably in collaboration with Mrs Schröder. The design was organized around a grand piano which was placed on a diagonal axis. The furniture, some free-standing, some built-in, was also placed on the diagonal, including a divan with its head cut obliquely to fit against the wall and a triangular table which fitted under the window. The floor was covered with diamond-patterned rush matting. This was the first time Rietveld had used diagonals in his interiors, although they had appeared in furniture designs like the Red Blue Chair. Here he may have taken the idea from Van Doesburg's recent paintings. However, there is also a practical reason: to place a grand piano on the diagonal is the most economical solution to the problem of how to site this awkwardly shaped instrument in a rectangular room. Another factor in the design

98

could have been the diagonal corner fireplace, an original feature of the house which may have suggested to Rietveld the diagonal arrangement of the furniture.

In 1926 Mondrian received a commission to design an interior for the German collector Ida Bienert in Dresden. This – his only interior design apart from his own studio (see Chapter 10) – was never executed. Mondrian wrote of the Bienert design to Oud: 'Without the preparatory study of my own interior, I wouldn't have been able to do it.' Bienert was the wife of a wealthy industrialist who owned an important collection of modern art including works by Kandinsky, Klee, Chagall, Malevich and Moholy-Nagy. Her daughter was a student at the Bauhaus and she herself was a close friend of its director, Walter Gropius. Bienert bought two paintings by Mondrian after seeing an exhibition of his work at the Kühl und Kühn Gallery in Dresden in 1925 and commissioned him to redesign a study-bedroom for her house in the wealthy suburb of Plauen. However, the design was not realized because Mondrian insisted on going to Dresden to supervise its execution and the Bienerts were not prepared to pay for him to do so.

Mondrian did four drawings for the room, two of which were 'exploded box' plans and the other two axonometric views. The latter are very unusual in Mondrian's work. In drawing these projections he had to use the diagonal lines he so carefully avoided in his painting, as in Van Doesburg and Van Eesteren's collaborative drawings for the architectural projects in the 1923 Rosenberg show (see Chapter 10). The distribution of planes of colour and different shades of grey in the interior was closer to the way he arranged his studio at this time than to his contemporary easel paintings. Thus, the planes are butted against each other, not separated by black lines as in the paintings, and, as in his studio, the primary colours were employed quite sparingly. Most of the planes were in shades of grey, black or white. The largest area of colour was a red rectangle, equivalent in size to the length of the divan bed and placed immediately above it, 'as if to deny any possibility of rest by the sheer force of visual stimulation', as one commentator has put it.

Music rooms, studios and houses for artists and collectors were common themes for architectural competitions, 'ideal' projects (that is, not intended to be realized) and collaborations between architects and artists at the beginning of the century, in the milieu of the Arts and

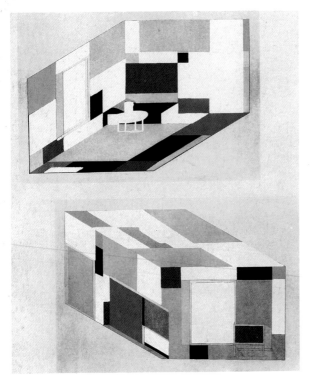

83, 84 Piet Mondrian, drawing for Ida Bienert interior, 1926, and construction at the Pace Gallery, New York, 1970. The realization was executed in formica on the basis of Mondrian's essay 'Home-Street-City', published in *Vouloir* and *i10* in 1927 with reproductions of the Bienert drawings. He wrote: 'Surfaces will be smooth and bright, which will also relieve the heaviness of the materials. This is one of the many cases where Neo-Plastic art agrees with hygiene, which demands smooth, easily cleaned surfaces.' The realization was not entirely accurate: the oval table was misinterpreted as a rug.

Crafts movement and continental Art Nouveau. Such precedents were a basis for the De Stijl idea of the collaborative project or designed interior.

Of the commissions actually executed by De Stijl artists and designers in Holland, many were for the houses of manufacturers, doctors and architects. Some were even for working-class 'clients' (although of course not commissioned by them), such as the working girls who stayed at De Vonk or the port workers who moved into Oud's Spangen blocks. Most of these collaborative works disappeared or were completely altered within ten years of their completion, but this is normal with interior design. It is clear that many clients found it difficult to live with them and only the most determined, like Mrs Schröder, reconstructed their lives according to the demands of their interiors. However, the Schröder house was a complete architectural entity and will be discussed in the next chapter.

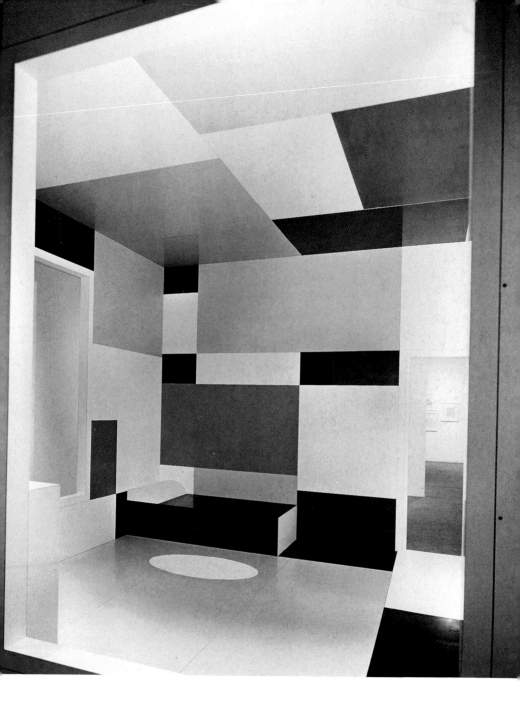

85, 86 Robert van 't Hoff, bungalow for J. N. Verloop, Huis ter Heide, 1914; the Henny house, Huis ter Heide, designed 1914, completed 1919. With its strong horizontals and wide-angled hipped roofs of slate, deep porches, planters and verandahs, the bungalow is reminiscent not only of Wright's early houses but also of the bungalows built before the First World War in England, where Van 't Hoff studied and began to practise. Unlike the Verloop bungalow, the Henny house does not attempt to blend with the natural world around it but stands out as a geometric man-made artefact.

Architecture

Compared to interior design schemes, conversions and collaborations between architects and artists, the realization of a De Stijl architecture was subject to the inevitable delays and compromises inherent in the processes of commissioning and construction. During and immediately after the First World War there was more building activity in Holland than in the combatant countries of Europe, despite the short supply of finance, materials and labour. However, most De Stijl architecture remained at the project stage, as drawings or models, partly because of the difficulties in persuading clients to commission modernist buildings.

It has frequently been claimed that the Schröder house was the only true example of built De Stijl architecture and Rietveld has commonly been represented as the major De Stijl architect. However, it is necessary to reassess the work of the architects initially associated with De Stijl – Van 't Hoff, Wils and Oud – in the light of changed attitudes to early modernist architecture.

De Stijl architecture has typically been characterized as asymmetrical, geometric and flat-roofed, painted in white or light greys, with accents in primary colours. Yet none of the buildings actually built at the time when their architects were associated with De Stijl incorporated all these qualities, with the exception of the Schröder house. Van 't Hoff's Henny house of 1915–19 at Huis ter Heide, near 86 Utrecht, remained symmetrical and axial, although it was starkly geometric and had a flat roof. Wils's 1918 café-restaurant De Dubbele 87 Sleutel (The Double Key) in Woerden was asymmetric, but built of brick with a pitched roof. Oud's De Vonk also had a pitched roof and 64,65 was of brick, although its interior was geometric and abstract.

Apart from the Schröder house, Wils's Daal en Berg housing estate 88,89 in The Hague, 1919–21, perhaps came closest to the De Stijl ideal. Van Doesburg stayed in one of Wils's apartments in the winter of 1922–3 and although Wils was no longer associated with De Stijl, he praised the scheme to De Boer: 'It is delightful to live in a space that is so fresh

and clean! . . . There is a lot to see here, in spite of the fact that the use of colour is still deficient.' (Presumably Wils had done this himself.) 'Still it's delightful to see that the ideal which drove me to found De Stijl all of six years ago is now turning into a reality.' And he reproduced three photographs of the estate and a plan in the Fifth Anniversary issue of *De Stijl*, in December 1922.

Van 't Hoff's Henny house seemed to Van Doesburg to embody the principles of early De Stijl, although like Rietveld's early experimental furniture it had been designed before Van 't Hoff became involved with De Stijl in 1918. Van 't Hoff had visited America in June 1914 where he met Frank Lloyd Wright and saw many of his buildings, bringing back a large collection of documentation and photographs of his work. On returning to Europe, he received a commission for a small bungalow for J. N. Verloop, to be built in the garden of Verloop's parents' house in Huis ter Heide.

The following year Van 't Hoff was commissioned to design a larger villa at Huis ter Heide for A. B. Henny, an Amsterdam businessman. The Henny house was built using a concrete frame which was very unusual for the time, particularly in domestic buildings, and the first frame collapsed during construction due to the inexperience of the contractors. Berlage had experimented in 1911 with a concrete house at Santpoort, constructed according to a system patented by Thomas Edison. However, the concrete frame construction Van 't Hoff used was more advanced and enabled the Henny house to be designed with dramatic cantilevered roofs and porches.

The house is square in plan, horizontal in emphasis, plain to the point of bareness, although sophisticated in its detail. It is like a modernist 'deconstruction' of Palladio's famous Villa Rotonda with its square plan, central citing in its grounds, and porches and balconies on every facade which function as modernist pediments and loggias. On the ground floor the southern half of the house is one large living-room, lit by windows on three sides. Glazed doors in the south facade lead onto a rectangular covered terrace or large porch overlooking a square pool. The plain mullions between the long horizontal bands of windows constitute almost the only strong vertical accents in a predominantly horizontally organized design. The interior detailing was highly refined: for instance, the electric wiring was concealed inside carefully sited wooden trunking incorporated into the geometric design, and the central heating radiators were hidden in shafts in the wall which also concealed the drain and water pipes.

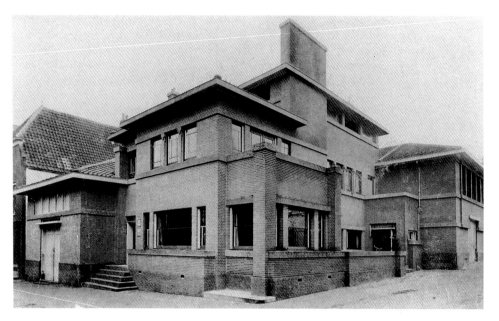

87 Jan Wils, De Dubbele Sleutel, Woerden, 1918 (demolished 1970s). Van
Doesburg collaborated on the colour designs for the interior and exterior, where
he accentuated the asymmetrical divisions of the windows by alternating light and
dark colours (Veronese green and orange), and black and white.

The Henny house, or the Concrete house as it was sometimes
called, could perhaps be described as the first modernist house. There
are similarities with Le Corbusier's almost contemporary Villa
Schwob (1916), but Van 't Hoff's design is more audaciously and self-
confidently 'modern'. It was reproduced (twice) in the *De Stijl*
magazine in 1919 and contrasted with a romantic Amsterdam School
country house designed by C. J. Blaauw (who had recently attacked
Van Doesburg) in an article by Huszár. Huszár compared the Henny
house to the characteristic industrial products of the twentieth century
like the motor car, whereas the house by Blaauw, he argued, evoked
the romantic and picturesque tradition, 'the world of the *cottage* and
the oil lamp'.

Although the Henny house had been commissioned by a
prosperous client and was very comfortably fitted and finished, it was
also designed with the intention that its construction would be

satisfying to the labourers who built it, because its structural logic would be clear to them – so claimed the Belgian architect Huib Hoste, who was close to De Stijl at the time, in an article in the Amsterdam newspaper *De Telegraaf*. This was no doubt based on statements by Van 't Hoff himself. A similar preoccupation with how a work was made, and the involvement of the workers who made it, was also expressed, as we have seen, in early statements by Rietveld about his experimental furniture (see Chapter 5).

Van 't Hoff contributed a number of articles to *De Stijl*, believing its principles were close to his own. He supported the magazine financially and helped to recruit subscribers before falling out with Van Doesburg in 1919. Later, he abandoned architecture and settled in England in 1922.

Like Van 't Hoff, Wils was influenced by Wright. However, whereas Van 't Hoff was mainly interested in Wright's 'machine aesthetic', Wils responded to the romantic and lyrical qualities of
87 Wright's work. Thus De Dubbele Sleutel was given a pyramidal form with roofs, balconies and porches spilling down and flying out asymmetrically from a central block surmounted by a high, wide chimney-slab, the main vertical accent in an otherwise predominantly horizontal composition. It was built of brick, broken up by concrete lintels and parapets which were carried on beyond the windows and balconies to form long horizontal strips which both divide and link the brick masses.

Unlike Oud, whose strong bias towards symmetry sometimes conflicted with the De Stijl elements in his work, Wils seems to have had an innate feeling for asymmetrical form. In October 1918 he contributed an article to *De Stijl* entitled 'Symmetry and Culture', in which he described how symmetry progressively decreased from the natural to the cultural, man-made artifact. Wils saw asymmetry as essentially modern, in contrast with the monumental symmetry of Classical architecture and he believed it embodied the highest cultural achievement of man.

In 1919 he was commissioned to design sixty-eight middle-class
88,89 houses for the Daal en Berg Garden Suburb Co-operative Housing Association in The Hague. Eventually it became a joint project with the municipal housing authority whereby Wils also designed sixty apartments in low-rise blocks for less well-off tenants. The estate was erected between 1920 and 1921.

The houses were designed to be built of concrete, but local building

regulations eventually prevented its use except in the foundations. Construction continued in brick faced with cement to create the appearance of concrete. Flat roofs and the cement-rendered facades gave the houses a severe impression, softened today by the well-grown gardens and the greenery of the communal garden around which they are grouped. Each pair of semi-detached houses is staggered in relation to the pair in the street behind, interlocking so that they fit snugly together. On the street fronts this creates a varied effect of protruding and receding masses emphasized by cut-back balconies and porches.

The houses are spacious and comfortable inside with a large hall, a living/dining-room and a kitchen with serving-hatches between the two, and three bedrooms and a bathroom on the upper floor. The apartment buildings were also designed to a high specification with service lifts, rubbish chutes from the kitchens to a central collection bin, and speaking tubes from each apartment to the main entrance, the doors of which could be opened by remote control.

The Daal en Berg estate was an important contribution to social housing in Holland in the years immediately following the First World War. Although it was designed for middle-class occupants, many architects like Oud who were working to a much tighter specification for working-class housing, took note of Wils's designs and the ingenious and elegant planning solutions which he employed.

In 1921 Wils also designed a small estate of workers' houses for the town of Gorinchem which presents an interesting contrast. Where he had designed the middle-class dwellings with flat roofs and the appearance of being built of concrete, the workers' houses had steeply pitched tiled roofs and plain brick walls giving them a traditional, cottagey quality. Wils did, however, give them modern metal windows with long horizontal bands of glass, a little like those used by some of the Amsterdam School architects.

Wils had signed the 'First De Stijl Manifesto' published in the November 1918 issue. However, in early 1919 Van Doesburg was threatening legal action for money owed, presumably payment for one of the designs on which he had collaborated. After this Wils seems *90* to have taken no further part in De Stijl activities, although photographs of the Daal en Berg estate were shown in the 1923 Paris *139* Rosenberg exhibition.

Oud was the collaborator closest to Van Doesburg when De Stijl was founded. It was probably for this reason that both men felt so

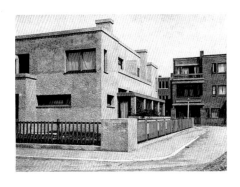

88 Jan Wils, Daal en Berg estate, The Hague, 1920–21.

89 Piet Zwart, Daal en Berg estate, The Hague, 1919–21, presentation drawing. Zwart, who was Wils's draughtsman, depicted the estate as it would be when the planting had matured.

90 Jan Wils, Cricket Clubhouse for 1928 Olympic Games, Amsterdam. The wooden clubhouse stayed closer to De Stijl principles than Wils's Olympic Stadium, an eclectic and romantic building combining De Stijl elements with details derived from Wright and the Amsterdam School.

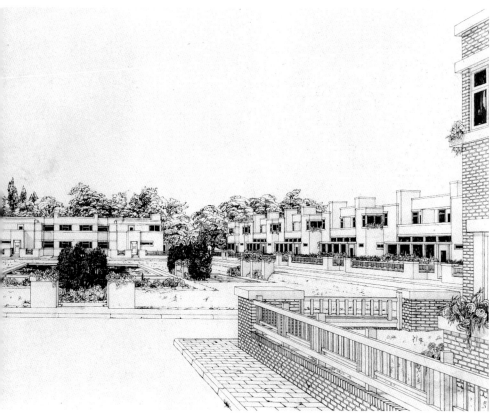

bitter about the break in 1921 over Van Doesburg's colour designs for Oud's second group of Spangen blocks in Rotterdam. Oud tried to put into practice idealistic ideas about the relationship between the individual and society, which he shared with other De Stijl collaborators, while working as an architect with a large and important municipal housing authority. However, the nature of such commissions meant that there were inevitable compromises.

Oud's built work was generally more conservative than his unrealized designs during his association with De Stijl, although when *De Stijl* appeared in 1917 he had recently been involved in a building in which many of the elements of De Stijl architecture were anticipated. In 1916 he had begun to work with the artist Menso Kamerlingh Onnes on the extension and modernization of an existing villa in the fishing village and seaside resort of Katwijk-am-zee. The Villa Allegonda belonged to Onnes's neighbour, J. E. R. Trousselot, a *92*

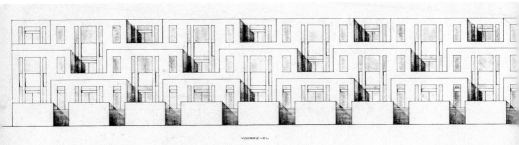

VOORGEVEL

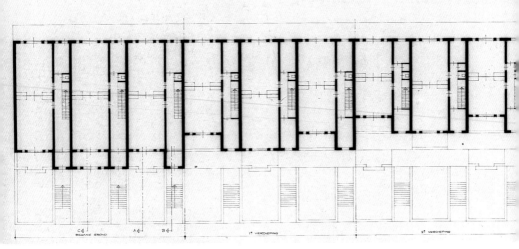

BEGANE GROND A B 1° VERDIEPING 2° VERDIEPING

tea merchant from Rotterdam. Oud later attributed most of the remodelling to Onnes but whatever the authorship of the design, the building was an important example of early modernist architecture. Onnes had recently visited Tunisia where he was impressed by the spare cubic simplicity of north African architecture with its white walls and flat roofs.

The conversion resulted in a dramatic exterior, stark and simple, composed asymmetrically of interlocking volumes in a manner which seems to anticipate aspects of the International Style of the late twenties and Oud's own work of that period. In 1927 Oud was asked to modernize the villa again and he had to make relatively few substantial changes in order to 'update' it.

A number of Oud's executed and unexecuted works were

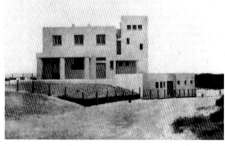

91 J. J. P. Oud, seaside housing, Scheveningen, 1917. Perspective, plan and sections. The design was an early attempt to create standardized building types, about which Oud later wrote in *De Stijl*.

92 J. J. P. Oud and Menso Kamerlingh Onnes, remodelling of the Villa Allegonda, Katwijk-am-zee, 1916. The conversion involved stripping off a wooden ornamental porch and shutters and adding the rectangular tower and open loggias.

illustrated in early issues of *De Stijl*. The most important of these were the 1917 designs for a block of terrace houses on the esplanade at Scheveningen and for a warehouse and factory at Purmerend in 1918– 22. Both were commissioned by his own family, although in the end neither was realized.

91
3

The drawings for the Scheveningen houses, a speculative middle-class development for his cousin, were reproduced in the first issue of *De Stijl* with a commentary by Van Doesburg. These show a series of interlocking units which could be repeated indefinitely to create rows of housing as required. Three floors are stacked one above the other, ingeniously stepped back and interlocked in order to create spatial variety in what otherwise would be a monotonous facade. This also gives each unit a sense of privacy and separation. By these means Oud

showed how it might be possible to achieve some element of individuality within a standardized scheme.

Although Oud did not work out the design in detail, the drawings suggest a building which would have had a very stripped exterior, simple and cubic like the Villa Allegonda, but quite symmetrical (unlike the Allegonda), with flat roofs and walls finished in white or grey plaster or painted concrete. In 'The Monumental Image of the City', Oud suggested that these qualities were particularly appropriate to buildings by the sea. With its references to nautical imagery and Mediterranean or north African vernacular building, modernist architecture has often appeared more acceptable at the seaside, the site of orientalist and exoticist fantasies in cold northern countries like Holland and Britain. Oud used similar references in his 1924–5 *107* housing at the Hook of Holland (see Chapter 8).

64,65 At the time he made the drawings for the Scheveningen houses, Oud was also working on designs for De Vonk. A comparison between the two makes clear the differences between Oud's unrealized and realized projects. Since Berlage had recommended him as architect to the director of De Vonk, Oud may have felt that he was expected to design the exterior at least in Berlagean style. As a result, he was criticized for his use of steeply pitched roofs, which appeared at odds with his own stated ideals and his more 'advanced' designs published in *De Stijl*. Van Doesburg suggested that he antedate the design to before the founding of *De Stijl*. Oud seems to have fallen in with this and the date for the design of De Vonk is often given as 1916 rather than 1917. However, the interior, particularly the stairway and the hall with its dramatic piercings of walls and complex interlocking spaces, has a cubic, volume-and-void quality reminiscent of the Scheveningen design and the remodelling of the Villa Allegonda. Despite its formal appearance, in the clarity and openness of the design of the hall, which was intended to be the symbolic centre of the community, Oud was careful to take into consideration the needs of the occupants. He provided ample space to stop and talk, and wide benches under the stairs for 'the children and their escorts to sit down for a moment with a book or needlework'.

93–6 The Schröder house, 1924–5, has always occupied a special position in *98* accounts of De Stijl. Since the death of Mrs Schröder in 1985 the house has been restored approximately to its original state. This has added to its mythic place in modernist architectural history by constructing a

simulation of a key moment in early modern architecture, as if it had been frozen in time.

The house was designed by Rietveld in close co-operation with Mrs Schröder, who was more co-designer than client and whose own ideas were rather distinct from De Stijl. It was Rietveld's first complete building. After her husband died in 1923 Mrs Schröder decided to build a new house in Utrecht for herself and her three children. She asked Rietveld, who had redesigned a room in her former apartment in 1921, to work with her on the new house. There was no formal commission of the kind usual between architect and client.

The only site they could find was at the end of a block of solid, *93* recently built brick apartment houses in Prins Hendriklaan, on the edge of the newly laid out middle-class suburbs to the south-east of Utrecht. Its main advantage was that it looked over open countryside of meadows, trees and canals. However, soon the land beyond the Schröder house was built on as the city grew rapidly in the later 1920s and 30s until by the end of the 60s there was a raised orbital motorway just beyond the edge of the house's small garden.

The first designs were begun at the end of 1923 and Mrs Schröder and her family moved into the house at the end of 1924, the interior being completed in 1925. Mrs Schröder continued to live there almost uninterruptedly until she died, aged ninety-five. Rietveld himself lived in the house for the last years of his life between 1959 and 1964. Alterations were made as the occupants' circumstances changed, for the house embodied Rietveld and Mrs Schröder's belief that a building was not a fixed entity but a palimpsest on which could be inscribed a life-style and a life-view.

Mrs Schröder wished to be able to open out large parts of the house for family use. Rietveld's initial idea was to make the upper floor a single completely open space. She, however, wanted a transformable area with movable partitions, which could either be open or closed, *95* so that she and her children might also have privacy if they wished. Rietveld produced a design using sliding and folding partitions a little *98* like those in traditional Japanese houses. The space on the upper floor *94* could be arranged in seven different ways, according to whether the partitions were completely open, completely closed, or in various combinations of partly open and partly closed. This transformable space could be adapted to new situations and combinations of inhabitants as Mrs Schröder's children grew up and left home and as

she herself continued to live in the house for the next sixty years. In order that the upper floor could be completely open when required it was described on the plans submitted to the planning authorities as an attic or loft (*zolder*), to circumvent the local regulations. As the partitions were not solid they did not have to be marked on the plans.

The design of the ground floor had to be more conventional to conform to the regulations. In practice this enabled the inhabitants to have the choice of the transformable upstairs space or the more

96 enclosed, private rooms downstairs, although glass panels at the top of the doors and above some of the partition walls created a sense of continuity between the small intimate spaces of these enclosed rooms, including the lavatory. The ceiling visibly extends beyond the boundaries of the individual rooms, so that while remaining private they are not completely isolated from one another, combining individuality and sociality.

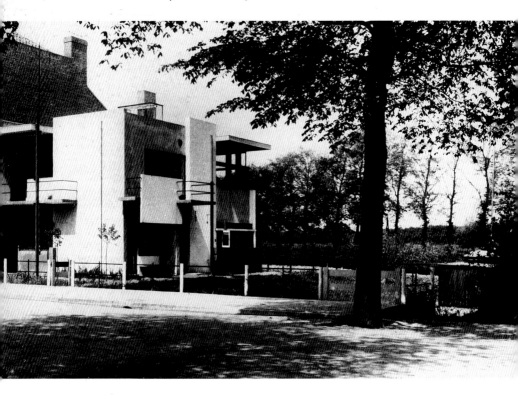

Gerrit Rietveld and Truus Schröder, Schröder house, 1924–5

93–5 Exterior, photographed c. 1925 (93). Interior with Mrs Schröder and her daughter, Han (sitting in the Berlin Chair), photographed c. 1925 (94). Plans of first floor showing partitions open and closed (95). Rietveld displaced the I-beam that supports the roof slab about a foot from the corner so that when the large windows on the upper floor are open the corner of the house 'disappears'. The ledge (centre right) was designed for the children to do their homework and in front of it can been seen the End Table.

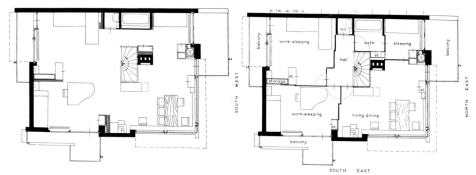

In the famous corner window on the first floor the division between inside and outside becomes so tenuous that interior and exterior space appear to intermingle. Yet, with its mixture of open and closed spaces, the house always remained private, personal and domestic – unlike Le Corbusier's villas, the interior of which, with their ramps and double-height interiors, appear like the public spaces of museums, garages or art galleries.

Rietveld and Mrs Schröder worked from the floor-plan: 'We found it essential to begin with the plan', she recalled, 'and to ask, what's the best view, where does the sun rise.' This is apparent in the organization of the living areas in the house. The chimney-breast with

its stove forms a free-standing but unchangeable element in the centre of the upper floor beside the stairwell. This hints at a traditional hearth at the stable core of the house. With the bathroom, lavatory, stairs, and the small bedroom used by Mrs Schröder herself, these were the only parts of the upper floor which could not be completely opened out. Rietveld used this system as a model for some of his later architectural experiments. From the late 1920s he designed a number of prototypes for 'core' houses for mass housing with a prefabricated unit containing central services: stairs, kitchen, lavatory and bathroom. To these could be attached different combinations of rooms according to the needs of the occupants.

To build the Schröder house Rietveld wanted to use concrete slabs, a very new technique at the time. However, the slabs would have had to be made on site, which would have been uneconomic for a single house – as opposed to the mass-produced municipal housing built in concrete-slab construction like Betondorp (Concrete Village) at Watergrafsmeer on the outskirts of Amsterdam. He therefore used conventional load-bearing brick, faced with plaster, with steel I-beams to support the roof and the balconies at certain points. The walls were painted white and grey, which gave the impression that the house was constructed of reinforced concrete. There is no evidence that this was a deliberate deception. However, some early commentators such as Gropius and the French architectural critic Jean Badovici erroneously described the house as built of reinforced concrete.

Colour was used quite sparingly on the exterior. Only the girders which supported the balconies and formed parts of the sub-frame of the larger windows were painted in the primaries. Inside, the walls and ceiling on the first floor were grey or off-white. The only

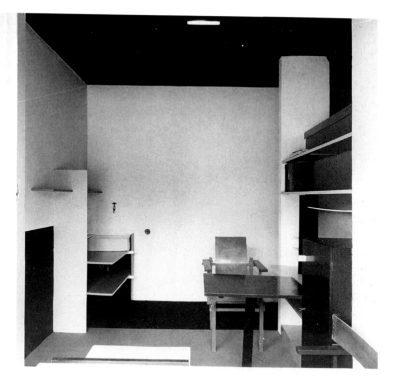

96 Schröder house, 1924–5. Downstairs study (photographed 1987), a private, enclosed room with a built-in desk and bookshelves. It was originally used by Mrs Schröder's son Binnert and was never altered.

exceptions were the wall which formed the chimney-breast, painted yellow at first and later ultramarine blue, and part of the wall of Mrs Schröder's bedroom which was originally a pale yellow. The sliding partitions were grey, white or black. The tracks on which they ran were painted in the primaries. Blue roller blinds were fitted to the bottom half only of the wide windows in the dining section. The floor was divided into rectangular interlocking sections of linoleum or felt in grey, black, red and white. 98

Neither Mrs Schröder nor Rietveld wanted to involve a De Stijl artist in choosing the colours for the house. According to Mrs Schröder, Rietveld wanted to use colour 'less as a *painter* and more in direct connection with the *simultaneous* creation of colour and

architecture'. When Van Doesburg heard of the Schröder house commission, he immediately enquired about the possibility of collaboration. In a postcard of March 1924 he said he had learned that Rietveld had received 'an ideal commission. . . . Is that so? Send me some news! As soon as you have some photographs, send me a few! I suppose you'll do the COLOUR yourself. I haven't heard anything from you on that score!' Van der Leck also proposed working on the colour design but Rietveld declined. He knew Van der Leck's belief that painting should 'destroy' the architecture rather than working with it. However, Mrs Schröder later bought a painting by Van der Leck, the only work by a De Stijl artist in the house.

The Schröder house is very small, no bigger than a semi-detached suburban villa. Every inch of space is used with great ingenuity and functions are made to 'double up'. There are many labour-saving devices and built-in features which were probably among Mrs Schröder's major contributions to the design. Each separate room or area which could be partitioned off was provided with a bed, a wash-basin and a gas point for a cooking ring so that each could be occupied in as private and self-contained a way as possible if necessary.

The built-in furniture was constructed by Van de Groenekan after Mrs Schröder and her children had moved into the house. Like Rietveld's experimental furniture, much of it has a ludic quality as if designed for play, as in many ways it was in a house where three young children were to grow up. It was deliberately made cheaply and often quite crudely, as Mrs Schröder wished to avoid the luxury and high-quality finish which would have marked the artifacts and furnishings of the social class to which she belonged.

In August 1925 Van Doesburg wrote to César Domela, whom he had recently involved in De Stijl, enclosing a photograph of the Schröder house, which he described as 'the application of our most recent principles'. His latest ideas on architecture had been published in 1924 in De Stijl as 'Tot een Beeldende Architectuur' (Towards a Plastic Architecture) and these ideas seemed to be closely realized by the Schröder house. The new architecture, he had written, developed from 'the precise determination of practical necessities which it embodies in a clear ground plan. . . . [It] has *opened* the walls, thus eliminating the *separateness* of the *interior* and the *exterior*. . . . The whole consists of one space, which is divided according to the various functional demands. . . . [The planes] which separate the different

functional spaces, can be *mobile*, which means that the separating planes (formerly the interior walls) can be replaced by movable screens or slabs (doors can also be treated in this manner) . . .' The new architecture, he wrote, is '*anti-cubic* . . . it does not attempt to combine all functional space-cells into one closed cube, but *projects the functional space-cells* (as well as overhanging planes, the volumes of balconies, etc.) *centrifugally* . . .' In this way architecture, for Van Doesburg, took on a 'hovering aspect', challenging the force of gravity. In place of symmetry, the new architecture 'proposes *a balanced relationship of unequal parts*, that is to say of parts which, because of functional characteristics, differ in position, size, proportion and situation.' It also avoids *frontalism* 'born out of a rigid, static concept of life', giving instead equal value to each facade of a building. Finally, wrote Van Doesburg, the new architecture uses colour organically, 'as a direct means of expression of relationships in space and time', for 'without colour, these relationships are devoid of the aspect of living reality; they are *invisible*. The equilibrium of the architectural relationships becomes a visible reality only through the use of colour.' Colour 'is not a decorative or ornamental part of architecture but its organic means of expression.'

Van Doesburg's declaration was written after his experience of making the colour drawings and models in collaboration with Van Eesteren for the Rosenberg show. Its various points clearly embodied what the two men had been trying to project in terms of 'ideal' architecture. The design of the Schröder house is in some ways close to the formal ideas in the Rosenberg projects – Rietveld had made a model for one of these and no doubt knew others from photographs and drawings – but they were unrealized (and unrealizable) 'ideal' architecture, whereas the Schröder house was realized.

The house was in progress when Van Doesburg's article was published, and it is unlikely that Rietveld or Mrs Schröder had read it before publication or that Van Doesburg had a clear idea of what the house would be like at the time when he was writing it (as is apparent from the postcard he sent Rietveld, cited above). It seems that Rietveld and Mrs Schröder had arrived at a practical demonstration of what Van Doesburg envisaged theoretically at almost exactly the same time.

The Schröder house was thus, in a sense, the embodiment of the 'most recent De Stijl principles', but at the same time, as we have seen, it also incorporates ideas evolved independently from De Stijl.

138
139

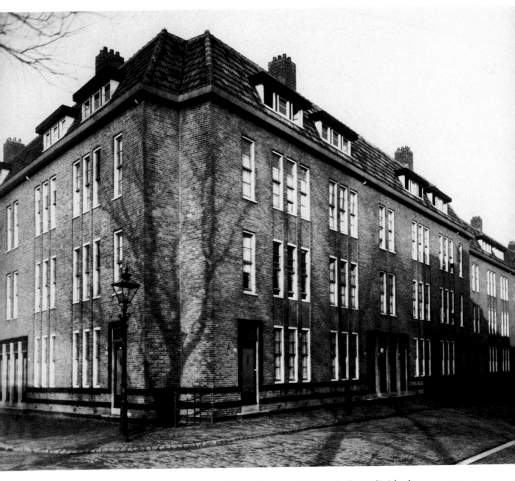

97 J. J. P. Oud, Spangen Block I, 1919. Although the individual apartments are not visibly separate on the outside, Oud gave each its own front door on the street, with a stained-glass window above (63).

Social Housing and the International Style

It is mainly through Oud's work that De Stijl architectural ideas are linked with social housing, although Rietveld, Wils and Van Eesteren were also involved with the design of low-cost housing for the working or lower-middle classes. Shortly after the founding of *De Stijl*, Oud obtained a job as an architect with the Rotterdam Housing Authority in January 1918. He had been put forward by Berlage for the post, which was an important and responsible one for a relatively unknown young architect of twenty-eight. He never, however, held the post of 'city architect' of Rotterdam, as often erroneously stated.

Although the population had increased by over fifty per cent during the first fifteen years of the century, Rotterdam had fallen behind other Dutch cities like Amsterdam in building low-rent accommodation for the working classes. The Rotterdam Housing Authority had been set up in 1916 to organize, design, build and run subsidized public housing of a basic quality in order to alleviate the situation whereby many working-class families could not afford what was provided on the open market or by housing associations.

In 'The Monumental Image of the City', published in the first issue of *De Stijl* in late 1917, Oud had formulated his ideas on housing. He argued that individual private houses should no longer be built in cities but instead large housing blocks should be constructed, using modern materials such as steel and concrete. Ideally these should be grouped around courtyards or squares to provide communal space and adequate fresh air and ventilation. He attempted to put some of these ideas into practice in his first years with the Authority, in the reclaimed areas of Spangen and Tussendijken.

The first blocks at Spangen, 1918–20, were designed with pitched roofs, the later Spangen blocks, 1919–21, had a mixture of flat and pitched roofs, while Oud's last large-scale estate at Tussendijken, 1921–4, had flat roofs. These dwellings were rather plain and severe by comparison with some of the Amsterdam School housing built at about the same time in the working-class suburbs of Amsterdam.

97

101

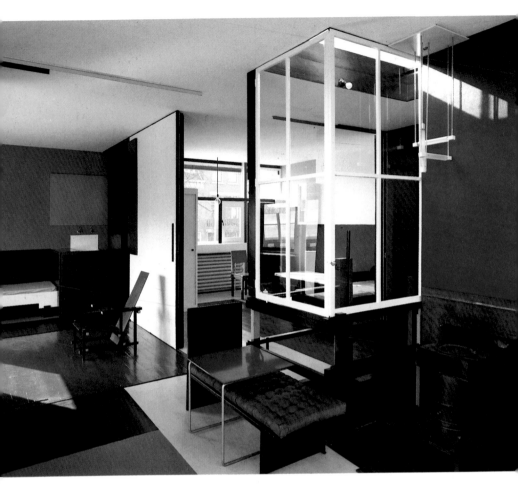

98 Schröder house, 1924–5. Interior, restored 1985–7, in which the sliding
partitions can be seen half folded back, behind the Red Blue Chair (centre left).

99 J. J. P. Oud, site-manager's temporary shed, Oud Mathenesse estate,
Rotterdam, 1923. Elevations, perspectives and plan.

100 J. J. P. Oud, Café de Unie, Calendplein, Rotterdam, from *L'Architecture
Vivante* autumn 1925. Exterior; drawing and plans. The café was intended to fill a
vacant site between two imposing 19th-century buildings for 10 years only but
survived for 15, until destroyed in the bombing of 1940. It was reconstructed
nearby in 1985 (155).

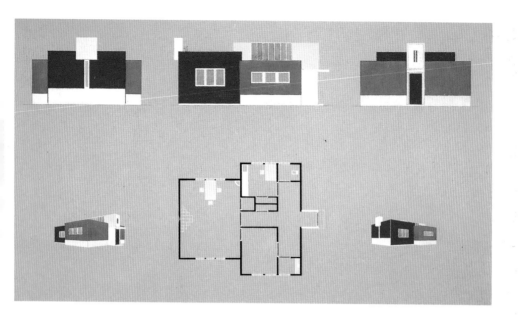

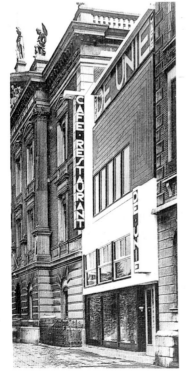

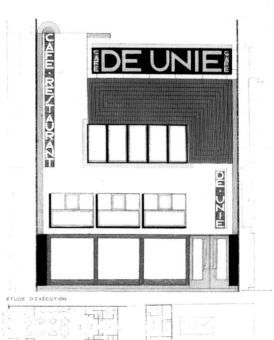

ÉTUDE D'EXÉCUTION

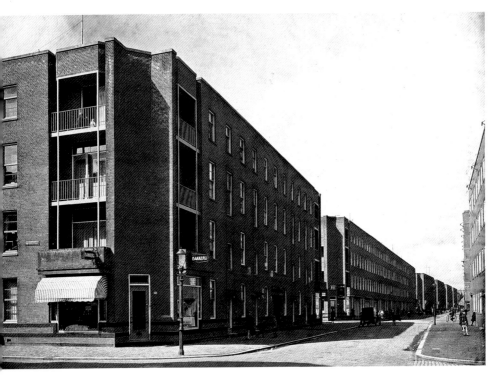

101 J. J. P. Oud, housing blocks, Tussendijken, Rotterdam, 1921 (destroyed 1940). Built round inner courts with both communal areas and individual gardens, five long rectangular blocks were finished in 1921 and a larger, splayed block overlooking an open public space in 1924.

However, Oud devised subtle and sensitive solutions in which the individual elements are related to the whole: windows and doors to the facades, the separate living units to the block, the individual inhabitants to the community. In stressing the street, the facade, the continuity with the city as a whole, he made his blocks fit into a pattern of communality beyond their immediate environment, the 'unity in diversity' or 'unity in plurality' advocated by Berlage.

In an article in the *Rotterdamsch Jaarboekje* in 1924 Oud wrote that at Spangen and Tussendijken he had tried to express the contrast between the vital rhythms of the city and the consequent need to

escape from them. To live in the city, he argued, one has to find a way of distancing oneself from its industriousness, to protect oneself from those very activities which make the city most the city. 'To express this in practical and aesthetic terms was the premise for the design of the blocks of houses reproduced here. The street: industry; the inner court: living.'

Later projects, such as Hook of Holland and Kiefhoek, which 107,108 provided separate individual houses for each family but were uncompromisingly 'modern' in their appearance, attempted to reconcile communal values with individual needs and aspirations. Oud probably considered that these also corresponded to his concept of what constituted 'monumentality' in architecture. This was nothing to do with size and could be created on a small scale as well as in a large scheme of housing blocks several storeys high.

Oud's official position often made his relationships with De Stijl difficult and he was to some extent constrained by this. As he wrote in 1920 to Van Doesburg, 'In the modern city we can be pure only in isolated buildings. The facts impose an impure, but necessary solution.' Van Doesburg was aware of the problems facing an architect who worked in a public position producing 'social housing'. He wrote to Oud on 18 December 1919 that his first Spangen blocks were 'in fact very good, considering the circumstances', and offered to illustrate them in *De Stijl*. However, they were never published there.

102 J. J. P. Oud, design for the Kallenbach house, Berlin, 1922, from *L'Architecture Vivante* summer 1924. Perspective.

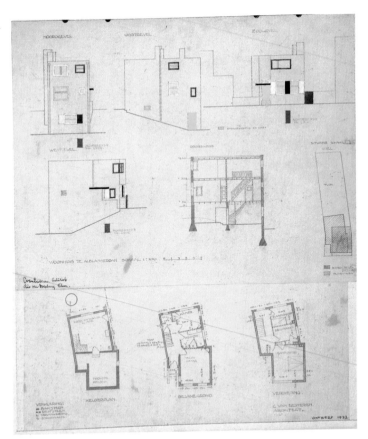

103 Cornelis van Eesteren, house, Ablasserdam, 1924. Elevations, cut-away and plans. This was his first excuted building; Van Doesburg did the colour scheme.

104 Theo van Doesburg, drawing for Maison particulière, 1923. The colour drawings often have only a tenuous relationship to the original designs by Van Eesteren for this structure.

105 Theo van Doesburg, colour design for Ciné-dancing, Aubette, Strasbourg, 1926–8. This and another drawing seem to have been made after the rooms were decorated and presumably most accurately represent the schemes as executed. In earlier sketches the colours are paler. The tonality of the surviving black-and-white photographs suggests quite saturated hues (145).

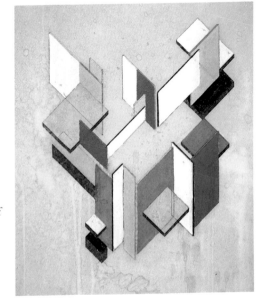

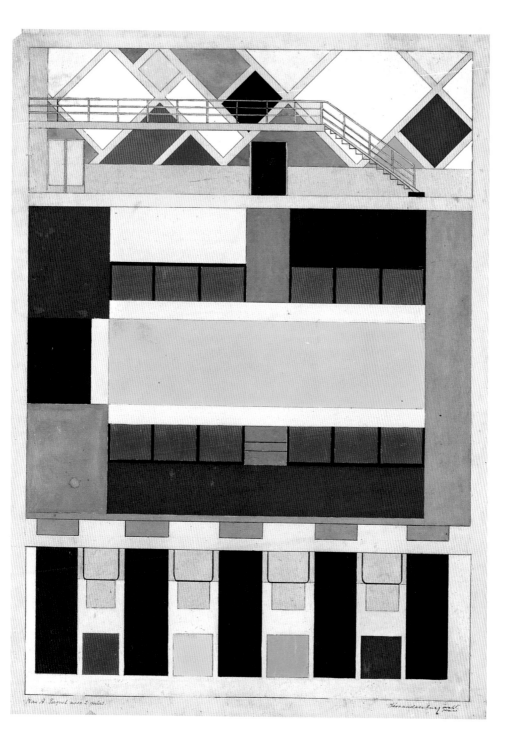

101 The Tussendijken blocks were the most stripped down and standardized of Oud's large Rotterdam estates and received a great deal of attention, particularly in German architectural magazines, although like Spangen they were never published in *De Stijl*. Oud's fellow architects and critics in Holland were often less enthusiastic about his housing. 'Just take a look at a block of flats by him', the architect and critic Jan Gratama wrote in 1922. 'It is forbidding in its deadly monotony.' However, Oud's former De Stijl colleague Wils defended his municipal block as 'taut' and 'finely ruled', praising 'the sobriety and at the same time the sensitivity of the great facade–planes of Oud'.

It must have been a relief for Oud to turn from what he described as 'perpetual workers' dwellings' to a commission he received at the end of 1921 through the Hungarian artist and designer László Moholy-
102 Nagy for a middle-class villa in Germany, where his reputation had by now spread. In spite of the fact that it was never realized, like the earlier ones for Scheveningen and Purmerend, and was for a luxurious house in a prosperous suburb of Berlin, it did provide him with new ideas for his later work at the Rotterdam Housing Authority. These were the use of white rendering (or reinforced concrete) instead of 'dingy and drab brick', and the possibility of giving each working-class family a separate dwelling with a garden, rather than an apartment in a communal tenement block. Although designed to a minimum specification, these were closer to the middle-class houses and villas that many of his European contemporaries were beginning to design at the time. He also took note of experiments in standardized middle-class housing in Holland, like Wils's Daal en Berg estate in The Hague.

In the Rotterdam city development plan, the corner of the Oud Mathenesse *polder*, immediately to the west of the canal that runs past Oud's Spangen blocks, had been reserved for the creation of a small park. With the financial crisis in housing of the early 1920s it was decided to build a temporary estate there for very poor families who had been displaced by slum clearance in the inner city, and Oud was
106 commissioned to design it in 1922. The individual houses were carefully thought out in terms of 'social control'. The kitchens were deliberately small and narrow (as they also were in Oud's later estates) so that they could not be used as living-rooms, a practice considered unhygenic and anti-social in the health, hygiene and fresh–air ideology of housing policies of the period. Although the houses were

128

106 J. J. P. Oud, Oud Mathenesse estate, Rotterdam, 1924. Careful attention was paid to the planting of trees and shrubs, which matured to provide new colour and spatial dimensions. Each house had a small garden or back-yard space.

tiny, sufficient bedrooms were provided (in the loft space of the attics) to encourage separate sleeping arrangements not only for parents and children but also for children of different sexes.

Oud used white-painted walls for the first time, with traditional pitched red-tiled roofs to produce a harmonious, standardized dwelling type which could be repeated in different combinations to create a small community that would thus embody the qualities of 'unity in diversity'. Windows and doors were painted yellow and blue to contrast with the red roofs and white walls. Van Doesburg wrote to Oud on 11 November 1924, recalling their split over the colour schemes for Spangen: 'In spite of the fact that you claimed that you wanted to keep colour out of architecture (which I can understand, if not accept), you now paint all your doors blue, window frames yellow etc.'

The Witte Dorp (White Village), as the estate became known, was well received in the local press, as well as abroad, particularly in Germany and America. *Het Dagblad van Rotterdam* described it as of

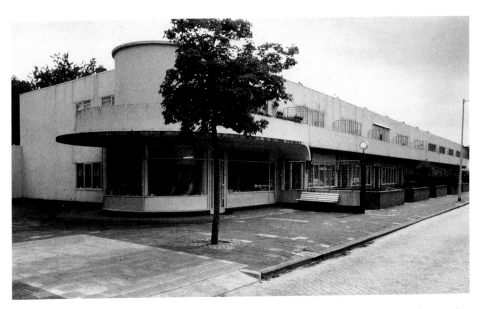

107 J. J. P. Oud, housing at Hook of Holland, 1924. The estate was closer to his 1917 Scheveningen esplanade design (91) than his housing in Rotterdam itself. It is a model of standardization: the terrace could have been extended indefinitely or reproduced as several rows. Smooth lines and dramatically curved shop fronts suggest liners, a marine imagery appropriate for the small fishing and passenger port.

'almost rural picturesqueness'. With its white walls it suggested the qualities of a wind- and salt-honed, white-washed fishing village on the coast rather than a rustic country one. This was an imagery that *107* Oud developed in his next project, the row of houses for workers at Hook of Holland, which had originally been a fishing village.

As semi-permanent materials and building techniques were used to construct Oud Mathenesse the houses deteriorated badly over the years, despite modernization after the Second World War, having continued in use far longer than their intended life of twenty-five years. After many attempts at consolidating the sinking foundations, the Rotterdam municipality finally decided to condemn the estate in the late 1980s, although there was a vigorous campaign to save it.

99 The site-manager's shed was designed for use while the estate was under construction. At the time, the quasi-concentric incised pattern

on its walls (which Oud repeated on the facade of the Café de Unie in Rotterdam in 1925) was condemned as 'decorative' by Van Doesburg, who wanted to exclude these works from the issue devoted to De Stijl by *Architecture Vivante* in 1925. Mondrian also disliked the shed, probably because it was too symmetrical, although this is not very apparent in photographs. Nevertheless through its almost sculptural qualities (at least when photographed from a certain angle), this small temporary building has been reproduced in modernist art histories as one of the seminal works of De Stijl architecture.

The commission for the Café de Unie came to Oud through the Rotterdam Housing Authority. It was on the Calandplein at the end *100* of the Coolsingel at what was the city centre of pre-1940 Rotterdam, (just as the Aubette, which Van Doesburg redesigned two years later, was at the very heart of Strasbourg). Although it has been described as a three-dimensional Mondrian painting, the design is closer to the typographical layout of the cover of *De Stijl* in its new format after 1921. Often dismissed as 'facade architecture', the café was indeed a three-dimensional graphic design intended to seize the attention of passers-by with its bold use of colour and lettering, to draw them across the street to look into the wide plate-glass windows and enter the interior.

Oud's Kiefhoek estate in south Rotterdam was designed in 1925 *108–10* and completed in 1930. The three-bedroom terrace houses were for the poorest workers with large families (six children). They were designed to an extremely economic specification, and were built for a cost of 2400 guilders, the equivalent of £213 at the time. This was half the cost of the concrete terrace housing built at Betondorp in Amsterdam of 1923, and a quarter of the cost of the Schröder house – which was very low for a one-off, architect-designed middle-class house.

Oud had hoped to use concrete as he had at Hook of Holland, but this proved more expensive than brick. His earlier designs for the estate – the plans for which have often been mistakenly published as those actually executed – included coal storage space, serving-hatches between kitchen and living-room, built-in ironing boards, showers under the stairs and running water on the upper floors. All these facilities had to be abandoned in order to keep costs to a minimum. Each house, however, has a back garden which helps to create a sense of privacy. Oud tried to reconcile the ideals of the inhabitants, who

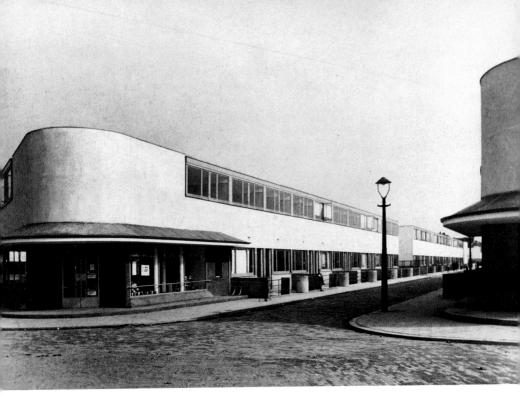

wanted individual houses with gardens, and the housing authorities, who wished to urbanize and 'aculturize' the 'poorest categories' of the working classes by re-establishing 'family values' within an ordered and disciplined community.

The geographical situation of Kiefhoek, among a number of estates built at the same period in south Rotterdam, was quite different from the isolated position of Oud Mathenesse. However, the village-like quality of the plan and the enclosed and secure feeling of the estate (which at the same time appears quite open once inside) separates it from its neighbourhood and most of the other estates around it.

As at Oud Mathenesse (which in many ways served as a prototype) all rooms were extremely small: the entrance hall is tiny, taking up as little space as possible from the living-room, which is at the front of the house. The two were kept separate, with pegs for clothes and space for the gas, water and electricity meters in the hall, 'so that the intrusion of Municipal officials into the living-room is avoided', according to Oud: 'Since there was no possibility of individual

108–10 J. J. P. Oud, Kiefhoek estate and church, Rotterdam, 1925–30. Period (left) and modern views. As at the Hook, many of Oud's preliminary sketches were closer to De Stijl formal ideas than the executed designs, probably because of cost. De Stijl elements can be discerned in the houses for larger families in the side streets (*110*) with their extra bedrooms like separate cells and in the church (*109*), where the massing of volumes at the right of the main entrance is reminiscent of the asymmetrical design for the factory at Purmerend (*3*).

variation, the architecture of the houses was based consequently on uniformity, and the complex as a whole draws its character from proportions and colour grouping.' In the 1980s the estate was restored to what seems to have been the original colour scheme: white walls, egg-yellow window frames and cherry-red doors, with the rounded shop-fronts (less dramatic than at the Hook) painted green.

Kiefhoek was presented to the second CIAM at Frankfurt in 1929 as an example of 'Existenzminimum'. This was a concept frequently extolled in social housing during the late 1920s in Holland and Germany: the provision of the best possible dwelling for the minimum cost. Oud also presented the estate to an English-speaking audience in 1931 in the art and design magazine *The Studio*, in an article entitled 'The £213 house: a solution to the rehousing problem for rock-bottom incomes in Rotterdam'.

Oud designed the New Apostolic Church at Kiefhoek in 1929, waiving his fee. The only decorative feature, the stained glass, was by Huszár. The building was described by the American architectural

109

historian, Henry-Russell Hitchcock, in his short monograph on Oud published in 1931, as 'one of the most beautiful creations of modern architecture'. To other critics it was so plain and neutral that it looked as much like a factory as a church. In Frank Yerbury's *Modern Dutch Buildings* (1931), it was captioned merely as 'Meeting Hall'. By the 1950s even Hitchcock had shifted his position, writing that 'the main auditorium block is so box-like that it holds its place among the rows of houses only by its size, offering no expression whatsoever of its special purpose – it could as easily be a garage.' The church is a focal point in the estate yet at the same time remains visually rather separate from it. Conceived as a symbol of a traditional rural community, but appearing like a factory, garage or meeting hall, the building also suggested urban meanings related to work and collectivity. It thus located the estate within rural/urban discourses current in the architectural debates and social housing policies of the period.

In the summer of 1927 Oud was asked to submit plans for a row of
111,112
five standardized workers' houses for the Weissenhofsiedlung housing project, the international architectural exhibition organized by the Deutsche Werkbund in Stuttgart. Mart Stam was the only other Dutch architect invited to contribute. After ten years at the Rotterdam Housing Authority Oud was at the height of his career. He was probably the best-known Dutch architect of his generation abroad, although his reputation was nowhere near as secure within Holland. He was almost the only architect who kept strictly to the Weissenhof brief for well-constructed workers' houses at minimum cost. Most of the other houses, like those by Le Corbusier, were designed much more luxuriously. Oud's design for the kitchen, to a much fuller specification than for any of his Rotterdam estates, had built-in cupboards, standard-height working surfaces, sinks and draining-boards. It was designed in collaboration with Erna Meyer, who had attended Van Doesburg's De Stijl Course in Weimar (see Chapter 9) and had published a best-selling handbook of good housekeeping in 1926, *Der Neue Haushalt, ein Wegweizer zu Wirtschaftlicher Hausführung* (The New Household, a Guide to Economical Household Management), which went through thirty reprints in a year. The kitchen was a major contribution to the debates about the standardized modern kitchen in Germany in the late 1920s. (The well-known 'Frankfurt Kitchen' had been designed by Greta Schütte-Lihotzky in 1926 for Ernst May's standardized municipal housing in Frankfurt.) Oud and Meyer took note of the views of

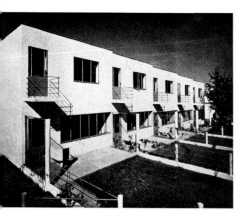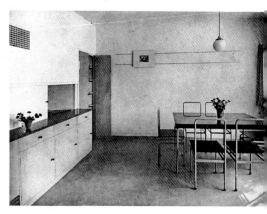

111, 112 J. J. P. Oud, terrace houses, Weissenhofsiedlung exhibition, Stuttgart, 1927. Period photograph; living-room, from *L'Architecture Vivante* spring 1928. The houses had showers and water upstairs, unlike the Keifhoek estate. There was a separate room for washing clothes, as recommended by the advocates of the 'new kitchen' in Germany. One of the serving-hatch doors between the kitchen and dining/living-room was made of mirror glass. This could be angled so the housewife could see into the living-room and out into the garden at the front to keep an eye on the children at play.

housewives. Oud, indeed, had earlier written an article for *i10* entitled 'Housewives and Architects', which was followed by proposals for functional housing for the Weissenhofsiedlung by the Professional Organization of Housewives.

The birth of the 'International Style' in architecture has generally been dated from the Weissenhofsiedlung although internationalism had been an issue in modernist architecture since at least the mid-1920s and Gropius's *International Architektur* had been published in 1925. Paradoxically, despite the internationalism of the International Style, every country had its own particular regional variant, especially Holland. The Dutch version was known as the *Nieuwe Bouwen* (New Building) – deliberately employing the vernacular word for building rather than architecture, to imply a social rather than an individualistic aesthetic role and to avoid giving undue privilege to architects. The most politically committed of these, J. B. van Loghem, Ben Merkelbach and Stam, went to work in the Soviet Union for a time and regarded De Stijl as a manifestation of 'bourgeois formalism'.

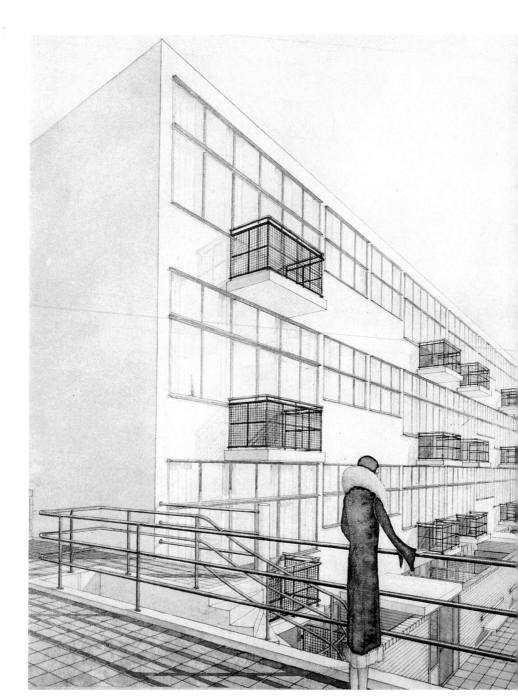

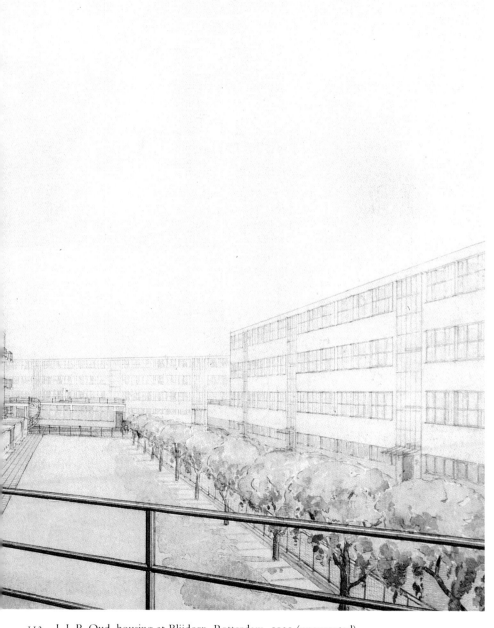

113 J. J. P. Oud, housing at Blijdorp, Rotterdam, 1931 (unexecuted).
Perspective. Blijdorp was a huge scheme for working-class housing, although in
Oud's drawing a fashionably dressed woman is depicted gazing across well-
manicured gardens.

Of the artists who had been associated with De Stijl only Van Eesteren became fully engaged with the New Building. Oud, an inveterate 'non-joiner' was, nevertheless, respected for his housing work at Rotterdam. Rietveld remained on its periphery, unjustly regarded as something of an exclusive architect, although considered a fertile source of innovative ideas.

Kiefhoek and Weissenhof were Oud's last housing projects to be built. In 1931 he produced designs for a large estate in Blijdorp, an area to the north of Rotterdam's centre where a comprehensive plan for new housing was being developed. These, however, were never executed. His design consisted of a series of long rows of four-storey apartment blocks with cantilevered balconies and continuous rows of large windows. In terms of 'social engineering' they were closer to the urbanism of the apartment blocks at Tussendijken than to the village-like housing at Kiefhoek. However, unlike the earlier estates, here the blocks were to be open-ended rows (*strokenbouw*), in accordance with the principles of openness and avoidance of closure favoured by the architects of the New Building. Oud's design had apartments on the ground floor with their own gardens encroaching onto the public open space between the blocks, as in his earlier enclosed estates at Tussendijken. This was not in line with the more militant ideas about social collectivity prevalent among the New Building architects in the early 1930s. The commission passed to a more 'ideologically correct' New Building architect, J. H. van den Broek. Oud's scheme exists only in plans and a few hypnotically compelling pen and colour-wash drawings. In early 1933 he left the Rotterdam Housing Authority, which was re-organized under another name.

Through his association with De Stijl and the fame of his Rotterdam work Oud had gained an important international reputation while still in his thirties. His social housing was widely published and discussed abroad, particularly in Germany and the USA but also in England and France. His contribution to the Weissenhofsiedlung consolidated his reputation and established his claim to be considered one of the major masters of the International Style. He was described in *The Studio* in 1933 as 'perhaps the best-known contemporary Dutch architect whose designs for flats and workmen's dwellings have achieved a world-wide celebrity'. In his monograph Hitchcock called Oud 'an architect of the first rank'. In *The International Style*, which Hitchcock wrote with the architect Philip Johnson to accompany the influential exhibition of the same

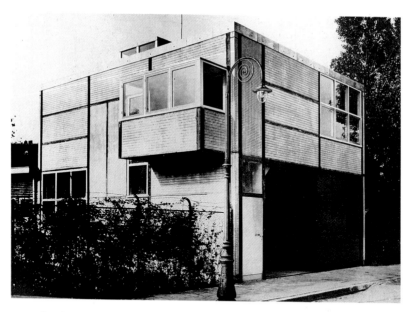

114 Gerrit Rietveld, Chauffeur's house, Utrecht, 1927. Period photograph. The exterior was painted black overlaid with a pattern of small white circles applied through a perforated steel sheet, creating a *pointilliste* effect of luminous grey from a distance.

title at the Museum of Modern Art, New York, in 1932, Oud was named as one of 'the four leaders of modern architecture', with Mies van der Rohe, Le Corbusier and Gropius. However, his international reputation did not survive his change of style in the later 1930s, when he introduced ornamental elements into his designs, and it has only recently begun to rise once more.

Rietveld regarded the Schröder house as an experiment which could feed into his 'ordinary' work, like the early experimental furniture to which it has often been related. He believed he could use the experience gained in what was by necessity less 'pure' work, just as he used ideas tried out in his experimental furniture in later designs for batch production. The Schröder house, described by a critic in the mid-1920s as 'the prototype of future housing', was not a prototype for working-class housing. Rather, it was a model for middle-class

139

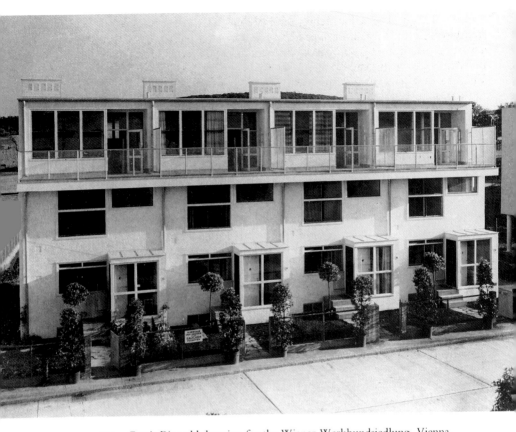

115 Gerrit Rietveld, housing for the Wiener Werkbundsiedlung, Vienna, 1930–32. Here, outside Holland, Rietveld was able to realize his only working-class housing before the 1950s. Designed to a minimum specification with a ground area of *c.* 4 × 8 m, each house was only 1 room wide. Space was saved with a tiny spiral staircase and minimal landings and corridors.

living in reduced circumstances, increasingly common later in the century. Many features first tried out there were incorporated in later designs, particularly that of the open, transformable living space, which could also be modified and adapted to suit working-class families.

114 In 1927 Rietveld was commissioned to design a garage in Utrecht with an apartment above for the chauffeur and his family. Although a

unique design, the Chauffeur's house was like a prototype for standardized housing, built of prefabricated concrete slabs slotted into a framework of steel I-beams. The house was illustrated in *De Stijl* and in *i10* in 1927, with a short description of its construction by Rietveld. This modest accommodation was designed with almost as much ingenuity and care as the Schröder house and became almost as well known. However, the method of construction was unsatisfactory: the house leaked badly, necessitating substantial alterations.

Rietveld and Mrs Schröder collaborated on a number of designs for standardized housing, including some intended as working-class dwellings. In these the living, dining and kitchen areas were planned as a single open space which could be closed off by sliding partitions. As in the Schröder house there were also separate private rooms: a bedroom and a study. But none of these were realized. The collaborative works actually built were for middle- rather than working-class clients, like the row of speculative terrace houses in the Erasmuslaan opposite the Schröder house, where Mrs Schröder was both collaborator and client. However, such designs could be adapted to mass housing, and they were illustrated and discussed as such as in the New Building magazine, *8 en Opbouw*. They were based on a one-metre module with the staircase and utilities grouped vertically, following the 'core' idea, to keep them separate from the living and sleeping areas. The ground floor contained the kitchen and a dining/living space. This could either be opened out completely or divided by partitions which folded like an accordion. Above were two floors of bedrooms. For these and many of his later houses Rietveld designed very wide, deep windows, which flooded the living-rooms and the bedrooms with light – much more generous than in comparable designs by Oud, who was parsimonious in his use of glass, describing it in one of his early articles as a 'luxury'. Rietveld believed that a free use of glass need not be associated with luxury. He also incorporated large windows into the lower middle-class housing he designed for Robert Schumannstraat in Utrecht, 1932, and five terrace houses for low-income families for the Wiener Werkbund-siedlung in Vienna, 1930, a building exhibition of model housing based on the Weissenhofsiedlung.

Some of the ideas about flexibility first tried out in the Schröder house and later incorporated in Rietveld and Mrs Schröder's Erasmuslaan housing were adapted for workers' houses by New Building architects. In the blocks designed by Van den Broek for

115

Blijdorp in Rotterdam the apartments had sliding partitions which enabled rooms to be opened out into one large space or divided into smaller spaces. Similar ideas were used in the first block of high-rise working-class apartments in Holland designed by Brinkman, Van der Vlugt and Van Tijen in Rotterdam in 1933–4, which also had sliding glazed partitions and folding beds. A model apartment was supplied with Rietveld furniture by Metz.

The more radical of the New Building group saw this use of 'flexible space' as a defeat, or at least a compromise in the struggle against the tenacious hold of the traditional 'bed alcove' on the Dutch working-class, particularly in Rotterdam, where these continued to be built until 1937. For what, they argued, was the adaptable living space but a modernized version of the unhygenic bed-alcove in the living room? Furthermore, a transformable living space resulted in inadequate separation among these different functions. This might be acceptable to the well-off Mrs Schröder and her particular family circumstances, but might not at all suit a working-class family with the father on shift-work.

In 1936 Rietveld designed the Bioscoop cinema in the centre of Utrecht, with apartments above, the top one of which he rented for himself and his family. Here he made one large space with only a lavatory, shower and a small bedroom for his wife and himself separate from the main living area. The children slept in bunk beds along the walls concealed behind a curtain (like bed-alcoves). This, rather than the transformable space of the Schröder house, was Rietveld's own preferred way of living – a forerunner of the 'loft' of the 1980s and 90s.

None of Rietveld's ideas for low-cost social housing were accepted in the years between the Wars. (His only commission for public housing came much later in the 1950s.) In the 30s his practice consisted almost entirely of middle-class villas and summer-houses. Sometimes he designed these with pitched roofs or occasionally thatch and barge-boarding, shocking the hard-liners of the New Building. It was only in the 1950s that Rietveld began to command an international reputation, based largely on his early furniture and the Schröder house of thirty years before. In the foreword of the 1966 edition of *The International Style*, Hitchcock wrote: 'Hindsight suggests that Holland might have been better – or also – represented by Rietveld than by Oud.'

After collaborating with Van Doesburg on the Rosenberg 1923 exhibition, Van Eesteren worked on a number of domestic projects in Holland, most of them unrealized, and several competition designs. A *103* Corbusier-like skyscraper block was illustrated in the Tenth Anniversary issue of *De Stijl*, although by this time he and Van Doesburg had fallen out. Van Eesteren also designed (with L. G. Pineau) a proposed redevelopment of Paris with skyscrapers on either side of the Madeleine. He was to develop such modernist ideas in his career as a town planner in Amsterdam between 1929 and 1959. Another competition design, for Unter den Linden in Berlin, 1925, was awarded a prize but not executed. Here he anticipated methods of grouping large blocks that emerged in the 1950s.

Since nothing came of Van Eesteren's competition entries he took a job as assistant to Wils from 1924 to 1927, working on the design of the Olympic Stadium in Amsterdam, and in 1929 was appointed architect to the Amsterdam Urban Development Department, which had been set up in 1928 by the city council to prepare and co-ordinate the expansion of the city along 'scientific' lines. The director and his associates were social scientists. Van Eesteren, who had studied town planning with Pineau in Paris, was the only member of the team to have any practical architectural background or knowledge of town planning. (He was later appointed head of the town planning section.) After conducting extensive research into population growth and the need for housing, traffic routes, green space and other facilities, the Department produced the General Expansion Plan (AUP) for west Amsterdam in 1935, designed to meet urban expansion needs until the year 2000. The AUP became a model for urban planning all over the world.

It was probably Van Eesteren's experience and contacts in France and Germany, as much as his association with De Stijl, that were instrumental in his meteoric rise in CIAM, where he was elected president at its third congress in Brussels in 1930. Here, urban planning was promoted as the basis of the modern architectural environment. This was to have a great effect on post-war European reconstruction and was a major factor in the dominance of international modernist architecture in the 1950s and 60s. Through Van Eesteren's later career, De Stijl had, in many ways, its greatest impact on the development of modernism in twentieth-century architecture and urban planning. However, many of the most characteristic of De Stijl architectural ideas – smallness of scale and

143

intimacy of aspect, as in Rietveld's Schröder house, Wils's Daal en Berg estate and Oud's Kiefhoek – were elided into the megalithic vision of the modern city of Van Eesteren, who has been described as 'the urban planner who revolutionized the practice of *building cities* and restructured the practice of architectonic design'.

In trying to solve the problems of mass housing after the War, Dutch architects like Jan Bakema, Van den Broek and Van Eesteren planned new urban quarters on a vast and inhuman scale. They used slab blocks and standardized units, often transcribing literally formal solutions from De Stijl paintings, like Van der Leck's abstract compositions or Van Doesburg's *Rhythm of a Russian Dance*, into three dimensions on an enormous scale, as the architectural critic Richard Padovan has pointed out. The city was treated like a huge relief sculpture. The pedestrian scale at which the city is experienced by its inhabitants – that of the individual housing unit and its relation to its neighbours – was completely ignored.

While Rietveld and Mrs Schröder began from the floor plan, later Dutch modernist architects and planners started from the city plan. De Stijl artists and architects stressed the universal and the collective rather than the individual (which they considered had been too much emphasized in the past), but they always advocated a balance between the two. This balance Oud and Rietveld strove to retain in their housing designs of the 1920s and 30s.

116 Theo van Doesburg, 'La Cité de Circulation', 1924–9. Although producing utopian designs for tall buildings in the late 1920s, he believed it was a mistake to want to renew cities completely, as Le Corbusier had projected, 'because we do not know in which direction life will develop'.

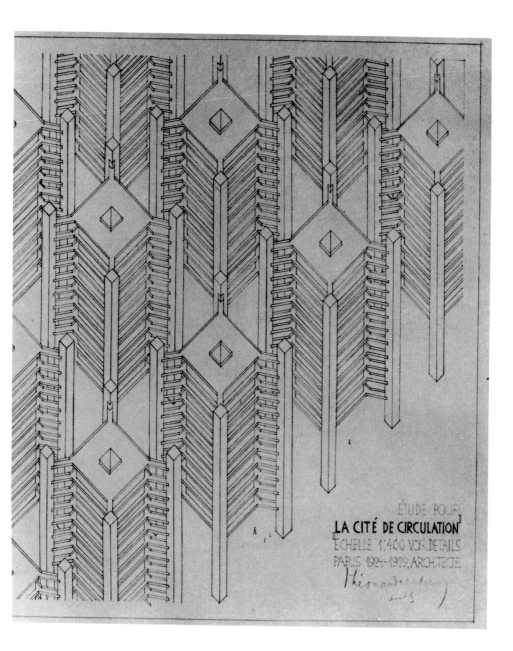

ÉTUDE POUR
LA CITÉ DE CIRCULATION
ECHELLE 1:400 VOIR DÉTAILS
PARIS 1924-1929, ARCHITECTE

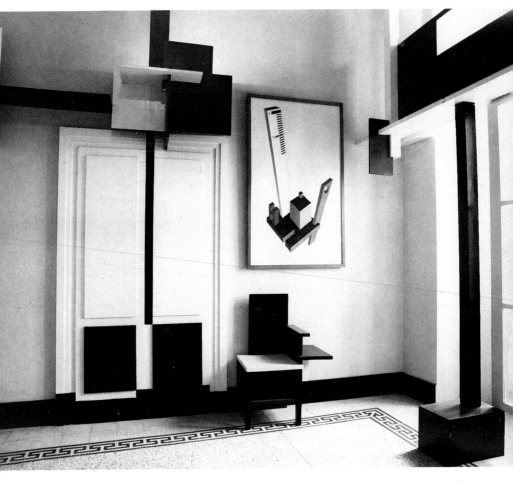

117 Ivan Panaggi, interior from the Casa Zampini, Macerata, 1925–6. In the
1920s Futurist designers like Panaggi and Virgilio Marchi produced interiors and
furniture that were close to De Stijl.

The Machine Aesthetic and European Modernism

Since the 1930s De Stijl has been positioned in modernist art and architectural histories as the link between the pre-1914 avant-garde of Cubism and Futurism and the post-1918 modernism of geometric abstraction and International Style architecture. In the 1950s and 60s architectural critics like Bruno Zevi and Reyner Banham ratified and extended such readings in more sophisticated historical narratives. Banham claimed that the 'theorists' of De Stijl had 'transmogrified' the romantic and anarchistic enthusiasm for the machine of the pre-war Futurists into the concept of 'machinery as the agent of collective discipline'. He argued that 'they seem to have the best right to be considered the true founders of that enlightened machine aesthetic that inspired the best work of the twenties.'

The machine had not occupied an especially important place in the early writings by De Stijl artists, although Van Doesburg had used it as a symbol of the 'spirit of the age' as early as November 1917 in a lecture, 'De stijl der toekomst' (The Style of the Future), written immediately after *De Stijl*'s first issue was published. During the first three years of De Stijl the importance of the machine and mechanization for the visual arts had been mainly emphasized by the architects, especially Oud and to a lesser extent Van 't Hoff and Wils, deriving their argument from the writings and practice of Wright as much as from the Futurists. Oud pointed out that all parts of Wright's Robie house, including the furniture, were machine-made, like the parts of a mass-produced car. 'The architect of today is no longer constantly present on the site during construction, he merely comes to supervise . . .', he wrote in *De Stijl* in February 1918. 'It is in his office that he establishes the form and proportions of the building, which is then delegated to others for execution.'

For Oud a building was a standardized realization from drawings, which could be reproduced many times. In the May 1918 issue of *De Stijl* he argued that by employing the products and methods of mass production in an aesthetic as well as a functional manner 'the architect

appears here as a producer, as the person who stages mass products in an architectural setting, i.e., through the art of relationships.' Oud believed standardization would produce cheaper, quicker and more efficient construction methods, obviating the need for specialized labour, which was in short supply in Holland during and immediately after the War. He also believed it could create a new kind of harmony and beauty close to that of modern painting. By using standardized materials the architect would design buildings in a similar way to that in which Mondrian, Van der Leck, Huszár and Van Doesburg constructed their paintings from 'standardized' elements (squares, rectangles, primary colours). The individual elements would be subordinated to the totality yet remain discrete, in line with the De Stijl aesthetic and social ideology.

After the War Oud revisited Germany, going to Berlin in 1919,

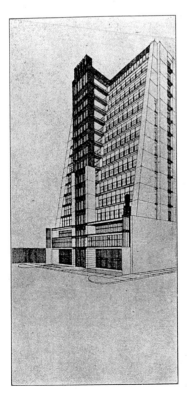

118 Antonio de Sant'Elia, Casa a Gradinate, from *De Stijl* (vol. 2, no. 10) August 1919. Marinetti sent Van Doesburg photographs of drawings by this Futurist architect who had been killed in the First World War. Their publication (with a commentary by Van 't Hoff) in *De Stijl* had a powerful impact on the development of modern architecture.

119 I. K. Bonset, from *De Stijl*, Tenth Anniversary issue, 1928, actually Nelly van Doesburg made up as a man, dressed in flying helmet and leather jacket – unmistakable signifiers of a Futurist persona. In his writings, however, Bonset is presented more as a Dadaist.

148

and at the end of that year began to write in *De Stijl* about architecture in a European rather than a purely Dutch context. Then and later he argued for an architecture of 'early Classical purity' which would abolish the distinction between art and utility, and he quoted the Belgian architect Henry van de Velde on the similarity between a Greek temple and the modern functional design of a liner. The new style would correspond to the 'general impetus of the spirit of the age' as found in 'our daily life', in railway locomotives and motor cars, in electrical and sanitary goods, in machinery in general and in sportswear and men's clothing. Such enthusiasms are found in the writings of German architects associated with the Werkbund like Hermann Muthesius just before 1914, and predate the discussion of these ideas by Le Corbusier and Ozenfant in the magazine *L'Esprit Nouveau*, which first appeared in October 1920. The reference to men's clothes is probably derived from the Austrian architect and designer Adolf Loos, who singled these out as well-designed modern artifacts in essays published at the turn of the century. Oud also no doubt drew on the writings of the Futurists: in the January 1920 issue of *De Stijl* he commented on photographs of two designs for a radio station and a standardized apartment building by the Futurist architect Mario Chiattone.

For Oud technical perfection rather than the slight imperfections of the hand-made article (i.e., the artist's touch), is the hallmark of the new aesthetic sensibility. Modern aesthetic beauty, he concluded, depends no longer on 'sensuous' values like ornament, but on more 'spiritual' values such as relationship, clarity of form and pure colour, which can be achieved by machine production.

Mondrian may have known the Futurist leader Marinetti while working in Paris before the First World War, and after his return there in 1919 they often met when Marinetti was in Paris promoting post-war Futurism. In a number of letters from Paris, Mondrian urged Van Doesburg to invite Marinetti to contribute to *De Stijl* and *118* himself wrote about Futurist 'noise music' for it in August and September 1921. Altogether, his essays of the early 1920s contain many positive references to Marinetti and Futurism, and in 1922 Marinetti presented him with an autographed copy of his 1913–19 Futurist poems, dedicated 'affectionately to the creator of Neo-Plasticism'. This was one of the few books Mondrian kept until his death.

Van Doesburg had a long-standing interest in Futurism and had

been a subscriber to the Futurist manifestos for many years, possibly since 1912. He learnt Italian in Leiden in 1916 so that he could read Futurist manifestos and other writings more easily, and had further lessons in 1919 in order to summarize, comment on and liberally quote in translation a number of post-war Futurist manifestos in *De Stijl*.

Early in 1921 he met Marinetti for the first time, in Milan. He now saw Futurism as the forerunner of Dadaism in its destructive tendencies and its implacable hostility to the old, and began increasingly to emphasize the importance of the destructive element in his own writings. Later that year he introduced Futurism as a movement which attacked the old and cleared the way for the new in the Dutch magazine *Het Getij*, of which he had recently become arts editor, and reprinted three Futurist manifestos. At about this time Van Doesburg also adopted the pseudonym Aldo Camini, which it has been suggested signifies 'the old must go' (*aldo* meaning 'old' or 'the eldest' in Italian, and Camini being derived from *camminare*, 'to go'). His poetry, which he published in *De Stijl* under his Dadaist pseudonym I. K. Bonset, owed a great deal to Futurist theory and practice. The De Stijl 'Literature Manifesto' (written jointly with Mondrian in 1920) was heavily indebted to Marinetti's 'Technical Manifesto of Futurist Literature' of 1912.

From 1920 Van Doesburg increasingly turned his attention to architecture and its relationship with the modern technological environment. In the April 1920 issue of *De Stijl* he published a photograph of the interior of an American factory, the Bethlehem Shipbuilding Works. He described this in quasi-religious terms in the May issue as a new 'paradise of glass, iron and light', where machines were 'prayers of light and movement in a direct relationship with space'. Factories and department stores were 'the cathedrals of mechanical production and of human life'. In the summer of 1921 he wrote extensively about the 'machine aesthetic' or the 'mechanical aesthetic' – a term which he seems to have originated – in three articles in *Bouwkundig Weekblad*. Between 1921 and 1922 he developed these ideas more fully. In 'Der Wille zum Stil' (The Will to Style), a lecture delivered in spring 1922 in Jena, Weimar and Berlin, and published simultaneously in German in *De Stijl*, he declared that the machine 'represents the very essence of mental discipline . . . mechanics is the immediate balance of the static and the dynamic – the balance of thought and feeling.'

Die eigentliche Sphäre des Films ist die des „bewegten"
Raumes, der „bewegten" Fläche, der „bewegten" Linie.
Bewegt: d. h. Raum, Fläche, Linie vielmals und nach-
einander.

HANS RICHTER FILMMOMENT

Dieser Raum ist nicht architektonisch oder plastisch,
sondern zeitlich, d. h. das Licht bildet durch Wechsel der
Qualität und Quantität (Hell, Dunkel, Farbe), Lichträume,
die nicht voluminös sind, sondern eben nur durch F o l g e
das zum Raum machen, was, wenn man den Zeitverlauf
unterbräche, nur Fläche, Linie, Punkt wäre.
Soweit über die Art des E n t s t e h e n s des Lichtsraums,
über den Charakter des E n t s t a n d e n e n folgendes:
Der Vorgang als Ganzes enthält erst die Qualität: Zeit
dadurch, daß in ihr wieder die Einzelheiten (Rhythmus

und Gegenrhythmus) synthetisch so organisiert sind, daß
das Ganze E i n t e i l b a r ist. Diese Zeiteinheit verhält sich
zum Raum wie eine Raumeinheit zur Fläche.
Die Aufgabe, die besteht, ist also: den Spannungsvor-
gang, der im einzelnen zum Lichtraum führt, zur Grund-
lage im Aufbau des Ganzen zu machen, so daß nicht
eine einfache Summe von Raumeinheiten entsteht, son-
dern eine neue Qualität.
April '23. Berlin.

DE BETEEKENIS DER 4e DIMENSIE VOOR DE
NIEUWE BEELDING '
HENRI POINCARÉ
POURQUOI L'ESPACE A TROIS DI-
MENSIONS?

Les géomètres distinguent d'ordinaire deux sortes de
géométries, qu'ils qualifient la première de métrique et
la seconde de projective; la géométrie métrique est
fondée sur la notion de distance; deux figures y sont
regardées comme équivalentes, lorsqu'elles sont „égales"
au sens que les mathématiciens donnent à ce mot; la
géométrie projective est fondée sur la notion de ligne
droite. Pour que deux figures y soient considérées
comme équivalentes, il n'est pas nécessaire qu'elles
soient égales, il suffit qu'on puisse passer de l'une à
l'autre par une transformation projective, c'est-à-dire
que l'une soit la perspective de l'autre. On a souvent
appelé ce second corps de doctrine, la géométrie quali-
tative; elle l'est en effet si on l'oppose à la première,
il est clair que la mesure, que la quantité y jouent un
rôle moins important. Elle ne l'est pas entièrement
cependant. Le fait pour une figure d'être droite n'est
pas purement qualitatif; on ne pourrait s'assurer

' Voor dit hoofdstuk verzamelen wij uitsluitend alle documen-
ten die op de 4e dimensie betrekking hebben. Als inleiding
drukken wij hier, een der belangrijkste, wetenschappelijke
artikelen van Henri Poincaré af.

120 Hans Richter *Filmmoment*, from *De Stijl* (vol. 6, no. 5) 1923. Van Doesburg
published a number of writings by Richter and Eggeling and illustrations of their
experimental work. He himself also wrote about film.

Van Doesburg attacked hand- or craft-work, assaulting some of the
cherished notions of the Arts and Crafts movement. Far from being
satisfying to the majority of workers who practised it, he claimed,
hand-work debased man to the status of a machine. 'The correct use of
the machine (to build up a culture) is the only path leading towards
the opposite, social liberation.' However, he warned, quality not
quantity was 'the premise for a correct use of the machine'. Here lay
the artist's role, to create what he had christened 'the machine
aesthetic'.

He saw 'the will to style' in painting, sculpture and architecture, in
literature, jazz, the cinema and in functional products. Van Doesburg
cited the standard artifacts admired by avant-garde and modernist
artists and architects from Futurism onwards: iron bridges, loco-
motives, cars, aeroplane and airship hangers, skyscrapers, examples of
which he had illustrated in *De Stijl* since early 1920. He added one
favoured by De Stijl artists and designers – children's toys, pointing
out that 'art is play, and this game possesses its own rules.'

Film was also discussed at some length in 'Der Wille zum Stil'. The
120 writings and experiments of the abstract film-makers Hans Richter
and Viking Eggeling, whom Van Doesburg had met in Germany in
1920, were an important stimulus for his ideas about the machine
aesthetic. 'This specific use of film technique provides pure plastic
painting with a new means of expression which contains an artistic
solution to the problem of statics versus dynamics, of space versus
time', he declared. Such ideas were incorporated later in his theories of
'Elementarism' and 'Counter-Composition' in painting (see Chapter
4). His own most dynamic experiment with colour in architecture
was to be the Ciné-Dancing for the Aubette in Strasbourg (see
Chapter 10). For Van Doesburg, as for many modernists of the first
decades of the twentieth century, film was the potent symbol of the
ultimate machine aesthetic.

'Every mechanism is the spiritualization of an organism', he had
written as I. K. Bonset in *De Stijl* in 1921: by the time he wrote 'Der
Wille zum Stil' the machine had become for him an analogue of
human creativity. The machine aesthetic replaced the theosophically
inspired mysticism that characterized Mondrian's early writings in *De
Stijl*. However, by 1923–4 Van Doesburg was already questioning the
ideas of functionalism and the machine aesthetic: 'Let us not forget
that the progress to functionalism signified the protest against
arbitrary decorations in architecture', he wrote, 'but that nevertheless,
the non-functional, the irrational, the uneconomical, are also
functions essential to life and frequently constitute the living source of
a creative consciousness.'

In 'Vers une construction collective' (Towards a Collective
Construction) – published in 1924 but probably written for the 1923
Rosenberg exhibition – Van Doesburg declared that 'the machine in
art is an illusion like any other'. A year later he announced 'The Death
of Modernism', writing that paintings, buildings and sculptures
'constructed in a totally "different" way, designed according to an
entirely different system of seeing and thinking, are merely extreme
cases which . . . isolate the new from life, and are often in contrast to
it.' The machine aesthetic was replaced by a renewed interest in
'space-time' and the 'fourth dimension'. This, Van Doesburg
believed, could be represented not only by film but also by the
104 constructive use of colour planes in architecture, as demonstrated in
138 the collaborative designs with Van Eesteren he had exhibited at the
139 Rosenberg gallery.

In 1926 Van Doesburg revisited Italy to see Marinetti, who had moved to Rome. He discussed his ideas about Elementarism and Counter-composition with him and the Futurist painters Enrico Prampolini and Giacomo Balla. The results of these discussions are apparent in a number of articles on Elementarism and Counter-Composition in *De Stijl* in 1926–7, which show a renewed interest in dynamism and the abstract expression of movement.

 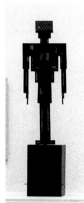

121, 122 Poster for Schwitters and Van Doesburg's Dada tour in Holland, 1923; Vilmos Huszár *Mechanical Dancing Figure* 1917–20, reconstructed 1980s. Van Doesburg would read Bonset's sound poetry, which Schwitters interrupted, barking like a dog. Sometimes Huszár gave demonstrations of his mechanical puppet, while Nelly van Doesburg played piano pieces such as 'Rag-Time' by Eric Satie or 'Funeral March of a Crocodile' and 'Military March of a Termite' by Vittorio Rieti.

Van Doesburg's anarchistic temperament made him naturally sympathetic to Dada. He justified his interest by presenting it as the destructive element which must sweep away the old to make way for the new, which would be inscribed by De Stijl and the machine aesthetic. Sensing that Mondrian would not appreciate a whole-hearted commitment of *De Stijl* to Dada, he used the pseudonymous Bonset as a mouthpiece for his more extreme Dada pronouncements. Oud and Kok, however, were told the secret.

Much of *De Stijl* was given over to works by Dadaist contributors in 1921. In 1922 Van Doesburg launched another magazine entitled

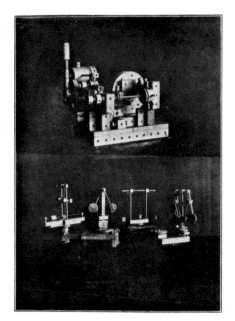

123, 124 Models constructed from Meccano, illustrated in *De Stijl* (vol. 5, no. 5) May 1922; Theo van Doesburg, typography for *Mécano*, including 1922 covers, left. *Mécano* was a single sheet folded in 4 like the instructions for Meccano kits and printed in similar typography. Four issues were published, differentiated by De Stijl colours: yellow, blue, red and white. De Stijl elements resembled standardized Meccano parts. This 'mechanical object, do-it-yourself dynamic children's toy' from *De Stijl* was a miniature engine with machines made from Meccano.

124 *Mécano*, edited by I. K. Bonset (with layout by Van Doesburg). The contents were largely Dadaist, or 'neo-Dada', according to the magazine's subtitle. It was advertised in *De Stijl* in January 1922: 'Mécano, International Periodical for intellectual hygiene, mechanical aesthetic and Neo-Dadaism'. After Van Doesburg began to bring out *Mécano*, fewer Dada items appeared in *De Stijl*.

In 1922 Van Doesburg gave a number of Dada performances in Germany, at Jena, Dresden and Hanover, with Hans Arp, Kurt Schwitters, Tristan Tzara and Raoul Haussmann, while Nelly played *121* the piano under her professional names of Petro van Doesburg. In *122* early 1923 Van Doesburg, Nelly and Schwitters made a Dada tour of Holland.

The Dadaist activity of Van Doesburg more or less ceased after he moved to Paris, in early summer 1923, where his last contribution seems to have been to design sets for Tzara's 'Soirée du coeur à barbe' in July, for which Sonia Delaunay designed the costumes and Nelly played 'Proeven van Stijlkunst' (Examples of Stijl Art) by the Dutch modernist composer Jacob van Domselaer. This evening, which was interrupted by Breton and the Surrealists, is often considered to mark the formal end of Dada as a movement.

1922

GÉRANT LITÉRAIRE: I. K. BONSET

C — A—I—N—O

E — M

No

No / [White, Blanc,] [Wit, Wed]. 1923

4 — 5
en

ADMINISTRATIE: UTR. JAAGPAD 17, LEIDEN (HOLLAND)

1923

HOLLAND'S
BANKROET
DOOR DADA

N B T Thuisbezorging zonder prijsverhooging

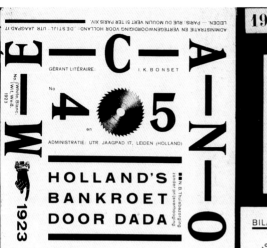

Et je trouve qu'on a en tort de dire que le Dadaisme, le Cubisme, le Futurisme, reposaient sur un fond commun. Le deux dernières tendances étaient surtout basées sur un principe de perfectionnement technique ou intellectuel tandis que le Dadaisme n'a jamais reposé sur aucune théorie et n'a été qu'une

Protestation

(Tristan Tzara)

Dada est la force désintéressée, ce n'est pas une maladie, pas une énergie pas une vérité.

Evola

Waar het hart leeg van is loopt de neus van over.

Bonset

C — A—I—N
E — M — O

No Gelb, Yellow 1922

No Jaune, Geel 1922

GÉRANT LITÉRAIRE: I. K. BONSET MÉCANICIEN PLASTIQUE: THEO VAN DOESBURG

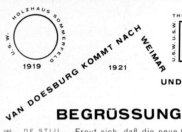

MÉCANO

AAN DE ADMINISTRATIE
„DE STIJL"
HAARLEMMERSTR. 73ᴬ
LEIDEN
Holland

BILANZ DES STAATLICHEN BAUHAUSES WEIMAR

HOLZHAUS SOMMERFELD

U.S.W.

1919

VAN DOESBURG KOMMT NACH WEIMAR

1921

THEATER JENA

U.S.W. U.S.W. U.S.W. U.S.W.

1922

UND

Nur das □ des Stijls ist gesetzlich geschützt

DE STIJL
1916
HOLLAND
1923

Paris 1923

BEGRÜSSUNG

Freut sich, daß die neue Gestaltung in der Malerei (NEO-Plasticismus) schon einen derartigen Einfluß auf die Kunstentwicklung Europas ausübt.

THEO VAN DOESBURG
P. MONDRIAN
C. VAN EESTEREN

SCHON VIELE BENUTZEN
DAS □ ☞

ABER nur wenige

VERSTEHEN ES

Van buiten kwadraat van binnen Biedermeier

Van Doesburg's relationship with the Bauhaus in Weimar has been the subject of much controversy and argument. Nevertheless, the impact at approximately the same time of Dutch and Russian modernism, largely through Van Doesburg and El Lissitzky's influence, was undoubtedly instrumental in bringing about the change in Bauhaus teaching methods and attitudes from craft-based ideas to the machine aesthetic and mass production, which occurred around 1923. Van Doesburg visited the Bauhaus at Gropius's invitation, spending several days there in late December 1920 and early January 1921. 'At Weimar I have radically overturned everything', he boasted to Kok in a letter of 7 January. 'This is the famous academy, which now has the most modern teachers! I have talked to the pupils every evening and I have infused the poison of the new spirit everywhere.' He announced that '*De Stijl* will soon be published again and more radically' (the first issue in the new format was about to appear). Probably he hoped that Gropius would offer him a post. Gropius may even have hinted at this during his first visit, perhaps withdrawing the offer after having seen his more aggressive and disruptive side when he returned to Weimar in the spring of 1921.

He remained in Weimar, on and off, until early 1923, supported mainly by Gropius's partner, Adolf Meyer, the younger members of the Bauhaus staff and the more radical of the students. He gave lectures in the town, which attracted large audiences, held regular receptions for Bauhaus students and teachers on Saturdays, and between March and July 1922 ran a 'Stijl course'. His declared aim was to promote a more systematic and less individualistic manner of working and teaching than that in operation at the Bauhaus at the time, dominated as it was by Expressionist and craft ideas which Van Doesburg bitterly attacked in his lectures and seminars. The Stijl course, which took place on Wednesday evenings, consisted of an hour of practice and an hour of theory. A number of the Bauhaus teachers and many students attended or contributed to this.

When Gropius grew disenchanted with Van Doesburg he turned to Oud for information on new ideas in Dutch art and architecture, writing to him on 15 October 1923 that he wished to 'make direct contact with Dutch architecture' and in particular with Oud's own work. As with Van Doesburg, it was Meyer who took the initiative. He arranged the translation into German of Oud's 'architectural programme', 'Over de toekomstige bouwkunst en hare architectonische mogelijkheden' (On Future Architecture and its Architecto-

125
126

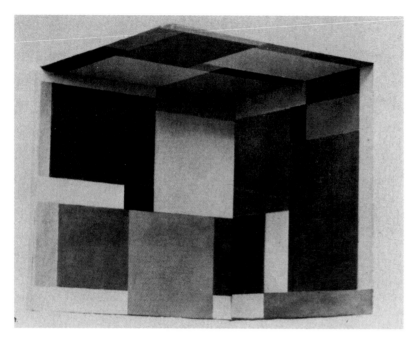

125, 126 Max Burchartz *Study for Colour Composition in Three Dimensions, c.*
1922; Werner Gräff, drawing of a motor bike, from *De Stijl* (vol. 5, no. 12)
December 1922. Among Van Doesburg's followers at the Bauhaus were Burchartz
and Gräff, who attended his 'Stijl course' in Weimar. Burchartz translated
Mondrian and Van Doesburg's Bauhaus books into German. His *Study* may be
compared with Mondrian's design for Ida Bienert (*83*). Gräff contributed stylized
geometric designs for motor bikes and cars to *De Stijl* and a manifesto, 'For the
New'.

nic Possibilities). This essay, originally given as a lecture in Rotterdam and published in Dutch in *Bouwkundig Weekblad* in 1921, appeared in the German magazine *Frühlicht* in summer 1922. It has been described by Banham as 'the first major theoretical pronouncement by any of the leading architects of the mainstream of development in the twenties.' However, most of its ideas had already been published in Oud's earlier contributions to *De Stijl*. What was important was that it appeared in German and hence reached a much wider and more influential European audience.

Oud was invited to deliver a lecture on modern Dutch architecture (which he had given in Holland in March 1923) as part of the programme of the 'Bauhaus Week' in August 1923, accompanying an exhibition of Bauhaus work since 1919. It later appeared in a volume of Oud's essays on modern Dutch architecture, published in the series of Bauhaus books edited by Gropius and Moholy-Nagy that included *127* volumes by Van Doesburg and Mondrian.

158

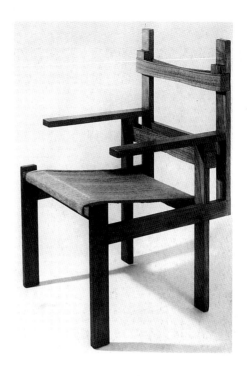

127 Theo van Doesburg,
jacket for Bauhaus Book No. 6,
1925

128 Marcel Breuer, chair,
1923. Although Rietveld
furniture was not exhibited at
the Bauhaus (as often stated), it
was well known from
illustrations in *De Stijl* and Van
Doesburg's lectures there. It
clearly impressed furniture
school students like Breuer, who
became a Bauhaus teacher, an
architect and a furniture
designer.

Van 't Hoff had sent photographs of works by De Stijl artists and architects to Russia in 1918–19. In April 1919 *De Stijl* reprinted a report from the German art magazine *Das Kunstblatt* about plans for the re-organization of art institutions in Russia by Vasily Kandinsky, under the direction of the Soviet Commissar for education and culture, Anatoly Lunacharsky. By September Van Doesburg was in correspondence with the Dutch painter Chris Beekman, who had been in contact with Malevich since about 1917. 'Of course I am looking forward to communication with our Russian colleagues', he wrote: 'Will their works still remain under the aegis of Expressionism, or will they have progressed? Russia is the only contact which we have missed.' It was not until the June 1921 issue of *De Stijl* that he could write of 'a radical school of artists' working in Moscow, which included Ivan Puni, Alexander Rodchenko, Liubov Popova, Varvara Stepanova and Olga Rozanova, reproducing their work in the September 1922 issue. He made personal contact with the Russian avant-garde in April 1922 while he was in Berlin to deliver his lecture 'Der Wille zum Stil': Kandinsky, who had recently left Russia and

129
130

was shortly to take up a post at the Bauhaus; Lissitzky, who was to be his most important Russian contact, and several other artists who were there in connection with the 'First Russian Art Exhibition', which was to be held at the Van Diemen Gallery that October. This was the first exhibition of avant-garde Russian art in the West. It was shown again at the Stedelijk Museum in Amsterdam between 28 April and 28 May 1923. Lissitzky accompanied the exhibition to Holland and gave lectures in a number of cities, where he met many Dutch artists and architects, including Oud, whose Rotterdam housing he admired, Huszár and Van Eesteren.

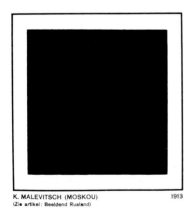

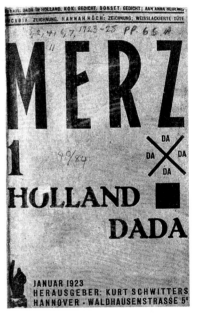

129, 130 Title-page of *De Stijl* (vol. 5, no. 9) September 1922, illustrated with Malevich's *Black Square* (1915); cover of *Merz* (no. 1) January 1923. Works by Rodchenko, Popova and Puni were also reproduced in this *De Stijl* issue. The first number of Schwitters' Dadaist magazine *Merz* focused on 'Holland Dada'. The diagonal cross with 'Da' printed between its arms forms an abstracted logo of the sails of a windmill, the traditional power source of Dutch hydraulics, the 'mechanical' that opposes, harnesses and tames the 'natural'. The black square forming the windmill's base also perhaps refers to Malevich's square.

DE STIJL

MAANDBLAD VOOR NIEUWE KUNST, WETENSCHAP EN KULTUUR. REDACTIE: THEO VAN DOESBURG. ABONNEMENT BINNENLAND F 6.-, BUITENLAND F 7.50 PER JAARGANG. ADRES VAN REDACTIE EN ADMINISTR. KLIMOPSTRAAT 18 'SGRAVENHAGE (HOLLAND).

5e JAARGANG No. 6. **JUNI 1922.**

EL LISSITZKY

PROUN

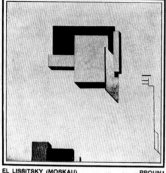

EL LISSITZKY (MOSKAU) PROUN·

Nicht Weltvisionen, SONDERN — Weltrealität
Proun nannten wir die Haltestelle auf dem Aufbauwege der neuen Gestaltung, welche auf der von den Leichen der Gemälde und ihren Künstlern gedüngten Erde entsteht. Das Gemälde stürzte zusammen mit der Kirche und ihrem Gott, dem es als Proklamation diente, zusammen mit dem Palais und seinem König, dem es zum Throne diente, zusammen mit dem Sofa und seinem Philister, dem es das Ikon[1] der Glückseligkeit war. Wie das Gemälde: so auch sein Künstler. Die expressionistische Verdrehung der klaren Welt der Dinge durch die Künstler der „Nachbildenden Kunst" wird sowohl das Gemälde als auch seinen Künstler nicht retten, sondern bleibt eine Beschäftigung für Karikaturenschmierer. Auch die „reine Malerei" wird mit ihrer Gegenstandslosigkeit die Vorherrschaft des Gemäldes nicht retten, doch beginnt hier der Künstler mit seiner eigenen Umstellung. Der Künstler wird vom Nachbilder ein Aufbauer der neuen Welt der Gegenstände. Nicht in der Konkurrenz mit der Technik wird diese Welt aufgebaut. Noch haben sich die Wege der Kunst mit denen der Wissenschaft nicht gekreuzt.

■

Proun ist die schöpferische Gestaltung (Beherrschung d. Raumes) vermittels der ökonomischen Konstruktion des umgewerteten Materials. ▬

Der Weg des Proun führt nicht durch die engbegrenzten und zersplitterten wissenschaftlichen Einzeldisziplinen — der Aufbauer zentralisiert alle diese in seiner experimentellen Erfahrung.

Die Gestaltung außerhalb des Raumes = 0. Die Gestaltung außerhalb des Materials = 0.

$$\frac{Gestaltung}{Material} = \frac{Masse}{Kraft}$$

Das Material bekommt Gestalt durch die Konstruktion. Zeitgemäße Forderung u. Ökonomie der Mittel bedürfen einander wechselseitig.

■

[1] Heiligenbild.

131 Title-page of *De Stijl* (vol. 5, no. 6) June 1922, with the opening of Lissitzky's 'Proun' article and an illustration. Later in 1922 a de luxe double issue of *De Stijl*, printed on special paper in Berlin, was devoted to Lissitzky's abstract, typographical children's tale *The Story of Two Squares*.

In the June 1922 issue of *De Stijl* Van Doesburg published Lissitzky's article 'Proun', which Lissitzky described as the 'interchange station between painting and architecture' and the 'annulment of the divorce between art and life'. This was clearly close to Van Doesburg's own ideas about painting applied to architecture, which he was propagating through De Stijl. *131*

By the middle of 1924 the two men had become aware of divergences in their views, no doubt exacerbated by their personal ambitions. This eventually ended in complete antipathy, with Lissitzky bitterly attacking Van Doesburg in print and he replying with crude invective in *De Stijl* in 1927.

Lissitzky visited Holland again in 1926, when he was taken by Stam, who had become his closest Dutch contact, to meet Rietveld

and see the Schröder house. According to Lissitzky's widow, Sophie Lissitzky-Küppers, he made sketches of 'many exciting possibilities suggested to him' by the house, which he used in his teaching at Vkhutemas (the re-organized art and design schools in Russia). He wrote about the Schröder house and other designs by Rietveld and Schröder in an article for a Russian publication in 1926. Photographs and drawings of the house were exhibited at the first (and apparently only) exhibition of international modern architecture in Moscow in 1927.

Van Doesburg's relationship with Moholy-Nagy remained less competitive than with Lissitzky (despite the fact that Moholy-Nagy was appointed by Gropius to the Bauhaus teaching post which Van Doesburg had probably coveted) and continued until Van Doesburg's death. Moholy-Nagy's important article 'Production and Reproduction' was published in the July 1922 issue of De Stijl, illustrated with works by him and two other Hungarian artists, László Péri and Lajos Kassák, who was also a typographer and writer. In the summer of 1922 Moholy-Nagy wrote to Oud, 'At one time, I thought that Van Doesburg was merely Mondrian's mouthpiece. Today I see that Van Doesburg has much greater vitality and awareness of the present (without wanting to make this a qualitative judgment) than Mondrian.'

Moholy-Nagy provided a link between De Stijl and Central Europe that Van Doesburg was keen to cultivate. In Hungary De Stijl *132* *133* ideas were circulated largely through the magazine *MA* (Today), edited by Kassák and published from Vienna after the defeat of the Hungarian Soviet in 1919.

There were also important contacts with Czech and Yugoslavian modernist movements, but it was in Poland that De Stijl found its most creative reception among the artists and architects of Polish Constructivism. In the paintings and sculptures of Henryk Stazewski, *134* Władysław Strzemiński and Katarzyna Kobro, ideas close to De Stijl were combined with those received directly from Russia (Strzemiński and Kobro had both been students of Malevich at Vkhutemas). De Stijl work was reproduced in the magazines *Blok*, *Praesens* and *a.r.* ('revolutionary artists – real avant-garde') and there is a large correspondence between Van Doesburg and Polish artists and architects. With the writers Julian Przyboś and Jan Brzekowski, *136* Stazewski, Strzemiński and Kobro set up the Museum Sztuki (Museum of Art) in Lodz. Founded at almost exactly the same time as

132 Lajos Kassák *Form-architecture* from *MA* 1923. Kassák produced a series of prints, paintings and typographical works taking Huszár's linoprint reproduced in the April 1918 *De Stijl* (vol. 1, no. 6) (*35*) as the basis for inventive, simplified abstractions.

133 Theo van Doesburg, cover of *MA* July 1922, largely given over to his work. Initially, *MA* was Expressionist in character, shifting towards Constructivism in 1921. The contact between *De Stijl* and *MA* may have been through Moholy-Nagy, who became *MA*'s German editor in 1921, or perhaps through Huszár.

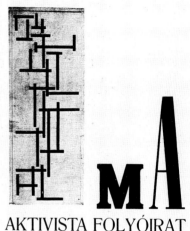

AKTIVISTA FOLYÓIRAT

the Museum of Modern Art in New York, it is remarkably parallel in its institutional construction of a modernist tradition and historiography, which had an important influence on the development of modernist art in post-war Poland. Like the Guggenheim Museum in New York (or the Museum of Non-Objective Art as it was first called), the small but exemplary collection of the Sztuki originally included only abstract works – Van Doesburg donated one of his most important Counter-Compositions. It also included paintings by Huszár, Vantongerloo, the German Constructivist Friedel Vordemberge-Gildewart, Arp and Taeuber-Arp.

Around 1925, after his break with Mondrian, Van Doesburg began to name new collaborators from a wide spectrum of the international avant-garde, including Domela, Vordemberge-Gildewart, Brancusi *135* and the Austrian artist and designer Frederick Kiesler. Of these, Kiesler's work seems closest to late De Stijl ideas. He had trained as an architect and worked with Loos, emigrating to America in 1926 but remaining in correspondence with Van Doesburg until the latter's death. Kiesler became a key figure in the production of American modernism, although his importance has only recently been recognized. His set for Karel Capek's play *R.U.R.*, produced in Berlin in April 1923, was illustrated in the May–June issue of *De Stijl*. At the

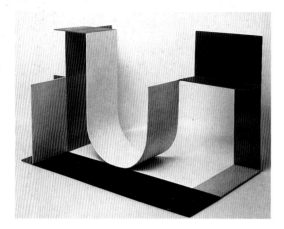

134 Katarzyna Kobro *Spatial Composition 4* 1929. Kobro wrote in 1929 that Van Doesburg's experiments with colour in architecture 'promised spatial solutions in the construction of sculpture from flats and solids'.

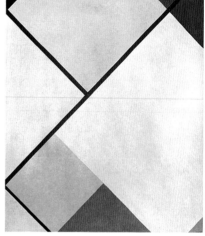

135 César Domela *Neo-Plastic Composition No. 5 C* 1925

end of 1925 Van Doesburg published a manifesto and an article by
137 Kiesler on his system of exhibition design, illustrated with five
photographs of his work. One of his theatre designs was illustrated in
the 1928 Tenth Anniversary issue of *De Stijl* with a series of maxims in
which Kiesler proposed 'A system of tension in free space. The change
of space in urbanism. No foundations, no walls. The detachment
from the earth, the suppression of the static axis. By creating new
possibilities for life, a new society will develop.' It was not surprising
that Van Doesburg should have been so enthusiastic about Kiesler's
work. In 1923 he had written in the manifesto 'Tot een constructieve
dichtkunst' (Towards a Constructive Poetry) – datelined Vienna and
published under his Bonset pseudonym in *Mécano* – 'A city is a
horizontal tension and a vertical tension. Nothing else. Two straight
wires connected with each other are its image.'

164

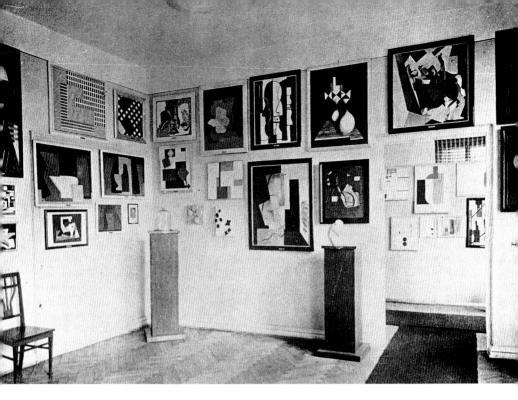

136 The International Collection of Modern Art, Museum Sztuki, Lodz, 1932. Van Doesburg's *Counter-Composition XV* (1925) is at the top, left of the corner, and Huszár's *Sitting Woman* (1926) is diagonally to the right below it.

137 Frederick Kiesler *City in Space* 1925. De Stijl was excluded from the Dutch pavilion at the Paris 1925 Arts Décoratifs exhibition but this utopian 'space construction', shown in the Austrian section of the theatre department, was extraordinarily close to De Stijl designs by Rietveld and others. It became a model for much later modernist exhibition, stage and display design.

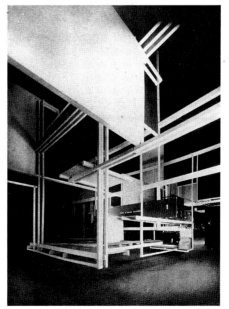

138 Cornelis van Eesteren and Theo van Doesburg with the model of the
Maison particulière, 1923. Behind the two men is a colour design by Van
Doesburg, made earlier in 1923, for Van Eesteren's diploma project for an
Amsterdam University hall.

De Stijl in France

France became the major arena for De Stijl activity after Van Doesburg moved to Paris in 1923, even though De Stijl was more sympathetically received in Germany and Central Europe. The post-1918 Paris art world was hostile to abstraction as radical and unbending as that advocated by *De Stijl* and practised by Mondrian and Van Doesburg. Almost as soon as the War was over *De Stijl* launched attacks on what Jean Cocteau had christened 'the return to order', the stylistic 'retreat' (in modernist terms) to decorative and figurative representation in art. Nor did this opposition abate. In 1925 Mondrian bitterly lashed this trend in 'De huif naar den wind' (Blown by the Wind), one of his last essays published in *De Stijl*. It was illustrated with a photograph of himself in his studio, standing straight-backed and severe in front of one of his minimal paintings of the period, cigarette in hand, dressed in his habitual sober suit – the heroic image of the uncompromising, non-bohemian abstract artist.

For Mondrian, the studio had become not only the site for producing his work and his self-image as an artist, but also where his work – rarely seen in exhibitions in Paris – was viewed by critics, curators and other artists. He began to organize the studio he rented in rue de Coulmiers in November 1919 after his return to Paris that summer, arranging coloured rectangles on the walls and painting the furniture. There are no photographs of it, only of the later studio in the rue du Départ. However, from descriptions by Mondrian himself and a Dutch journalist who wrote about it in 1920, it seems that the rectangular planes were probably arranged on the walls in a manner similar to Van Doesburg's and Huszár's early coloured interiors, which he would have known from photographs and drawings.

The idea of the artist's studio as an ideal environment was clearly much in Mondrian's mind at that period. He announced in a letter to Van Doesburg in December 1919 that he had been to see Courbet's famous painting *The Artist's Studio*, and in 'Les Grands Boulevards', a literary sketch he wrote while Van Doesburg was staying with him in

February 1920, he described, 'The Cubist on the boulevard. Courbet in his studio and Corot in a landscape . . . everything in its place.'

In 1921 he moved to the rue du Départ, a street beside the Gare Montparnasse, renting two rooms connected by a hallway and steps. These were a small room where he cooked and slept, and the studio proper. In the bedroom-cum-kitchen, screened by a curtain, were the necessities of living: Mondrian's spartan cooking implements and toilet articles. Visitors and friends recalled that soft-porn pin-up pictures of nude or semi-nude girls were pinned above the bed. All such representational images, however, were strictly banished from the studio. This was organized in a similar way to the rue de Coulmiers but was subjected to constant changes in arrangement which parallelled, and sometimes anticipated, those of Mondrian's easel paintings. It was an asymmetric room with five walls, an awkward space which Mondrian broke up by re-arranging the furniture, some at right-angles to the walls. A large black cupboard and a white-painted easel were lined up together to form a room-divider, behind which was a couch or spare bed. He arranged painted rectangles of plasterboard, or sometimes blank canvases, on the wall, interspersed with finished or partly finished paintings. On the easel by the cupboard he placed further coloured rectangles. Against the back wall stood a smaller easel. Sometimes Mondrian displayed finished paintings on this, sometimes it was left empty as a central feature of the space, like a Constructivist sculpture. He did not use either of the easels for painting but worked on his canvases laid flat on one of the studio tables. On the floor were two rugs, one grey, the other red. Different arrangements of the studio were photographed, and *147* Mondrian sometimes sent these to magazines for reproduction. Clearly, he regarded the studio interior as a work of art in its own right which should be recorded for posterity. In this he influenced a number of artists, including Domela, the Frenchmen Félix del Marle and Jean Gorin and the Belgian Jozef Peeters, who arranged their studios in a similar manner after visiting his.

In September 1922 Van Doesburg had written to Kok from Germany, 'In Paris everything is completely dead. Mondrian suffers a good deal from this, and I know that he would be in much better spirits if he would only realize that nothing new can grow in reactionary soil. I am convinced that the new area of culture is in the North.' By 1923, however, he had decided that Paris was still the cultural centre where an international or European reputation had to

be produced and ratified. *De Stijl* had been available in Paris since 1918, probably through Severini. As the majority of the articles published in the magazine were in Dutch, its impact would have been mainly through the illustrations. Only when Mondrian's pamphlet *Le Néo-Plasticisme* and Van Doesburg's *Classique-Baroque-Moderne* were published in French in 1920 was De Stijl theory accessible to artists and critics in France.

The works which probably made the greatest impact in France through reproduction in the early issues of *De Stijl* were not the paintings of Mondrian, Van Doesburg and Van der Leck, but those of Huszár. He had experience of commercial graphic design and his cover for *De Stijl* and the related linoprints illustrated there were calculated to produce the maximum impact by strong simplified asymmetrical forms and 'figure and ground' optical reversals. These were effective despite the indifferent black-and-white printing on poor-quality paper of the early *De Stijl*. Huszár's painting *Still Life Composition (Hammer and Saw)*, 1917, was one of only two works ever reproduced in colour in the magazine (the other being Lissitzky's *Story of Two Squares*, 1922). The French painter Fernand Léger was one of the first artists to appreciate the 'dynamic potential' of these works by Huszár when he saw them illustrated in *De Stijl*. Almost certainly they had a direct effect on his own post-war works.

The De Stijl exhibition at Rosenberg's gallery in autumn 1923 *138* contained no paintings, sculpture or furniture but only photographs, *139* drawings, models of architecture and interiors and the latest De Stijl *104* ideas on colour as applied to these. Thus painting was exhibited only in Van Doesburg and Van Eesteren's collaborative designs. In the years immediately after the First World War, Rosenberg had emerged as one of the most influential avant-garde dealers in Paris. He favoured the idea of a collective, monumental art appropriate to collaboration with architects. He interpreted post-war developments

139 (overleaf) The Rosenberg exhibition 'Les Architectes du groupe de Stijl', Paris, autumn 1923. The maquette for the Hôtel particulier (centre foreground) was constructed by Rietveld, who made small changes to Van Eesteren's design. The Maison d'artiste model is behind the Hôtel particulier; the Maison particulière is far left. Apart from the Van Doesburg/Van Eesteren models, the exhibition included work by Wils, Oud, Huszár, Rietveld and the Utrecht artist Van Leusden, who made models of designs for some remarkable small urban structures (centre left).

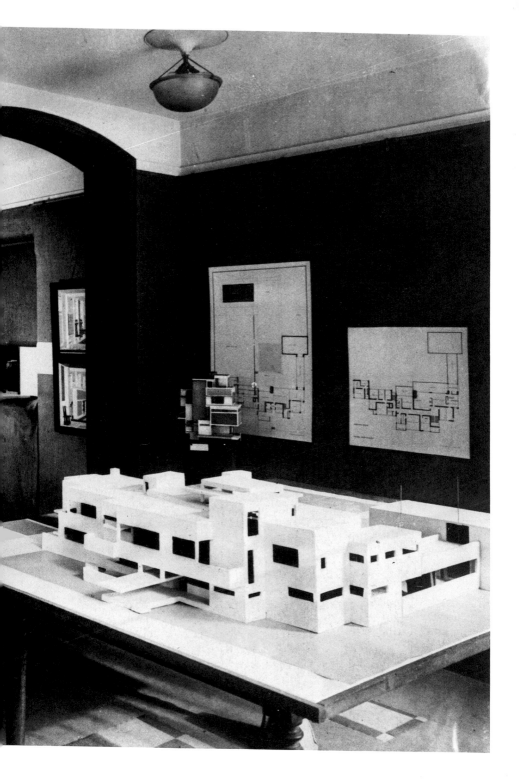

of Cubism as leading towards this and promoted artists who seemed to him to be working towards such a collaborative, architectural style. The concentration on architecture and interiors clearly suited Van Doesburg and an exhibition at Rosenberg's was an opportunity to present De Stijl ideas and achievements in a prestigious gallery in what was still regarded as the art capital of Europe.

Mondrian had initially operated as mediator between Rosenberg and Van Doesburg while the latter was living in Holland and Germany. Although Rosenberg had shown some of Mondrian's paintings in two mixed exhibitions in 1921, only one work had been sold (to Mrs Kröller-Müller, who was one of the gallery's most important clients). Rosenberg had not been prepared to buy the rest outright himself, as he did with artists whose work he believed he could sell later. Nor was he prepared to give Mondrian the one-man exhibition which he had apparently promised him earlier. (His first one-man exhibition in Paris was at the Jeanne Boucher gallery in February 1928.) As a result Mondrian became less involved in negotiations about the De Stijl exhibition. He was also wary of Van Doesburg's ambitious ideas about art and architecture. Thus none of Mondrian's work was shown in the exhibition.

In early 1923 Van Doesburg received a definitive contract from Rosenberg for the autumn of that year. The exhibition was to be entitled 'Les Architectes du groupe de Stijl'. As very little De Stijl architecture had yet been built, and De Stijl was never really a group, it was necessary to supplement photographs of the few extant buildings with models and drawings for new or 'ideal' projects.

Having fallen out with Oud, who had also been involved in the initial discussions, Van Doesburg approached Wils and Rietveld who, however, did not come up with any definite proposals. At the end of March 1923 he secured the collaboration of Van Eesteren, whom he had met in Weimar the previous year while Van Eesteren was there on a bursary. This gave Van Doesburg the chance to co-operate with an architect in a much more ambitious way than with Oud or De Boer. Yet, although ambitious, these designs were 'paper' or 'ideal' projects with no possibility of realization and, of course, with none of the problems associated with realized projects. They have become icons of modernism more widely circulated and fetishized than any realized De Stijl collaborations, with the possible exception of the Aubette and the Schröder house. Their persuasive and continuing power within modernist architectural histories owes a

great deal to the dynamic projection technique of axonometry, which the two helped to revive, giving a new currency and vitality to an ancient drawing system. To Van Doesburg these projections suggested ideas for painting, in particular new ways of creating dynamic representations of three-dimensional, or even four-dimensional, space by two-dimensional means. With his dramatic and effective application of primary colour, this arresting series of images was ideally suited to the reproduction techniques of the period or, for that matter, to those of histories of modern architecture and design today.

Van Doesburg and Van Eesteren began work in the summer on designs, colour drawings and models for three imaginary or 'ideal' houses: a large villa for an art collector, the Hôtel particulier; a middle-class family house, the Maison particulière; and a studio house for an artist, the Maison d'artiste. The design of the Hôtel particulier was almost entirely the work of Van Eesteren (although the model *139* was made, and the design slightly modified, by Rietveld), the Maison particulière was a joint work and the Maison d'artiste largely that of Van Doesburg. Van Eesteren's design for the Hôtel particulier revealed his clear understanding of modernist architectural practice. It showed his familiarity with the work of the most 'advanced' contemporary German architects like Mies van der Rohe, and the latest Russian ideas introduced into Germany by Lissitzky, and also with the formal vocabulary of earlier De Stijl architecture, the sculpture of Vantongerloo and the furniture of Rietveld. It did not, however, go beyond being a knowing and highly competent sum of these individual constituents. The two other projects very definitely did.

In 'Vers une construction collective', Van Doesburg declared the end of an era of destruction and the dawn of one of construction. In his coloured drawings for the Maison particulière he used colour- *104* planes like building blocks from which highly complex spatial constructions were composed. This was carried through in the elaboration of the models for both the Maison particulière and the *138* Maison d'artiste. Whereas the Hôtel particulier was a loosely linked series of volumes grouped around a square pool, with a clearly defined front and rear facades, the other two have no specific orientation. Each facade is as important as any other.

In the Maison particulière the aim was to reveal the development of space centrifugally, from the centre of the house, the stairwell, to the

edges of the building, creating a structure where different groups of rooms formed loose, independent units interlocking with one another and connected at different levels by stairs and landings.

Only a single 'counter-construction' colour drawing by Van Doesburg for the Maison d'artiste survives. This and an elevation are very brusquely and crudely executed, suggesting that he probably did not make a series of elaborate colour drawings for this project. The 'experimental' work had already been done in the earlier drawings and he was able to plunge more or less straight into the design of the Maison d'artiste. Here the cubic 'cells' were arranged eccentrically round a central core in such a way that it is almost impossible to identify separate 'storeys' or floors.

Even though greater credit can be apportioned to one or the other of the two men for the individual projects, the drawings and models for the three houses remain an extraordinary and unequalled example of collaboration both within De Stijl itself and within twentieth-century modernism. None the less, despite or rather because of their originality, the Rosenberg projects remained 'ideal' or 'paper' architecture.

The exhibition had a mixed reception in Paris. It was not discussed and praised as much as Van Doesburg would have wished and many important French critics and architects ignored it, but it was not received totally unfavourably, as has often been said. The critics of publications as diverse as *L'Humanité*, *L'Amour de l'art* and *L'Architecture* covered it extensively. Although complaining that it was too reductivist, too full of right-angles and lacking in softening curves, they managed to find something good to say about it, suggesting that French architects and designers could learn something from it, as indeed they did. Le Corbusier had maintained a distant and often hostile attitude towards De Stijl. Nevertheless, its impact can be clearly discerned on his work, while Van Doesburg's own architectural ideas and his notions about the machine aesthetic were formed by a process of symbiosis with, and reaction to, those of Le Corbusier.

In July 1920 Van Doesburg had drawn attention in *De Stijl* to the forthcoming appearance of *L'Esprit Nouveau*, adding that: 'The director, Paul Dermée, is in touch with the editor of *De Stijl* about the possibility of a mutual collaboration.' The 'De Stijl Literature Manifesto' was reprinted in the first issue of *L'Esprit Nouveau*, in October 1920, without comment. Mondrian and Van Doesburg were listed as 'collaborators' until the seventh issue. (Dermée, who was the

139

174

magazine's director until the third issue, had fallen out with his associates Le Corbusier and Ozenfant because of his allegiance with the Dadaists.) When Mondrian submitted a French version of his essay on Neo-Plasticism and Futurist noise music, originally published in German translation in *De Stijl*, to *L'Esprit Nouveau* in 1921, Ozenfant and Corbusier rejected it. (It was subsequently published in another French magazine, *La Vie des lettres et des arts*, in April 1922.) If Le Corbusier and Ozenfant were less than enthusiastic in public about De Stijl they were equally disdainful of the Bauhaus and of Russian avant-garde art and architecture. They rejected offers of contributions to the magazine from Lissitzky, as well as from Mondrian and Van Doesburg.

Le Corbusier, Léger, the architect Robert Mallet-Stevens and Sonia Delaunay were present among others at the opening of the Rosenberg show. To rub in the fact that he was no mere 'paper architect' but was actually building, Le Corbusier apologized for not having shaved and for his dirty clothes, saying he had come straight from the construction site. Whatever his public attitude to De Stijl, the impact of the show is discernible in Le Corbusier's work. He changed the design of the Villa La Roche, on which he was then working, immediately after visiting the exhibition and began to use colour in his architecture. At first he used more subdued 'Purist' colours, only employing primary colour much later in his Salvation Army Hostel in Paris of 1933. He also started to use axonometric projection in his drawing after 1923.

A few months before the Rosenberg show Mallet-Stevens designed sets for Marcel L'Herbier's futuristic film *L'Inhumaine*. Some of these – particularly the set for the exterior of the engineer's laboratory (the interior was designed by Léger) – were close in style to early De Stijl architecture and design. However, Mallet-Stevens never assimilated the more complex spatial ideas of the Van Doesburg/Van Eesteren projects into his own architectural work and seemed to find the more volumetric and monumental forms of early De Stijl more congenial to his own ideas and practice, or easier to accommodate as built form.

When most of the De Stijl work was shown again as part of an exhibition at the Ecole Speciale d'Architecture, including work by French architects, in Paris early in 1924 (probably on the initiative of Mallet-Stevens) it received a fuller and more enthusiastic response. 'The French are still far from equalling the virtuosity of the Dutch,

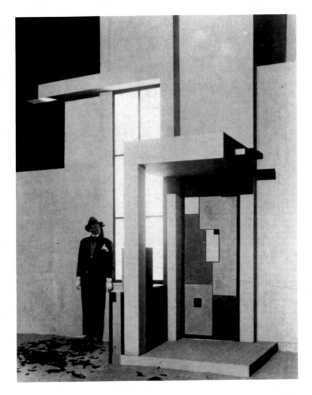

140 Robert Mallet-Stevens, set for exterior of engineer's laboratory in *L'Inhumaine*, directed by Maurice L'Herbier, 1923. Although Mallet-Stevens designed it shortly before the Rosenberg exhibition, he would have been familiar with De Stijl works from illustrations in *De Stijl* (*3, 4*).

141 Robert Mallet-Stevens, house in rue Mallet-Stevens, Paris, 1927. In the cul-de-sac named after its architect, in the wealthy suburb of Auteuil, the formal language of early De Stijl was adapted for a French middle-class clientele.

who assert their authority as masters of the genre', wrote a critic in *L'Architecture*. This showing was also widely discussed in the Dutch general and professional press. The quasi-official nature of the venue no doubt appeared to confer a sense that De Stijl had been 'accepted' in France, although this was far from the truth. Much to Van Doesburg's chagrin, De Stijl was excluded from official representation in the Dutch pavilion at the 1925 Exposition des Arts Décoratifs, which was dominated by the *Wendingen* group, or Amsterdam School.

De Stijl painting was shown most extensively in Paris at the end of 1925, in the exhibition 'Art d'aujourd'hui' organized by the Polish artist Victor-Yanaga Poznanski. This attempted to show an alternative view of post-war art from that exhibited in the dealers' galleries and most group shows in Paris, with the main emphasis on abstract art. It included paintings by Van Doesburg, Mondrian, Huszár,

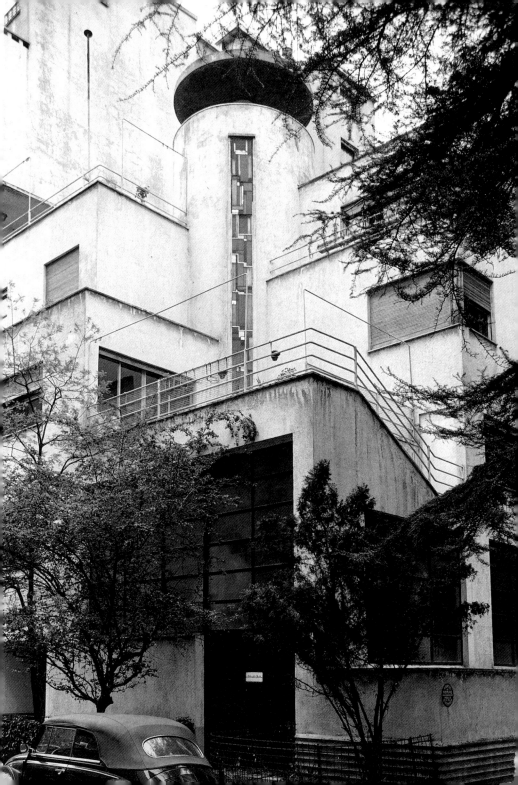

Domela and Vordemberge-Gildewart, which constituted the largest 'group' showing of works by former and current De Stijl artists (as opposed to architects) to date. Music by the American avant-garde composer George Antheil, whom Van Doesburg had recently named a De Stijl collaborator, was played at the opening. The Vicomte and Vicomtesse de Noailles, virtually the only collectors to interest themselves in abstract art in Paris in the 1920s, who had recently commissioned a colour design by Van Doesburg for a small room in their villa at Hyères in the south of France, purchased six pictures from the exhibition, including works by Mondrian and Vordemberge-Gildewart. However, the price they paid for their Mondrian (700 francs) was very low in comparison with the most expensive French artists of the period. Reviewing the exhibition in *Cahiers d'art*, Christian Zervos wrote: 'Neo-Plastic work reveals a total disdain for images born of sensuous passion in life. Van Doesburg, Domela, Mondrian suppress all natural and human meanings.' This reaction was not untypical.

In France, De Stijl continued to be regarded as primarily an architectural movement. Hitchcock's short monograph on Oud was published in Paris in 1931. The most complete coverage of De Stijl architecture was given by *L'Architecture Vivante*, one of the most influential magazines of the period, edited by Jean Badovici and published by Albert Morancé, who also published *L'Art d'Aujourd'-hui*. A special issue on De Stijl appeared in 1925.

Illustrations of work by De Stijl artists and essays by Mondrian and Van Doesburg were also published in the Lille-based magazine *Vouloir*. Its visual arts editor, Félix del Marle, was particularly impressed with the work by Mondrian and Van Doesburg shown at the 'Art d'aujourd'hui' exhibition. In 1927 Del Marle had the subtitle of the magazine changed from 'Organe constructif de littérature et d'art moderne' to 'Revue mensuelle d'ésthétique Néo-Plastique' and published Mondrian's essay 'Le Home–la rue–la cité' (Home–Street–City) with reproductions of his Bienert design. This issue, the theme of which was 'Ambiance', also included reproductions of a number of realized and unrealized De Stijl interiors, among them photographs of the Schröder house.

Along with the Rosenberg projects, the Aubette has generally been considered Van Doesburg's major collaborative work. It was an enormous undertaking: the complete redesign, refurbishment and

178

decoration of the interior of a vast architectural complex in the main square of Strasbourg, which had been used for many functions, military and civil, over the years. The building dates partly from the thirteenth century. It was radically restructured by the military architect François Blondel between 1764 and 1767 who closed off the north side of the place Kléber, which it almost completely fills. In 1921 three Strasbourg businessmen leased part of the Aubette from the municipality, planning to convert it into a café, restaurant, ballroom and cinema. (The exterior was listed as a historic monument and could not be altered.)

The commission to redesign the interior was initially offered to Hans Arp, who was born in Strasbourg, and his wife Sophie Taeuber-Arp, who had recently designed interiors for one of the proprietors. The Arps felt unable to cope with the architectural demands of the project on their own and asked for the assistance of Van Doesburg, who then took charge. The contract was negotiated in the autumn of 1926 and the majority of the plans were completed by February 1927. The interior was finished and the building opened to the public a year later.

The Aubette was a public commission on a scale comparable to the murals painted by Robert and Sonia Delaunay for the 1937 International Exposition in Paris, or Brancusi's sculptural ensemble at Tirgu Jiu in Romania. Van Doesburg described it as a *gesamtkunstwerk* (total work of art): 'the first realization of a programme which we have cherished for years'. Although designed for the bourgeois rather than the working class, the Aubette was as ambitious in conception as Victor Horta's Maison du Peuple of 1897–1900 in Brussels. A more recent precedent – stylistically, rather than in terms of scale or clientele – was Rodchenko's design for a Workers' Club, which was shown at the 1925 Arts Décoratifs exhibition. When the project was completed in early 1928, Van Doesburg published detailed descriptions and photographs in the special issue of *De Stijl* devoted to it. He saw it as the major realization of De Stijl collaboration and of his ideas about the use of colour in architecture, to be celebrated and recorded in the magazine in the fullest and most lavish way possible. It was the last issue to appear in his lifetime.

142

Not only did Van Doesburg take charge of the overall organization of the project, he also designed virtually every piece of equipment, from the electrical fuse-boards to the ash-trays and crockery, which

were decorated with a distinctive Aubette lettering, based on the standardized alphabet he had designed in 1918–19. Taeuber-Arp was

assigned the 'feminine' Patisserie and Tea-room, and the 'intimate'

Aubette Bar, while Arp decorated the basement American Bar and Cellar Dance-hall in his freer, organic, 'Pre-Morphist' style. The circulation areas of hall and main staircase were decorated in an abstract, geometric style which the Arps had developed during the First World War, contemporaneous with the early works of De Stijl. Van Doesburg designed the main public rooms on the ground floor and first floor. As far as can be judged from the designs, contemporary photographs and the recollections of those who visited the Aubette shortly after its completion, the different styles worked together to produce a dynamic relationship between the different parts of the complex.

The first floor rooms have been confusingly referred to by different names in published descriptions of the Aubette, and indeed on the original plans. Clearly, ideas about their functions changed as the plans progressed, and these functions were in any case intended to be multiple. The Ciné-dancing (or Grande salle) was used for showing films, dancing and cabaret. The Petite salle dancing (or Salle des fêtes) was used for balls, weddings and banquets. Although Van Doesburg employed his new dynamic, diagonal Elementarist style of Counter-composition in the designs for the Ciné-dancing, he used an orthogonal, horizontal–vertical scheme for the Petite salle dancing. This harmonized with the rectangular architecture of the room and the long windows which lit it. The oblique scheme for the Ciné-dancing, by contrast, worked against the orthogonal architecture, with its horizontal gallery and vertical window and door openings. This contrast served to accentuate the dynamic rhythm of the diagonal planes of colour on walls and ceiling.

Van Doesburg used secondary colours as well as primaries, as in his early stained glass and interiors, although he had rarely combined primaries and secondaries in the same scheme before, juxtaposing them in the Ciné-dancing to create dissonant effects. The colours in the Petite salle dancing were more subdued, with some earth colours, which he had recommended as a contrast to primaries in an article written shortly before starting work on the Aubette.

Perhaps because of the lower ceilings and the generally busier and more visually cluttered spaces, he chose less dominant colour combinations for the two downstairs restaurants, the Café Restaurant

The Aubette, Strasbourg, 1926–8

142　Cover of Aubette issue of *De Stijl* 1928. The diagonal printing of 'Aubette' suggests that Van Doesburg regarded the diagonals he used in the Ciné-dancing as the climax of the scheme. Its significance was very different from when he had 'Barok' printed diagonally across the cover of *Klassiek-Barok-Modern* in 1920 (19).

143　Theo van Doesburg, directory for the Aubette, using his special Aubette lettering, with a different colour for each room. It was placed left of the main entrance, so customers could orientate themselves, and was repeated in the individual rooms.

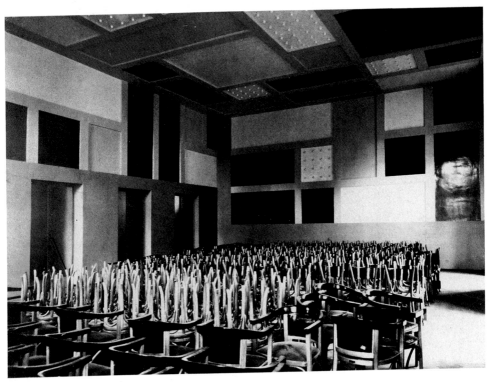

144, 145 Theo van Doesburg, Petite salle dancing and Ciné-dancing. Among the coloured planes in the Petite salle dancing (based on a 120 cm module derived from the height of the radiators), white enamel squares and rectangles were placed as reflectors for rows of naked light bulbs, creating massed points of light. These were separated by raised bands painted a neutral grey. In the Ciné-dancing this was reversed: the diagonal elements were painted on stucco panels so the wide neutral bands between them appeared like recessed channels, creating an effect of relief planes of colour.

146 Sophie Taeuber-Arp, Tea-room. The panels were designed to be in mosaic but for financial reasons were executed in paint. In her colour drawings the panels have an almost jewel-like quality.

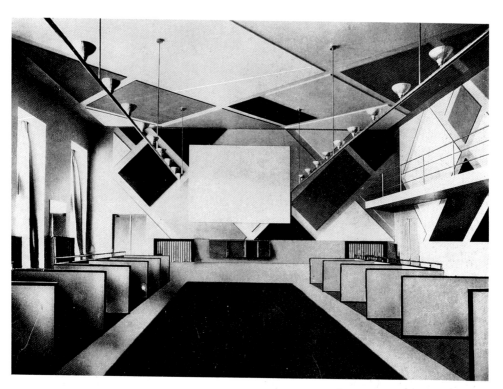

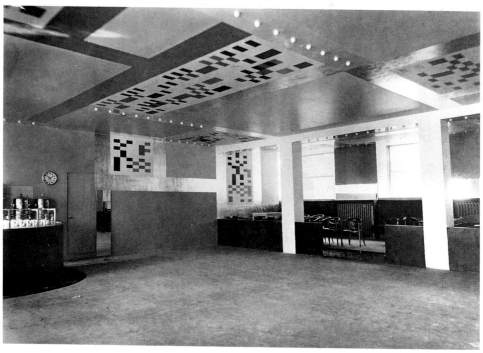

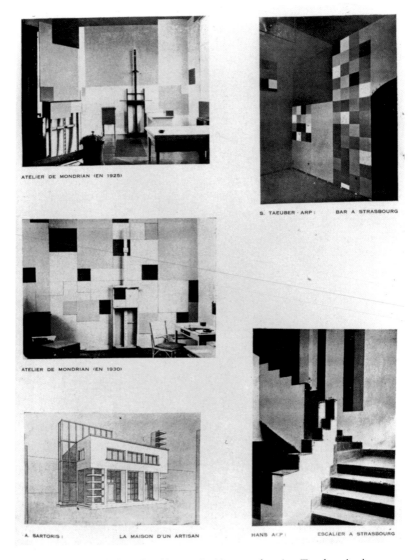

ATELIER DE MONDRIAN (EN 1925)

S. TAEUBER - ARP : BAR A STRASBOURG

ATELIER DE MONDRIAN (EN 1930)

A. SARTORIS : LA MAISON D'UN ARTISAN

HANS ARP : ESCALIER A STRASBOURG

147 Page from *Cercle et Carré* (no. 3, Paris) 1930, showing Taeuber-Arp's Aubette bar, Arp's colour design for the Aubette staircase and Mondrian's studio in 1926 (not 1925) and 1930.

and the Café Brasserie. The colours were painted straight onto the walls and ceilings, butted against one another as in his earlier paintings. Van Doesburg probably adjusted his style in these rooms to fit in with the adjoining Tea-room and Patisserie. Here Taeuber-Arp designed ornamental panels of asymmetrical yet rhythmic combinations of black, grey and red squares and rectangles on a white background, alternating with plain squares and rectangles of differing dimensions in shades of grey, divided from each other by wide bands of silver paint. This created a more intimate and less monumental effect than Van Doesburg's rooms. Next to the Tea-room was the Aubette Bar, which she decorated with squares of bright colour grouped together, alternating with larger squares and rectangles of grey and white. In the Cellar Dance-hall, Arp worked in a much freer way, using biomorphic forms in yellow, black and blue-grey. 'Since those of us who collaborated here were people of different orientation, we made it a principle that each one was free to work according to his own ideas', Van Doesburg wrote in *De Stijl*, adding that in the Cellar Dance-hall 'the inspiration was that of an unbridled imagination.' *146* *147*

Van Doesburg believed that he and the Arps had realized what he had earlier described as the aim of monumental art: 'To place man within painting instead of in front of it and thereby enable him to participate in it.' Although well received in the Strasbourg newspapers, the Aubette was completely ignored by the art and architectural press in France. Nothing appeared in *Architecture Vivante*, presumably because Van Doesburg and Badovici had fallen out after the special *De Stijl* issue in 1925. The only article to appear in the Dutch architectural press was Van Doesburg's own in *Bouwbedrijf* in 1929. One of the few contemporary professional comments was that of Hitchcock, who complained in a book published in 1929, 'Here Elementarist painting so dominates the designs that they have little architectural existence.'

The decorations were unpopular with the clientele of the Aubette from the day it opened, and almost immediately the proprietors began to modify them, from November 1928. Within a few years the interiors had been completely altered or covered over. (They were not destroyed by the Nazis during the Second World War, as is sometimes stated.) As early as 1930 they were already vastly changed. The works by Arp were half-covered by kitsch drawings and paintings and all the rooms were in bad repair. In 1938, when a

brochure celebrating the Aubette's tenth anniversary was issued by the proprietors, virtually all the decorations by Van Doesburg and the Arps had disappeared.

'The opening of the Aubette at Strasbourg will signify the beginning of a new era of visual art. Elementarism will be a fact for ever', Van Doesburg wrote to Del Marle shortly before the opening. Later he complained in his diary that he despaired of any hope of changing people's moral behaviour by means of architecture and painting. This was the enormous ambition which he had for art and architecture and for the project of De Stijl. It was hardly surprising that he was disappointed.

Although the Aubette was disliked and quickly altered, it has secured a unique place in art and design history by photographs, drawings, exhibitions and reconstructions: the two main rooms decorated by Van Doesburg were reconstructed in reduced scale or near life-size for several exhibitions in the 1960s, 70s and 80s. In the early 90s they were restored to Van Doesburg's original designs. Like the restoration of the Schröder house and the reconstruction of Oud's Café de Unie, this has further reproduced and circulated them as iconic images of De Stijl and early modernism. The Aubette has been described as 'the ultimate expression of Van Doesburg's aesthetic ideals' and the 'final statement in the dialogue he carried on with Mondrian's work.' However, it would probably be more accurate to say that it was the ultimate expression of his De Stijl aesthetic, for in the last three years of his life he evolved an aesthetic which in many ways was rather distant from De Stijl.

'When I returned from Strasbourg, financially as good as ruined, my morale stunned by all the beer and Alsace sauerkraut, beggarly and intellectually plundered', Van Doesburg wrote to Bart de Ligt in 1929, 'I was as good as finished and therefore had to start all over again from square one, just as in 1923.' In 1927, while still working on the Aubette, Van Doesburg had begun to design a studio house for his wife and himself, comprising living accommodation, a studio and a music room for Nelly. The plans were finalized in 1929 but the studio was not finished until late 1930, shortly before his death. This was to be a small, standardized cell, into which he planned to retreat in order to regenerate his strength for renewed assaults on the art world. It was the only complete building he designed to be realized. In adapting his ideas to the exigencies of cost, the construction process, the restriction of an awkward site and his own inexperience, he was forced to adopt a

148
149

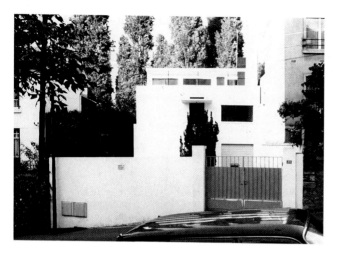

148, 149 Theo van Doesburg, studio at Meudon, 1929–30. Primary colours were applied to the exterior doors and windows in a similar way to his colour scheme for *103*. Van Doesburg also wanted to use colour on the outside walls of the studio but was prevented by lack of time and money. Inside, hinged partitions allowed rooms and corridors to be opened out into larger spaces, as in the Schröder house (*98*).

relatively conventional modernist solution, compared to his 1923 collaborations with Van Eesteren for the Rosenberg exhibition. The plot was far too small and narrow for anything as structurally daring as the Maison d'artiste – or for that matter, the Maison particulière – even had he had the technical knowledge and experience to handle such a project.

Although he had made his earliest design for the studio while working on the Aubette, he did not use Counter-Composition in its decoration. Perhaps he had come to the conclusion that, however suitable for a Ciné-dancing, this was too restless for a private house and studio, where he needed a calm and restful environment in which to paint and write. A flat rectangular concrete plane masks the only diagonal element in the composition, the steps that cross the facade from street level to the front door, which opens onto the upper floor.

Theo and Nelly van Doesburg moved into the studio in December 1930. He had planned this to be a centre of renewed collective activity but was only to live there for two months. The acute asthma from

which he suffered had become increasingly severe. In late February he went with Nelly to Davos in Switzerland for treatment and died there suddenly on 7 March 1931 from a heart attack. After his death, Nelly van Doesburg continued to live in the studio, where she preserved his archives until her own death in 1975. It now belongs to the Dutch state, and after restoration in the 1980s is used to provide accommodation and work-space for visiting artists and scholars from The Netherlands.

Van Doesburg had written his own version of the history of De Stijl in a series of articles published in the Swiss periodical *Neue Schweizer Rundschau* in 1929: 'This year, many conflicts due to differences of opinion have been resolved, so that the artists of De Stijl can face the international world as a united group with a new publication (*Nouveau Plan*).' He had recently renewed contact with Mondrian and Oud, although they seem not to have envisaged any further collaboration. Despite this attempt to suggest that De Stijl was still active, in his last paintings, as well as his later architectural designs, Van Doesburg had moved away from De Stijl, and even from Elementarism and Counter-composition. He now strove for a 'universal' art which he believed could be achieved by mathematical and systematic methods of composition.

He had always made some use of such methods in his abstract work, from his early stained-glass windows and his glazed brick and tile design for De Vonk. But in the past, particularly in his easel paintings, he had modified this method by introducing intuitive elements. By 1929 he believed that the composition of paintings and architectural designs could equally be achieved by systematic and rational principles. He wrote to Kok that he was 'attempting to realize a universal form, which corresponds absolutely to my spiritual conception'.

The new periodical – called not *Nouveau Plan* but *Art Concret* – and 'united group' Van Doesburg had promised in 1929 were launched in 1930, the aims of which were based on his new 'universal' principles. Apart from the French artist Jean Hélion, the members of the group were little known and only one issue of the magazine appeared. However, in February 1931 a meeting of artists was held in Van Doesburg's new studio which led to the formation of the influential Abstraction-Création group after his death.

In a manifesto which appeared posthumously in 1932, in the memorial issue of *De Stijl* edited by Nelly van Doesburg, he

150

150 Theo van Doesburg *The Origin of Universal Form No. II*, *c.* 1929 (detail). The drawing was also illustrated as a film storyboard in Van Doesburg's article 'Film als reine Gestaltung', in the German magazine *Die Form* May 1929.

concluded that the artist's studio must resemble a medical laboratory, possessing the atmosphere of high mountains where the cold kills the microbes. This not only reveals Van Doesburg's sense of rejection after the public lack of enthusiasm for the Aubette, the lack of any serious critical comment in France and Holland, and the absence of any further architectural commissions, but also shows the psychological effects of his chronic asthma. 'Looking around us, we see only manure, and it is in manure that filth and microbes live', he had written in 1930. This and his call for 'white painting' in the manifesto represent a yearning for the purity and cleanliness of the sanatorium more extreme even than the 'cult of hygiene' characteristic of the International Style.

Nine months before his death, Van Doesburg was received into the Catholic Church. According to the certificate preserved in the Van

Doesburg Archives in The Hague, on 13 June 1930 he swore before clerical witnesses to renounce 'the heresy of Luther'. The Meudon studio house was like a hermit's cell or small monastic retreat, which would create 'a direct relationship with God' – as he had written, many years before, about his design for the interior of Oud's vacation hostel, De Vonk. Stylistically Van Doesburg's studio is quite similar to Oud's last executed building in the International Style, the Kiefhoek church, in that they are both stripped, stark and garage-like, though Oud's meeting hall was designed for the strict Calvinist New Apostolic sect.

Although in many ways France proved less sympathetic to De Stijl than Germany or Central Europe, Van Doesburg had continued to work there up to his death, while Mondrian remained in Paris until driven out by fear of the approaching German bombardment and occupation. Both men felt that despite the difficulties more was possible there than in Holland. 'In Paris everything is simply a passing fashion. The snobs have the upper hand and all the "*artistes*" are upstarts who earn masses of money with rubbish', Van Doesburg had written in his letter to De Ligt in 1929. 'Still, relatively speaking, I can't complain about my exhibitions. I am singled out for discussion even though the remarks are anything but intelligent.' Despite the predominance of critical reactions like those of Zervos, Van Doesburg's later theory and practice were important for the development of abstract art in Paris during the decade after his death, largely through the activities of groups such as Abstraction-Création, who organized a retrospective of his work in 1934.

Mondrian's situation had begun to improve around 1925, not as the result of any serious attention in France, but because of interest in Germany and the USA. After moving to London in September 1938 he sent a letter to his friend the Swiss architect Alfred Roth: 'The sales are as always – but there is some understanding. At the moment I am showing with Constructivists and Surrealists at the London Gallery. The press has taken note of it, which in Paris was never the case.'

151 Theo van Doesburg *Composition* 1928. By this time he was producing deliberately awkward, unbalanced and unharmonious works that subvert or 'deconstruct' the serene, harmonious qualities of Mondrian's asymmetric but balanced paintings of the period. *Composition* is painted on the back of the canvas and incorporates the frame in the painting.

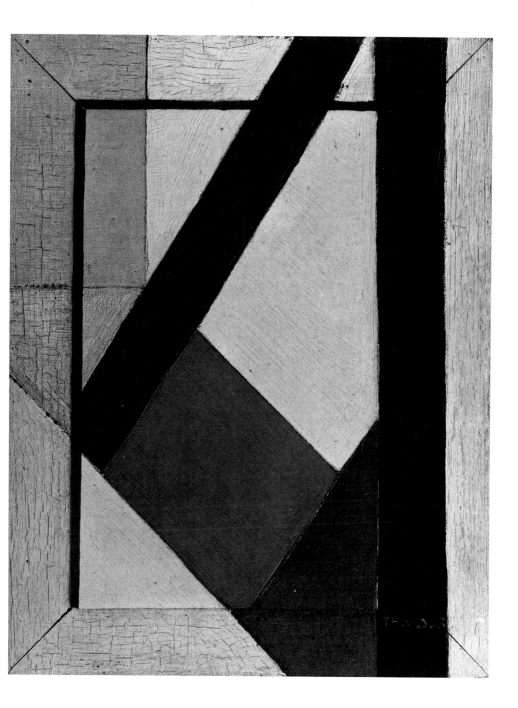

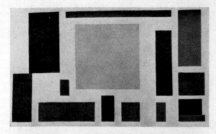

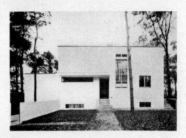

Plate 21 Van Doesburg: Composition (The Cow), 1916/17. Oil on canvas, 14¾×25″. The Museum of Modern Art, New York

Plate 22 Gropius: Director's House, Bauhaus, Dessau, 1926

INFLUENCE OF DE STIJL ABROAD

As is indicated in the chronology, the years 1920–1925 saw an astonishing expansion of the influence of de Stijl, first in Belgium, then in Germany, France, Eastern Europe and even in Russia where it met the earlier but less practicable abstract traditions of Suprematism and Constructivism.

The work of the Stijl group had been known in Paris through its publications well before the exhibition at Léonce Rosenberg's gallery in 1923. De Stijl influence upon French architects is not so obvious as upon German but it may be remarked that in France no building, not even by Le Corbusier, was as advanced in design as Rietveld's house, plate 15; and Le Corbusier's famous device of painting the walls of the same room in different colors had been anticipated by the Stijl designers.

As early as 1919, through the painter Feininger, de Stijl was already beginning to be known at the Bauhaus school of design at Weimar. Two years later van Doesburg himself began to divide his time between Weimar and Berlin. Though the degree of his influence is still controversial, van Doesburg's presence at Weimar seems to have stimulated important changes at the Bauhaus; from a somewhat expressionist mysticism and transcendentalism, the Bauhaus more and more turned toward clarity, discipline and the desire for a uniform and consciously developed style in architecture and the allied arts such as the Dutch movement had already initiated. Doubtless some of this change of direction was self-generated; furthermore, there was surely some French and, after 1922, some Russian influence at the Bauhaus; yet it remains significant that in 1922, for instance, Gropius, who had been engaged in designing a picturesque wooden blockhouse with cubistic decorations and a symmetrical façade, sent to the *Chicago Tribune* competition an austere, asymmetrical skyscraper project, its façade enlivened by a Stijl-like arrangement of balconies and other accents.

The influence of de Stijl upon German architecture may further be seen in Mies van der Rohe's plan for a country house done in 1922, the year after van Doesburg's arrival in Berlin. The resemblance between this plan and the broken orthogonal asymmetrical design of such Stijl paintings as van

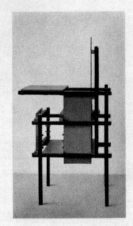

Plate 25 Rietveld: Child's chair, 1919

12

152 Page from Alfred Barr's pamphlet *De Stijl* 1951, published as an introduction to the MOMA exhibition. Barr's display of illustrations, adapted from his 1936 *Cubism and Abstract Art*, was intended to demonstrate the influence of De Stijl on European architecture and design.

Reproducing De Stijl

After Van Doesburg's death Oud helped Nelly van Doesburg edit the memorial issue of *De Stijl* (1932). Most former collaborators contributed, although some like Huszár and Vantongerloo refused because of their differences with Van Doesburg. Personal retrospectives of his work were held in Paris (1934) and Amsterdam (1936). De Stijl had encountered some resistance in France and Germany, although making a powerful impact on a number of influential artists, architects and designers. In the United States it was enlisted to produce a modernist canon from the mid-1920s. The first work by Mondrian to be sold to America, *Composition in White and Black*, 1926, was purchased by Katherine S. Dreier in 1926 for the Société Anonyme Museum of Modern Art initiated by Dreier, Marcel Duchamp and Man Ray in New York in 1920. The collection was first exhibited at the Brooklyn Museum in the winter of 1926–7 as the 'International Exhibition of Modern Art' and included work by Huszár, Domela, Vordemberge-Gildewart and Vantongerloo, but not Van Doesburg, who had been shown earlier in 1926 by Jane Heap at The Little Review Gallery in New York. Mondrian's painting was retitled *Clarification* by Dreier, who wrote in the catalogue that Mondrian and De Stijl had 'discarded everything but the very essence and through this have reached a clarification of thought – a rarified atmosphere – where few can follow'. According to Dreier, Holland had produced three great artists, Rembrandt, Van Gogh and Mondrian. The construction of Mondrian's international reputation as a 'modern master' dates from this exhibition.

De Stijl work, including Rietveld's furniture, was given a pivotal position at the Museum of Modern Art (MOMA) in New York. The 'master narratives' of modernist art and design which Barr constructed through the museum, its publications and exhibitions largely *152* defined the place De Stijl has occupied in almost all subsequent accounts. In Barr's *Cubism and Abstract Art*, first published to accompany the exhibition held at MOMA in 1936 and frequently

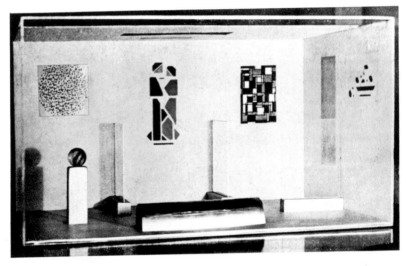

153 Vilmos Huszár, display case for the New York World's Fair, 1939. The case contained tiny facsimiles of paintings by (left to right) Mondrian, Huszár, Van Doesburg and Van der Leck.

reprinted, Van Doesburg was described as 'painter, sculptor, architect, typographer, poet, novelist, critic, lecturer and theorist – a man as versatile as any figure of the Renaissance'. At his death his reputation and that of De Stijl had been at a low ebb. Now, only five years later, they were secured and ratified.

Barr was particularly keen to demonstrate De Stijl's influence on the Bauhaus. And when the first major retrospective of De Stijl (organized at the Stedelijk in Amsterdam in 1951) was shown at MOMA in 1952–3, Philip Johnson argued in the preface to the American catalogue that not only was Gropius's Bauhaus building at Dessau put together on De Stijl principles of elemental, asymmetrical composition, but also Mies van der Rohe's recently completed Lake Shore Drive apartments. In 1956 H. L. C. Jaffé produced the first full-length monograph on De Stijl, which remained the standard work until superseded by more specialized studies in the 1980s when Van Doesburg's and other archives became available. This concentrated on its Dutch philosophical, cultural and intellectual origins, and the writings of De Stijl collaborators, giving particular emphasis to

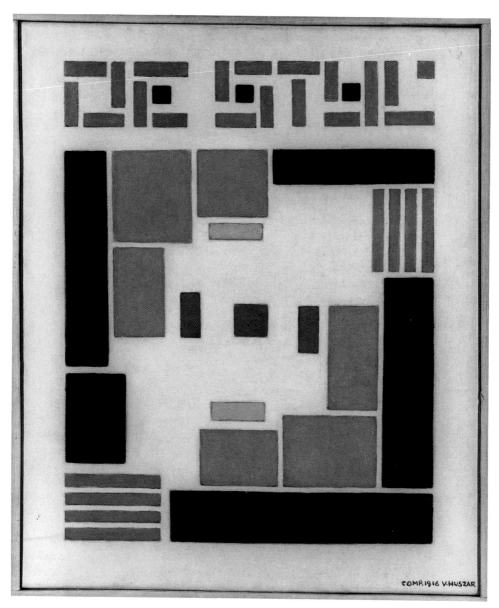

154 Vilmos Huszár *Composition 1916 'De Stijl'*, based on his 1917 logo for *De Stijl* (17) but almost certainly painted in the 1950s.

Mondrian's work and writings. Jaffé attempted to recover De Stijl for Holland and the Dutch tradition without denying its centrality to the international modernist tradition. The book was aimed not only at a Dutch but also at an international audience, published in English and widely distributed in Europe and the USA. In his revisionist history of the modernist architectural tradition, *Theory and Design in the First Machine Age* (1960), Banham also gave De Stijl a central place. Thus in the middle decades of the twentieth century De Stijl was constantly reproduced as one of the major components of the then dominant modernist style in architecture and design.

As an art ideology De Stijl was syncretic, gathering together ideas from philosophy, theosophy, popular science and pre-1914 avant-garde art movements like Cubism and Futurism. Through De Stijl and other developments in art and design of the immediate post-war period, the ideas of an earlier avant-garde were shaped into a modernism which became progressively institutionalized from the mid-1920s onwards. The obsession with 'flatness' which preoccupied Mondrian, Huszár and Van der Leck – and to a lesser extent Van Doesburg – became a paradigm of later modernism. Further flattened by reproduction, their work was circulated through illustrations in art historical narratives and monographs, and as postcards and slides.

From the start the production of De Stijl depended greatly on reproduction. The illustrations in *De Stijl* circulated De Stijl works in Holland and abroad during the First World War, and the impact of De Stijl in Paris immediately after the War was also largely through reproductions in the magazine. Reproduction was extended posthumously to many De Stijl artifacts, like Rietveld's furniture, and buildings through reconstruction of 'lost' works such as Oud's bombed Café de Unie and Van Doesburg's destroyed designs for the Aubette, or by restoration, as with the Schröder house.

A complete reprint of *De Stijl* appeared in 1968, although the English translation announced did not materialize. A major Van Doesburg retrospective in Holland the same year was followed by a large Rietveld exhibition in Amsterdam and London in 1971–2. The largest exhibition on De Stijl to date was arranged jointly in 1982–3 in

155 J. J. P. Oud, Café de Unie, Rotterdam, designed 1925, reconstructed by Design Group Opera in 1985 at 35 Mauritsweg, 500 m or so from its original site (*100*).

the United States and Holland. It was shown in Washington and Minneapolis and simultaneously in Amsterdam and Otterlo. A number of exhibitions of the work of individual De Stijl artists and architects, or aspects of De Stijl, were organized in Holland, France and the United States during the 1980s, and the complete writings of Mondrian, running to over four hundred pages, were published in English in 1986. So far there is no Dutch edition.

After Nelly van Doesburg's death in 1975 there was a dispute between the French and Dutch governments over whether Van Doesburg's archives and paintings from the studio at Meudon should be lodged in the Pompidou Centre in Paris or in Holland. Finally this was resolved, with the archives and the major part of the visual material going to the Rijksdienst Beeldende Kunst in The Hague, while the Pompidou took a selection of Van Doesburg's colour drawings and plans for the Aubette. The restoration of two of Van Doesburg's rooms in the Aubette in 1990 can be seen as a further utterance in this continuing dialogue. Thus De Stijl has been constantly produced and reproduced as both an international and a Dutch phenomenon, parallelling its earlier trajectory in the years after the First World War.

De Stijl has not only been reproduced in books and exhibitions but also by the work of later artists, designers and architects, who have incorporated ideas inspired by it. High claims have at various times been made for the impact and influence of De Stijl, since Van Doesburg himself reconstructed its history in the late 1920s in published and unpublished accounts. Zevi and Padovan have represented De Stijl architectural ideas as a progressive modernism which culminates in the work of Mies van der Rohe. Undoubtedly the impact of De Stijl formal ideas can be discerned in a number of his buildings such as the Barcelona pavilion (1929) but to give such priority to either De Stijl or Mies van der Rohe is both uncritical and ahistorical.

Perhaps because De Stijl ideas in architecture and interior design were rarely realized (and few of these survived) they retained a freshness that continued to stimulate designers and architects. Although formal concepts derived from De Stijl were misused in huge, inhuman post-war urban developments in Holland and elsewhere, the intimacy of scale preserved by Rietveld and Oud in their best designs can be found in the 1950s and 60s' work of Dutch architects such as Aldo van Eyck. In the 1960s and 70s the Van

157

156 De Stijl reproduced (clockwise from top left): model of the Red Blue Chair, box of matches, carrier bag with André Kertesz's photograph of the hall in Mondrian's studio, cassette tape of music liked by Mondrian, De Stijl T-shirts, advertisement for the Rietveld restaurant, Amsterdam, in the form of the Zig-Zag chair, De Stijl architectural stamps on a postcard of 1969, and model kits of the Schröder house and the Oud Mathenesse site-manager's hut.

157 Giandomenico Belotti, chair ('Homage to Theo van Doesburg'), 1980s, virtually identical to the chair Van Doesburg designed in 1930 for his Meudon studio.

Doesburg/Van Eesteren projects were a fertile source for 'deconstructionist' or 'post-modern' architects like John Hejduk and Peter Eisenman, and in the late 1980s an appropriation or pastiche of Van Doesburg's design for the Ciné-dancing at the Aubette was used to decorate the boardrooms of the post-modernist Landeszentralbank in Frankfurt, by Albrecht Jourdan Muller and Berghof Landes Rang.

Although Mondrian was received with enthusiasm in the United States, the influence of his painting was confined to a small number of lesser-known artists working in a geometric abstract style. Van Doesburg's work and writings had a more direct impact on artists after 1945 although in Europe rather than America, and it was his last work, not that of the De Stijl period, which has been most influential on artists working in serial or systematic ways. Conceptual and minimalist artists like Jan Dibbets, Sol LeWitt and Donald Judd have extensively collected Rietveld's furniture. Whether or not this can be considered as sculpture, it has been represented as such by the ways in which it has been exhibited and collected. In the late 1980s many of the original Dutch owners or their heirs began to sell Rietveld's early furniture, which by then was reaching prices normally commanded only by modern paintings or sculpture. Selected pieces continue to be made by Cassina and Alivar and marketed as luxuries. Meanwhile, many architects, designers, students and enthusiasts make Rietveld furniture themselves for the price of a few pieces of wood and a day or two's labour. Here, as frequently in twentieth-century art and design, reproduction is elided into production.

Select Bibliography and Sources

Archives

Van Doesburg Archives (VDA), Rijksdienst Beeldende Kunst (RBK), The Hague; Nederlands Architectuurinstituut (NA), Rotterdam/Amsterdam (Van 't Hoff, Oud, Wils and Rietveld archives); Stedelijk Museum, Amsterdam; Gemeentemuseum, The Hague; Rietveld Schröder Archives, Centraal Museum, Utrecht. The Schröder house, 50 Prins Hendriklaan, Utrecht, administered by the Centraal Museum, can be visited by appointment.

Fondation Custodia (FC), Institut Néerlandais, Paris (Mondrian and Oud letters); Musée nationale d'art moderne (MNAM), Centre Georges Pompidou, Paris (drawings for the Aubette). Van Doesburg's studio, 29 rue Charles Enfroit, 92190 Meudon-Val-Fleury, can be visited by appointment.

General

H. L. C. Jaffé, De Stijl, 1917–1931, London 1956 (repr. Cambridge, MA, and London 1986); extensive quotations from writings of De Stijl collaborators, linking their work and ideas to Dutch culture. De Stijl, London 1970, edited and introduced by Jaffé, contains translations from the De Stijl magazine. De Stijl, 1917–32, 2 vols, repr. Amsterdam and The Hague 1968. Index to De Stijl in Form (Cambridge), December 1967, 6, pp. 29–32, and March 1968, 7, pp. 24–32, and Francis Bach Kolling-Dandrieú and Jet Sprenkels-ten Horn, Index op De Stijl/Index of De Stijl, Amsterdam 1983. Paul Overy, De Stijl, London and New York 1969, a short intro. based on these sources.

In the 1980s some art and architectural historians reassessed De Stijl work in the light of newly available material. Carel Blotkamp (ed.), De Beginjaren van De Stijl 1917–1922, Utrecht 1982 (English trans: De Stijl: The Formative Years, 1917–1922, Cambridge, MA, and London, 1986), individual chapters on the pre-1922 work of the initial De Stijl artists and architects (a companion volume on the later years is in preparation). Nancy Troy, The De Stijl Environment, Cambridge, MA, and London 1983, a ground-breaking study of the De Stijl coloured interior and collaborative works. I have drawn heavily on these publications and those by Allan Doig and Evert van

Straaten listed by chapter. I would also like to record my debt to Jane Beckett, 'Discoursing on Dutch Modernism', Oxford Art Journal, 1983, VI, 2, pp. 67–79.

Other general works include Mildred Friedman (ed.), De Stijl 1917–1931: Visions of Utopia, Minneapolis and Oxford 1982, published in conjunction with the 1982–3 De Stijl exhibition of the same name in America and The Netherlands; Serge Lemoine, Mondrian and De Stijl, Paris and London 1987, a short intro. based on the above sources; Mondrian e De Stijl: L'Ideale Moderno, exh. cat., Fondation Cini, Venice, and Milan 1990, with essays by Dutch, American and Italian scholars (in Italian) on Mondrian's painting, De Stijl architecture, stained glass and applied colour.

The sources of quotations are listed here by chapter and page number.

CHAPTER ONE

For Van Doesburg's career as artist, designer, architect, theorist, promoter and propagandist: Joost Baljeu, Theo Van Doesburg, London 1974, based on VDA, with English trans. of many of his writings. Detailed documentation (in Dutch): Theo Van Doesburg, 1883–1931, exh. cat., Van Abbemuseum, Eindhoven 1968, with repr. texts by Van Doesburg and essays by Joost Baljeu, J. Leering and L. Leering-van Moorsel; Evert van Straaten, Theo Van Doesburg 1883–1931, een documentaire op basis van materiaal uit de Schenking Van Moorsel, The Hague 1983, a chronological documentation of the artist's career based on RBK archival material. See also S. Ex and E. Hoek, 'Theo van Doesburg 1883–1931/1931–1983 een bibliografisch overzicht', Wonen/TABK, 1983, 24, pp. 23–8.
11 Van Doesburg, 'L'Évolution de l'architecture moderne en Holland', L'Architecture Vivante, Autumn/Winter 1925, p. 15.

CHAPTER TWO

E. H. Kossman, The Low Countries, 1780–1940, Oxford 1978, is the most useful general source. The Age of Van Gogh: Dutch Painting 1880–1895, exh. cat., Burrell Collection, Glasgow 1990, contains useful

material. Berlage: Pieter Singelenberg, *H. P. Berlage, Idea and Style: The Quest for Modern Architecture*, Utrecht 1972. Amsterdam School: *Wendingen*, 1918–1931; Wim de Wit (ed.), *The Amsterdam School: Dutch Expressionist Architecture, 1915–1930*, Cambridge, MA, and London 1983. Wasmuth publications on Wright: *Frank Lloyd Wright: Ausgeführte Bauten und Entwürfe*, elephant folio, 2 vols, Berlin 1910; *Frank Lloyd Wright: Ausgeführte Bauten*, Berlin 1911. *The Early Work of Frank Lloyd Wright: The 'Ausgeführte Bauten' of 1911*, New York 1982, repr. of Wasmuth 1911 without the intro. by C. R. Ashbee. Dutch housing policy: Donald Grinberg, *Housing in the Netherlands, 1900–1940*, Delft 1982, pp. 33–41, 87; Hans van Dijk, *Guide to Modern Architecture in the Netherlands*, Rotterdam 1987, pp. 9ff. Theosophy and the spiritual: Robert Welsh, 'Mondrian and Theosophy' in *Mondrian* 1971 (see Ch. 4); Carel Blotkamp, 'Annunciation of the New Mysticism: Dutch Symbolism and Early Abstraction', in *The Spiritual in Art: Abstract Painting 1890–1985*, exh. cat., Los Angeles County Museum and New York 1986, pp. 89–111.
20 Henry Asselin, 'L'Architecture moderne en Hollande', *Art et Décoration*, 1925, XLVII, pp. 101–02, J. G. Wattjes, 'Moderne Bouwkunst in Utrecht', *Bouwbedrijf*, September 1925, II, 9, pp. 328–32.
21 J. H. Huizinga, *Dutch Civilization in the Seventeenth Century and other essays*, Harmondsworth 1968, pp. 155–6. Friedrich Marcus Huebner, 'Open Brief', *De Stijl*, June 1919, II, 8, pp. 94–5, *Het Nieuwe Bouwen: De Stijl* 1983, p. 23 (see Ch. 7). Roggeveen and Oud, *Holland Express*, 19 September 1917, X, 38, p. 455; 3 October 1917, X, 40, p. 479, Doig 1986, p. 37 (see Ch. 6).
26 Mondrian to Van Doesburg, 2 February 1921, RBK. Rietveld and Berlage, Singelenberg 1972, pp. 177, 228, n. 42.
33 Mart Stam, 'Away with the Furniture Artists' in Werner Gräff (ed.), *Innenraume*, Stuttgart 1928, pp. 128–30 (trans. Tim and Charlotte Benton, *Form and Function*, London 1975, pp. 227–8). Van Doesburg to Kok, December 1919, M. Friedman 1982, p. 48 (see General). Mondrian to Van Doesburg, 11 October 1919, RBK.
36 Van Doesburg to Evert and/or Thijs Rinsema, 19 June 1922, Christie's catalogue, Amsterdam, 21 May 1987, p. 100. Van Doesburg to De Boer, 29 December 1922, trans. Doig 1986, p. 117 (see Ch. 6).

CHAPTER THREE
Beckett 1983 (see General) is the source for much material here. Mondrian writings: Harry Holtzman and Martin S. James (eds and trans.), *The New Art – The New Life. The Collected Writings of Piet Mondrian*, Boston 1986 and London 1987; his Bauhaus book, *Neue Gestaltung*, Munich 1925, repr. 1974. For translations of many Van Doesburg writings: Baljeu 1974 (see Ch. 1). Sergio Polano, *Theo Van Doesburg: Scritti di arte e di architettura*, Rome 1979: Italian trans. of nearly all his writings on art and architecture and a useful but incomplete catalogue raisonné. Hannah L. Hedrick, *Theo van Doesburg, Propagandist and Practioner of the Avant-Garde, 1909–1931*, Ann Arbor, MI, 1980: a study of his poetry and fiction. See also Egbert Krispyn, 'Literature and De Stijl' in Francis Bulhof (ed.), *Nijhoff, Van Ostaijen, 'De Stijl': Modernism in the First Quarter of the 20th Century*, The Hague 1976. Van Doesburg's poetry collected in I. K. Bonset, *Nieuwe woordbeeldingen, de gedichten van Theo van Doesburg* (ed. K. Schippers), Amsterdam 1975. Van Doesburg's Bauhaus book, *Grundbegriffe der neuen gestaltenden Kunst*, Munich 1925 (English trans. *Principles of Neo-Plastic Art*, London 1968); his writings on art and architecture, repr. in *De nieuwe beweging in de schilderkunst*, Dordrecht 1983, and *Europese architectuur*, Nijmegen 1986. Other De Stijl writings are translated in Jaffé 1970 (see General).
39 J. H. Huizinga 1968, p. 156 (see Ch. 2).
40 Mondrian to Van Doesburg, *Mondrian from Figuration to Abstraction* 1988, p. 40 (see Ch. 4).
41 J. P. Mieras in *Bouwkundig Weekblad*, 24 November 1917, XXXVIII, 47, p. 273, trans. Beckett 1983, p. 74 (see General). Intro. to Blotkamp 1986, p. xi (see General). Van Doesburg, *Principles of Neo-Plastic Art*, p. 5. Mondrian's notes, trans. Welsh and Joosten 1969 (see Ch. 4).
42 Mondrian to Van Doesburg, Blotkamp 1986, p. 49 (see General).
43 Illustrations in Theo van Doesburg, *Drie Voordrachten over de Nieuwe Beeldende Kunst*, Amsterdam 1919.
46–8 Van Doesburg to Van der Leck, May 1917, M. Friedman 1983, p. 73 (see General). 'First De Stijl Manifesto', *De Stijl*, November 1918, II, 1, p. 2; a more accurate modern trans. in Holtzman and James 1987, p. 24.
49 New lay out, Mondrian to Van Doesburg, 5 August 1920, with sketches, partly reproduced in Van Straaten 1983, p. 98 (see Ch. 1). Mondrian to Van Doesburg and Lena Milius, 2 February 1921, RBK.
52 'Second De Stijl (Literature) Manifesto', *De Stijl*, April 1920, III, 6, p. 49. Van Eesteren to Van Doesburg, 26 December 1926, RBK, trans. Doig 1986, p. 164 (see Ch. 6).
53 Van Doesburg on *i10*, *De Stijl*, 1927 (actually 1928), series XIV, 79–84, p. 7; 'large publisher in Germany', Van Doesburg to Bart de Ligt, 7 February 1929, trans. Doig 1986, p. 219 (see Ch. 6). *Art Concret* (Paris), April 1930, p. 1, trans. 'Art Concret: The Basis

of Concrete Painting', Baljeu 1974, pp. 180–81 (see Ch. 1).

CHAPTER FOUR

Mondrian: Michel Seuphor, *Piet Mondrian*, Paris 1956 (rev. 1987, English trans. *Piet Mondrian: Life and Work*, New York 1956 and London 1957), contains illustrated catalogue, as does M. G. Ottolenghi, *Mondrian*, Milan 1974; H. L. C. Jaffé, *Piet Mondrian*, New York 1970 and London 1989; J. Joosten and R. P. Welsh, *Two Mondrian Sketchbooks 1912–14*, Amsterdam 1969 (with English trans.), a facsimile of 2 important sketchbooks from the period when Mondrian was developing his early abstractions. Coos Versteeg, *Mondrian, Een Leven in Maat en Ritme*, The Hague 1988, a popular biography by a journalist, in co-operation with the Mondrian scholar Herbert Henkels. Major exh. cats: *Piet Mondrian 1872–1944*, Art Gallery of Toronto 1966; *Piet Mondrian, Centennial Exhibition*, Solomon R. Guggenheim Museum, New York 1971; *Mondrian: Drawings, Watercolours, New York Paintings*, Staatsgalerie, Stuttgart 1980; *Mondrian from Figuration to Abstraction*, Tokyo and The Hague 1987–8.

For discussion and documentation of Van Doesburg's painting see Ch. 2 and H. L. C. Jaffé, *Theo Van Doesburg*, Amsterdam 1983 (in Dutch). See also Robert Welsh, 'Theo van Doesburg and Geometric Abstraction' in Bulhof 1976 (see Ch. 3). Relatively little has been published on Van der Leck and Huszár: R. W. D. Oxenaar, *Bart Van Der Leck tot 1920, een primitief van de nieuwe tijd*, The Hague 1976 (in Dutch); *Bart Van der Leck 1876–1958*, exh. cat., Rijksmuseum Kröller-Müller, Otterlo/Stedelijk Museum, Amsterdam 1976, text by Oxenaar (in Dutch and English); *Bart Van der Leck 1876–1958*, Institut Néerlandais, Paris 1980, text by Oxenaar (in French). See also Michel Seuphor, 'Le peintre Bart Van der Leck', *Werk*, 1951, XXXVIII, 11, pp. 357–60; the fullest published discussion in English is by Cees Hilhorst in Blotkamp 1986, pp. 153–85 (see General). S. Ex and E. Hoek, *Vilmos Huszár, Schilder en ontwerper 1884–1960*, Utrecht 1985, is a thoroughly researched monograph published on the occasion of the Huszár retrospective in Amsterdam and Budapest. Ex's essay on Huszár in Blotkamp 1986, pp. 77–121, is the only substantial discussion in English. For Domela's painting of his De Stijl period see Marcel Brion, *Domela*, Paris 1961; H. L. C. Jaffé, *Domela*, Paris 1980; *Domela: 65 ans d'abstraction*, exh. cat., Musée d'art moderne de la ville de Paris 1987.

60 Mondrian on Van der Leck, *De Stijl*, Van Doesburg memorial issue, January 1932, pp. 48–9, trans. M. Friedman 1983, p. 69 (see General).

62 Van Doesburg on *The Donkey Riders*, 'Bij be

bijlagen', *De Stijl*, November 1917, I, 1, pp. 11–12; Mondrian to Van Doesburg, M. Friedman 1983, p. 75 (see General).

66 Mondrian to Van Doesburg, 13 June 1918, Blotkamp 1986, p. 99 (see General; trans. modified).

67 Van Doesburg, Blotkamp 1986, p. 54 (see General). Vilmos Huszár, 'Iets over de farbenfibel van W. Ostwald', *De Stijl*, August 1918, I, 10, pp. 113–18; Wilhelm Ostwald, 'Die Harmonie der Farben, *De Stijl*, May 1920, III, 7, pp. 60–62.

68 Mondrian to Van Doesburg, 19 April 1920, Blotkamp 1986, p. 248 (see General).

CHAPTER FIVE

Vantongerloo: the best account is Nicolette Gast's in Blotkamp 1986 (see General). See also Georges Vantongerloo, *Paintings, Sculptures, Reflections*, New York 1948; *Georges Vantongerloo*, exh. cat., Marlborough Gallery, London 1962; *Georges Vantongerloo*, exh. cat., Kunsthaus, Zurich 1981. Rietveld (see also Ch. 7): Frits Bless, *Rietveld 1888–1964, een biografie*, Amsterdam and Baarn 1982 (in Dutch), covers furniture as well as architectural design; Daniele Baroni, *The Furniture of Gerrit Thomas Rietveld*, London and New York 1979, the most comprehensive work to date on the subject; *Rietveld*, Stedelijk Museum, Amsterdam 1981 (English version), a useful catalogue of material (mainly furniture) in the Stedelijk. *Rietveld Meubels, Om Zelf Te Maken: Werkboek/How to Construct Rietveld Furniture: Workbook*, Delft 1986 (in Dutch and English). Much new documentation and illustrations of Rietveld's early furniture designs in: *Rietveld als Meubelmaker 1900–1924*, exh. cat., Centraal Museum, Utrecht 1983, Dutch text by Marijke Küper. *Gerrit Rietveld: Craftsman and Visionary, A Centenary Exhibition*, exh. cat., Barry Friedman Ltd, New York 1988, with excellent illustrations and documentary material. See also Marijke Küper and Mart van Schijndel, 'Der Sitzgeist: Over het ontstaan van de Zigzagstoel', *Jong Holland*, May 1987, III, 2, pp. 4–11; Paul Overy, 'Gerrit Rietveld: Furniture and Meaning', and Brian Housden, 'Jolly Nice Furniture' in Tony Knipe and John Millard (eds), *2D/3D: Art and Craft Made and Designed in the 20th Century*, Sunderland 1987; *Rietveld Furniture and the Schröder House*, exh. cat., South Bank Centre, London 1990.

74 *De Stijl*, September 1919, II, 11, p. 136.

75 Sigfried Giedion, *Mechanization Takes Command* (1948), New York 1969, p. 485; Kenneth Frampton, *Modern Architecture, A Critical History*, London and New York 1985, p. 144. Rietveld to Oud, 4 May 1920, quoted Blotkamp 1986, p. 267 (see General).

76 Johan Huizinga, *Homo Ludens*, English edn, Harmondsworth 1970, p. 17.

79 G. Rietveld, 'Aanteekening bij kinderstoel', *De Stijl*, July 1919, II, 9, p. 102, trans. Brown 1958, p. 22 (see Ch. 7).

83 End Table, A. Boeken, 'Bij een paar afbeeldingen van werk van G. Rietveld', *Bouwkundig Weekblad*, 27 September 1924, XLV, 39, p. 382. Rietveld on De Stijl, G. *Rietveld Architect* 1971–2, np (see Ch. 7).

84 'X-Beelden', *De Stijl*, July 1920, III, 9, p. 77.

CHAPTER SIX

Allan Doig, *Theo Van Doesburg: Painting into Architecture, Theory into Practice*, Cambridge 1986, relates Van Doesburg's collaborative and architectural work to his painting and theoretical writings. Evert van Straaten, *Theo Van Doesburg, Painter and Architect*, The Hague 1988 (in Dutch and English), exhaustively describes and documents his collaborative and applied art works (including stained glass and colour designs for interiors and exteriors) and architectural designs, with excellent colour illustrations. See also Hellen Zeeders and Jan Cees Nauta, *Theo van Doesburg in Drachten*, exh. cat., Drachten 1988; Jane Beckett, '"De Vonk", Noordwijk, an Example of Early De Stijl Co-operation', *Art History*, 1980, III, 2, pp. 202–17; N. J. Troy, 'Theo Van Doesburg: From Music into Space', *Arts Magazine*, 1982, LVI, 6, pp. 96–101. Huszár's collaborative and colour work is documented in Ex and Hoek 1985 (see Ch. 4) and by Ex in Blotkamp 1986 (see General), Van der Leck by Hilhorst in Blotkamp 1986.

88–9 *De Stijl*, November 1918, II, 1, pp. 10–12, pl. I, and December 1918, II, 2, pl. II. 'Notes on Monumental Art' trans. Jaffé 1970, p. 103 (see General).

91 Van Doesburg to Oud, 3 November 1921, FC, Blotkamp 1986, p. 146 (see General). Van Doesburg to Oud, 18 December 1921, FC, *Het Nieuwe Bouwen: Voorgeschiedenis/Previous History*, Delft 1982, p. 160.

92 Spangen glass, *De Stijl*, June 1921, IV, 5, p. 78.

99 Mondrian to Oud (early 1926), FC, Troy 1983, p. 220, n. 66 (see General); comment, Troy 1983, p. 149.

CHAPTER SEVEN

Two important chapters on De Stijl in Reyner Banham, *Theory and Design in the First Machine Age*, London 1960; Bruno Zevi, *Poetica dell'Architettura Neoplastica*, Turin 1953 (rev. 1974), claims De Stijl as the ancestor of the most 'radical' branch of modernism; *Het Nieuwe Bouwen: De Stijl: De Nieuwe Beelding in de architectuur/Neo-Plasticism in Architecture*, Delft 1983, with well-researched essays by various architectural historians. Giovanni Fanelli, *De Stijl*, Guide all'architettura moderna, Rome and Bari 1983, a general intro. to the architecture with selected studies of individual buildings and artefacts. The architectural magazines *Bouwkundig Weekblad* and *Het Bouwbedrijf* contain articles on buildings by De Stijl architects published shortly after their completion. See also 'Mondrian ⟨–⟩ architectuur', in Carel Blotkamp, *Mondriaan in detail*, Utrecht and Antwerp 1987, pp. 9–101, and Allan Doig, 'De architectuur van De Stijl en de westerse filosofische traditie', *Wonen/TABK*, August 1982, 15–16, pp. 45–57.

Theodore Brown, *The Work of G. Rietveld, Architect*, Utrecht 1958, covers the architecture and some furniture, also a useful illustrated catalogue and translations of 2 essays by Rietveld. Brown's 'Rietveld's Egocentric Vision', *Journal of the Society of Architectural Historians*, December 1965, XXIV, 4, pp. 292–6, has further translated extracts from his writings. Four Dutch texts by Rietveld in Gerrit Rietveld, *Texten*, Utrecht 1979. Paul Overy, Lenneke Büller, Frank den Oudsten and Bertus Mulder, *The Rietveld Schröder House*, Cambridge, MA, and Guildford 1988, long interview with Truus Schröder, introductory essay by Overy and afterword by Mulder on house's restoration by Mulder. Bertus Mulder, Gerrit Jan de Rook and Carel Blotkamp, *Rietveld Schröder Huis 1925–1975* Utrecht and Antwerp 1975 (in Dutch), interesting material on the history of the Schröder house. Catalogues: G. *Rietveld Architect*, Stedelijk Museum, Amsterdam, and Hayward Gallery, London 1971–2; *Rietveld Schröder Archief*, Centraal Museum, Utrecht 1988 (in Dutch), with material on his interior design and furniture. Corrie Nagtegaal, Tr. *Schröder-Schräder: Bewoonster van het Rietveld Schröderhuis*, Utrecht 1987, a booklet about Schröder with Dutch texts of 2 articles by her from *De Werkende Vrouw* 1930.

Little on the other architects is available in English apart from the chapters on Oud, Van 't Hoff and Wils in Blotkamp 1986 (see General). Oud: Gunther Stamm, *J. J. P. Oud, Bauten und projekte 1906–1963*, Mainz 1984; Hans Oud, *J. J. P. Oud: Architect, 1890–1963*, The Hague 1984 (in Dutch with summary in English); Umberto Barbieri, *J. J. P. Oud*, Bologna 1986. Catalogues: *The Original Drawings of J. J. P. Oud 1890–1963*, text Jane Beckett, Architectural Association, London 1978; *Architectuur van J. J. P. Oud*, texts Oud, Umberto Barbieri, Bernand Colenbrander and Henk Engel, Lijnbaancentrum RKS, Rotterdam 1981–2. Late in life Oud published his own version of his relationship with De Stijl: J. J. P. Oud, *Mein Weg in 'De Stijl'*, The Hague and Rotterdam 1960 (in German), partly translated into English in Sergio Polano, 'Notes on Oud: Re-reading the Documents', *Lotus International* (Milan), September 1977, 16, pp. 42–9. Wils: Enzo Godoli, *Jan Wils, Frank Lloyd Wright e De Stijl*, Florence 1980. Van Eesteren: R. Blistra, *C. van Eesteren*, Amsterdam

1971 (in English).
104 Van Doesburg to De Boer, trans. Doig 1986, pp. 117–18 (see Ch. 6). Illustrations in *De Stijl*, December 1922, V, 12, unnumbered plates.
105 Vilmos Huszár, 'Aesthetische Beschouwing bij Bijlagen 3 en 4', *De Stijl*, January 1919, II, 3, pp. 27–31; illustration pl. III, also in *De Stijl*, May 1919, II, 7, pl. XV.
106 Huib Hoste, *De Telegraaf*, 19 March 1919, Blotkamp 1986, p. 212 (see General). Jan Wils, 'Symmetrie en kultuur', *De Stijl*, October 1918, I, 12, pp. 137–40.
112 Oud, 'Het Monumentale Stadsbeeld', *De Stijl*, 1917, I, 1, pp. 10–11, English trans. *Lotus International* (Milan), September 1977, 16, pp. 51–2. Antedating the design, Van Doesburg to Oud, 13 March 1919, Blotkamp 1986, p. 150, n. 22 (see General). Oud, Blotkamp 1986, p. 130.
116 Truus Schröder: 'Interview with Truus Schröder', in Overy *et al.* 1988, p. 56.
117 Truus Schröder, interview with Nancy Troy, Troy 1983, p. 119 (see General).
118 Van Doesburg to Rietveld, RBK, trans. Overy *et al.* 1988, p. 65. Van Doesburg to Domela, 27 August 1925, Doig 1986, pp. 168–9 (see Ch. 6). 'Tot een beeldende architectuur', *De Stijl*, 1924, VI, 6–7, pp. 78–83, trans. 'Towards a plastic architecture', Baljeu 1974, pp. 142–47 (see Ch. 1).

CHAPTER EIGHT
Grinberg 1982 (see Ch. 2) and works under Ch. 7. Oud's housing: Rob Dettingmeijer, 'De strijd om een goed gebouwde stad/The fight for a well built city', in *Het Nieuwe Bouwen in Rotterdam 1920–1960*, Delft 1982; Bernand Colenbrander (ed.), *Oud Mathenesse: Het Witte Dorp, 1923–1987*, Rotterdam 1987. See also *Het Nieuwe Bouwen Internationaal: CIAM, Volkshuisvesting, Stedebouw/International: Housing, Town Planning*, Delft 1982; Frits Bless, 'From Schröder house to worker's dwelling', *Het Nieuwe Bouwen: Voorgeschiedenis* 1982, p. 135 (see Ch. 6, p. 91); Pieter Singelenberg, 'Rietveld en woningtypologie 1927–1936', *Kunstwerk* 1980, 5, pp. 3–19. Pauline Madge, 'Controversen rond Rietveld', *Wonen/TABK*, August 1982, 15–16, pp. 37–43.
121 'The Monumental Image of the City' (see Ch. 7, p. 112).
125 J. J. P. Oud, 'Gemeentelijke Woningbouw in Spangen en Tussendijken,' *Rotterdamsch Jaarboekje* 1924, XLIX–LV, *Het Nieuwe Bouwen: De Stijl* 1983, p. 130 (see Ch. 7). Oud to Van Doesburg, M. Friedman 1983, p. 94 (see General). Van Doesburg to Oud, Blotkamp 1986, p. 136 (see General).
128 Jan Gratama, Doig 1986, p. 104 (see Ch. 6). Jan Wils, 'Woningblook in "Spangen" en Theater

"Scala" te Rotterdam van Architect L. C. v. d. Vlugt', *Het Bouwbedrijf*, August 1925, II, 8, p. 291. 'Perpetual workers' dwellings', 'dingy and drab', Oud to Van Doesburg (October 1921), Blotkamp 1986, p. 146 (see General).
129 Van Doesburg to Oud, 11 November 1924, RBK, trans. Doig 1986, p. 223 (see Ch. 6). *Het Dagblad van Rotterdam*, 28 June 1924, Colenbrander 1987, p. 55.
131 Van Doesburg quoted by Badovici to Oud, 10 June 1928, Oud archive, NA, Troy 1983, p. 211, n. 25 (see General).
132–3 Oud, 'The £213 house: a solution to the rehousing problem for rock-bottom incomes in Rotterdam by the architect J. J. P. Oud', *The Studio*, March 1931, 456, pp. 176, 177.
134 Henry-Russell Hitchcock, *J. J. P. Oud*, Paris 1931, np; Hitchcock, *Architecture: 19th and 20th Centuries*, Harmondsworth 1958, p. 378.
135 J. J. P. Oud, 'Huisvrouwen en Architecten', *i10*, 1927, 2, pp. 44–6.
138–9 *The Studio*, 1933, 501, p. 249. Hitchcock 1931, np (see p. 134); Henry-Russell Hitchcock and Philip Johnson, *The International Style*, New York 1932, *passim*.
139 Schröder house, E. E. von Strasser, *Neuere hollandische Baukunst*, Munich 1926, p. 21, Brown 1958, p. 58 (see Ch. 7).
142 Hitchcock and Johnson, new edn 1966, p. x.
144 Van Eesteren, 'urban planner', Umberto Barbieri, 'The City has Style' in *Het Nieuwe Bouwen: De Stijl* 1983, p. 131 (see Ch. 7). Richard Padovan, 'The Pavilion and the Court', *Architectural Review*, December 1981, CLXX, 1018, pp. 363–4.

CHAPTER NINE
'Film als reine Gestaltung' (Film as Pure Form), *Die Form*, 15 May 1929, IV, 10, pp. 241–8, trans. *Form* (Cambridge), Summer 1966, 1, pp. 5–11. Oud's early writings in *De Stijl* trans. *Lotus International* (Milan), September 1977, 16, pp. 51–4. See also Sergio Polano, 'Notes on Oud: Re-reading the documents', *Lotus International*, September 1977, 16, pp. 45ff. For De Stijl and Dada, K. Schippers, *Holland Dada*, Amsterdam 1974; Jane Beckett, 'Dada, Van Doesburg and De Stijl', *Journal of European Studies*, 1979, 9, pp. 1–25. Van Doesburg and the Bauhaus, Baljeu 1974, pp. 41, 43–4 (see Ch. 1); Claudine Humblet, *Le Bauhaus*, Lausanne 1980; Zevi 1974, p. 229 (see Ch. 7); *Theo Van Doesburg, 1883–1931* 1968, pp. 45–8 (see Ch. 1). Sophie Lissitzky-Küppers, *El Lissitzky*, London 1968. Krisztina Passuth, *Les Avant-Gardes de l'Europe Centrale*, Paris 1988, pp. 125–7. Andrzej Turowski, *Existe-t-il un Art de l'Europe de l'Est?* Paris 1986. Yehuda Safran, *Frederick Kiesler*, exh. cat., Architectural Association, London 1989.

147 Banham 1960, p. 153 (see Ch. 7). 'De stijl der toekomst', repr. Theo van Doesburg, *De nieuwe beweging in de schilderkunst*, Dordrecht 1983. J. J. P. Oud, 'Architectonische beschouwing bij Bijlage VIII', *De Stijl*, February 1918, I, 4, pp. 39–41, trans. *Form* (Cambridge), September 1967, pp. 9–11.

148 J. J. P. Oud, 'Bouwkunst en Normalisatie bij den Massabouw,' *De Stijl*, May 1918, I, 7, pp. 77–9, English trans. *Lotus International* 1977, pp. 53–4.

149 J. J. P. Oud, 'Orientatie', *De Stijl*, December 1919, III, 2, p. 13, trans. Jaffé 1970, p. 132 (see General). Oud, *De Stijl*, January 1920, III, 3, pp. 25–7, pl. III.

150–51 Bethlehem Shipbuilding Works, *De Stijl*, April 1920, III, 6, pl. IX, commentary, *De Stijl*, May 1920, III, 7, p. 64. 'The Will to Style', trans. Baljeu 1974, p. 122 (see Ch. 1).

152 I. K. Bonset, 'Het andere gezicht', *De Stijl*, April 1921, IV, 4, p. 49. 'Let us not forget . . .', *Architectura*, 1924, 28, p. 62, M. Friedman 1983, p. 204 (see General). 'Vers une construction collective', *De Stijl*, 1924, VI, 6–7, pp. 89–92, trans. Baljeu 1974, pp. 147–8 (see Ch. 1). 'De Dood de Modernismen', *De Stijl*, 1924–25, VI, 9, p. 122, *Het Nieuwe Bouwen: De Stijl* 1983, p. 77 (see Ch. 7).

153 'Painting and Plastic Art: On Counter-Composition and Counter-Plastic Elementarism (A Manifesto fragment) [Rome, July 1926]', *De Stijl*, 1926, VII, 75–6, pp. 35–43, trans. Baljeu 1974, pp. 156ff (see Ch. 1).

156–8 Van Doesburg to Kok, 7 January 1921, Jaffé 1956, p. 20 (see General). Gropius to Oud, 15 October 1923, Oud archive, NA, Humblet 1980, p. 193. Meyer to Oud, 9 January 1922, 20 April 1922, Oud archive, NA, Humblet 1980, pp. 193, 205, n. 191. J. J. P. Oud, 'Over de toekomstige bouwkunst en hare architectonische mogelijkheden', *Bouwkundig Weekblad*, 1921, XLII, 24, pp. 147–60. Banham 1960, p. 157 (see Ch. 7). J. J. P. Oud, *Holländische Architektur*, Bauhausbuch no. 10, Munich 1926.

159 Van Doesburg to Beekman, September 1919, M. Friedman 1983, p. 46 (see General). *De Stijl*, June 1921, IV, 6, p. 93; *De Stijl*, September 1922, V, 9.

161 *De Stijl*, June 1922, V, 6, pp. 81–5.

162 Sophie Lissitzky-Küppers 1968, p. 81. El Lissitzky, *Stroitelnaia Promyshlennost* (Moscow), December 1926, 12, pp. 877–81. 'Produktion-Reproduktion' *De Stijl*, July 1922, V, 7, pp. 98–101. Moholy-Nagy to Oud, 17–20 August 1922, Oud archive, NA, Doig 1986, p. 141 (see Ch. 6).

163–4 R. U. R., *De Stijl*, May–June 1923, VI, 3–4, np. F. Kiesler, 'Austellungssystem: Leger und Trager', 'Vitalbau-Raumstadt-Funktionelle-Architektur', *De Stijl*, 1925, VI, 10–11, pp. 138–46, trans. Benton 1977, p. 105–06 (see Ch. 2, p. 33). F. Kiesler,

'L'architecture élémentarisée', *De Stijl*, 1927 (actually 1928), series VII, 79–84, p. 101. *Mécano*, 1923, white, 4–5, np, trans. *Form* (Cambridge), 15 April 1967, 4, pp. 31–2.

CHAPTER TEN

De Stijl in France, cat. of 'De Stijl et l'architecture en France', Institut Français d'Architecture, Paris 1985, Brussels and Liège 1985, detailed essay by Nancy Troy and Yve-Alain Bois, 'De Stijl et l'architecture à Paris', with contributions on the relation between the work of Le Corbusier, Robert Mallet-Stevens and Eileen Gray and De Stijl. Allan Doig, 'Theo van Doesburg en Le Corbusier', *Wonen/TABK*, August 1982, 15–16, pp. 29–36. Christopher Green, *Cubism and its Enemies*, New Haven and London 1987, detailed treatment of Mondrian and Van Doesburg's activities and work in Paris in the 1920s. John Golding and Christopher Green, *Léger and Purist Paris*, exh. cat., Tate Gallery, London 1970. *Rob Mallet-Stevens: Architecture, Mobilier, Décoration*, Paris 1986, pp. 107ff.

Mondrian's studio: Herbert Henkels, 'Mondrian in his Studio', and 3 hitherto untranslated interviews with Mondrian in the 1920s in *Mondrian from Figuration to Abstraction* 1987–8 (see Ch. 4). Mondrian in 'Trialogue', *The New Art – The New Life* 1987 (see Ch. 3). Essays on Mondrian's studio in Yve-Alain Bois (ed.), *L'Atelier de Mondrian: Recherches et dessins*, Paris 1982. See also *iio*, exh. cat., Institut Néerlandais, Paris 1989. Yve-Alain Bois, 'Mondrian en France, sa collaboration à *Vouloir*, sa correspondance avec Del Marle', *Bulletin de la Société de l'Histoire de l'art français*, 1981, pp. 281–98, includes letters from Mondrian to Del Marle.

The Aubette: *Theo van Doesburg: Projets pour l'Aubette*, exh. cat., MNAM, Centre Georges Pompidou, Paris 1977; *Theo van Doesburg: Aspects méconnus de l'Aubette*, exh. cat., Musées de la Ville de Strasbourg 1989, with French trans. of Van Doesburg's text from *Het Bouwbedrijf*, 1929; Karl Gerstner, 'Die Aubette als Beispiel integrierter Kunst', *Werk*, October 1960, XLVII, 10, pp. 375–80.

167–8 Mondrian, 'De huif naar den wind', *De Stijl*, 1924 (actually 1925), VI, 6–7, pp. 86–8. Mondrian to Van Doesburg, 4 December 1919, *The New Art – The New Life* 1987, p. 395, n. 8 (see Ch. 3). Mondrian, 'Les Grands Boulevards', trans. *ibid*, p. 128.

168 Van Doesburg to Kok, Seuphor 1987, p. 127 (see Ch. 4).

174 *L'Esprit Nouveau*, *De Stijl*, July 1920, III, 9, p. 78.

176 *L'Architecture*, July 1924, *De Stijl in France* 1985, p. 62.

178 Zervos review, *Cahiers d'art*, January 1926, *The New Art – The New Life* 1987, p. 202 (see Ch. 3).

179 *Gesamtkunstwerk*, Van Doesburg to Adolf Behne, 7 November 1928, Ulrich Conrads and Hans G. Sperlich, *The Architecture of Fantasy*, New York 1963, p. 155.

180 Earth colours, Van Doesburg, 'Schilderkunst en plastiek: over contra-compostie en contra-plastiek – Elementarisme', *De Stijl*, 1926, series VII, 75–6, p. 41, trans. Baljeu 1974, p. 160 (see Ch. 1).

185 Van Doesburg, 'Notes on L'Aubette at Strasbourg', *De Stijl*, Aubette issue, 1928, VIII, 87–9, trans. Jaffé 1970, p. 237 (see General); monumental art, *De Stijl*, November 1918, II, 1, p. 12. Henry-Russell Hitchcock, *Modern Architecture, Romanticism and Reintegration*, New York 1929, p. 183.

186 Van Doesburg to Del Marle, 18 December 1927, Bois, 'Mondrian en France', 1981, p. 295. Diary extracts, *De Stijl*, memorial issue, January 1932, pp. 19–24. Aubette described, Troy 1983, p. 161 (see General). Van Doesburg to Bart de Ligt, trans. Doig 1986, p. 219 (see Ch. 6).

188–9 Van Doesburg, 'Der Kampf um den Neuen Stil' (The Struggle for the New), *Neue Schweizer Rundschau*, 1929, trans. *Het Nieuwe Bouwen: De Stijl* 1983, p. 29 (see Ch. 7). Van Doesburg to Kok, 23 January 1930, RBK, Van Straaten 1983, pp. 166–9 (see Ch. 1). Manifesto and white painting, 'Élémentarisme (Les éléments de la nouvelle peinture)', *De Stijl*, memorial issue, January 1932, pp. 17–19, trans. Baljeu 1974, pp. 183–5 (see Ch. 1).

190 Van Doesburg to Huib Hoste, 20 July 1918, Doig 1986, p. 59 (see Ch. 6). Van Doesburg to De Ligt, 7 February 1929, RBK, Doig 1986, p. 219. Mondrian to Roth, September 1938, Alfred Roth, *Begegnung mit Pionnieren*, Basel and Stuttgart 1973, p. 180.

CHAPTER ELEVEN

Alfred Barr, *Cubism and Abstract Art*, New York 1936 (repr. 1975); *De Stijl 1917–28*, 1951 (repr. 1961), pamphlet published as intro. to the MOMA, New York 1951–2 exhibition of the same title. Stedelijk Museum, Amsterdam 1951, cat. of same exh., English trans. of De Stijl texts and letters.

193 Katherine Dreier, *Modern Art*, exh. cat., Brooklyn Museum, New York 1927, p. 270.

194 Barr 1975, pp. 141, 156. *De Stijl* 1951, p. 5.

List of Illustrations

$15\frac{3}{4} \times 25\frac{1}{4} \times 15\frac{3}{4}$ (40 × 64 × 40). Museum Sztuki, Lodz
KROP, Hildo
8 Bridge sculpture, Amsterdam, 1926 (detail).
Granite, $31\frac{1}{2} \times 35$ (80 × 89). Photo courtesy Stedelijk
Museum, Amsterdam
LECK, Bart van der
2 *Composition 1918*. Oil on canvas, $21\frac{3}{8} \times 16\frac{3}{4}$
(54.3 × 42.5). Tate Gallery, London
16 *Leaving the Factory* 1910. Oil on canvas, $47\frac{1}{4} \times 55\frac{1}{8}$
(120 × 140). Boymans-van Beuningen Museum,
Rotterdam
24 *Composition 3* 1917. Oil on canvas, $37\frac{1}{2} \times 40\frac{1}{4}$
(95 × 102). Rijksmuseum Kröller-Müller, Otterlo.
Photo Frank den Oudsten
30 *Dock Work* 1916. Oil on canvas, $35 \times 94\frac{1}{2}$
(89 × 240). Rijksmuseum Kröller-Müller, Otterlo
31 Poster for Batavier shipping line, 1915. Lithograph
on paper, $30\frac{3}{4} \times 45\frac{1}{4}$ (78.1 × 114.9). Stedelijk
Museum, Amsterdam
32 *Composition 1917 No. 5*. Oil on canvas, $23\frac{1}{4} \times 57\frac{7}{8}$
(59.1 × 147). Private collection. From *De Stijl* (vol. 1,
no. 1) October 1917
70 Lettering for Metz, 1930s
71 Interior with wall hangings and carpet, *c.* 1930
(furniture by Rietveld). From *Mobilier et Décoration*
July 1930. Bibliothèque Nationale, Paris
72 Trade stand for the Bruynzeel company, Utrecht
Jaarbeurs, 1919, with P. J. C. Klaarhamer. Photo
courtesy Stedelijk Museum, Amsterdam
MALLET-STEVENS, Robert
140 Set for exterior of engineer's laboratory, still
from Maurice L'Herbier's film *L'Inhumaine* 1923
141 House, rue Mallet-Stevens, Paris, 1927. Photo
Tim Benton
MONDRIAN, Piet
1 *Composition in Colour B* 1917. Oil on canvas,
$19\frac{3}{4} \times 17\frac{3}{8}$ (50 × 44). Rijksmuseum Kröller-Müller,
Otterlo
22 Cover of *De Stijl* (vol. 4, no. 1) January 1921, with
Van Doesburg
25 *Composition in Line* initial state, 1916–17. Photo
courtesy Bremmer Archive, Gemeentearchief, The
Hague
26 *Composition in Line* 1917. Oil on canvas, $42\frac{1}{2} \times 42\frac{1}{2}$
(108 × 108). Rijksmuseum Kröller-Müller, Otterlo
34 *Composition in Red, Yellow and Blue* 1922. Oil on
canvas, $16\frac{1}{2} \times 19\frac{5}{8}$ (42 × 50). Stedelijk Museum,
Amsterdam
37 *Chequerboard with Light Colours* 1919. Oil on
canvas, $33\frac{7}{8} \times 41\frac{3}{4}$ (86 × 106). Collection Haags
Gemeentemuseum, The Hague
42 *Composition with Two Lines* 1931. Oil on canvas,
$31\frac{1}{2} \times 31\frac{1}{2}$ (80 × 80). Stedelijk Museum, Amsterdam
83 Ida Bienert interior, 1926. Drawing. Photo Frank
den Oudsten

OUD, J. J. P.
3 Factory at Purmerend, *c.* 1919. Drawing. From *De
Stijl* (vol. 3, no. 5) March 1920
55 Furniture in Villa Allegonda, *c.* 1928
64 De Vonk, Noordwijkerhout, 1917 (colour design
by Van Doesburg). Photo Frank den Oudsten
65 De Vonk, Noordwijkerhout, 1917, hall (colour
design by Van Doesburg). Photo courtesy Frank den
Oudsten
91 Seaside housing, Scheveningen, 1917. Perspective,
plan and sections, photo-type on cardboard,
$22\frac{1}{4} \times 15\frac{1}{2}$ (56.5 × 39.5). Archive J. J. P. Oud, inv. nr.
25, Nederlands Architectuurinstituut, Rotterdam/
Amsterdam. Photo courtesy Nederlands Architec-
tuurinstituut, Rotterdam/Amsterdam
92 Remodelled Villa Allegonda, Katwijk-am-zee,
1916, with Menso Kamerlingh Onnes. Rijksdienst
Beeldende Kunst, The Hague. Photo courtesy Frank
den Oudsten
97 Spangen Block I, Rotterdam, 1919. Rijksdienst
Beeldende Kunst, The Hague. Photo courtesy Frank
den Oudsten
99 Site-manager's temporary shed, Oud Mathenesse
estate, Rotterdam, 1923. Perspective and plan,
watercolour on paper, $25\frac{3}{8} \times 39$ (65 × 99). Archive J. J.
P. Oud, inv. nr. 34, Nederlands Architectuurinsti-
tuut, Rotterdam/Amsterdam. Photo courtesy
Nederlands Architectuurinstituut, Rotterdam/
Amsterdam
100 Café de Unie, Calendplein, Rotterdam, 1925.
Drawing and plans. From *L'Architecture Vivante*
autumn 1925. Photo Frank den Oudsten
101 Housing blocks, Tussendijken, Rotterdam, 1921
(destroyed 1940)
102 Design for the Kallenbach house, Berlin, 1922.
Perspective. From *L'Architecture Vivante* summer
1924. The British Architectural Library, RIBA
106 Oud Mathenesse estate, Rotterdam, 1924. Photo
Paul Overy
107 Housing at Hook of Holland, 1924. Photo Paul
Overy
108 Kiefhoek estate, Rotterdam, 1925–30. Neder-
lands Architectuurinstituut, Rotterdam/Amsterdam.
Photo courtesy Frank den Oudsten
109 Kiefhoek estate church, Rotterdam, 1925–30.
Photo Paul Overy
110 Kiefhoek estate, Rotterdam, 1925–30. Photo
Paul Overy
111 Terrace housing, Weissenhofsiedlung exhibition,
Stuttgart, 1927. Rijksdienst Beeldende Kunst, The
Hague. Photo courtesy Frank den Oudsten
112 Terrace housing, Weissenhofsiedlung exhibition,
Stuttgart, 1927, living-room. From *L'Architecture
Vivante* spring 1928. The British Architectural
Library, RIBA

113 Housing at Blijdorp, Rotterdam, 1931 (unexecuted). Perspective, watercolour on paper on cardboard, $30\frac{1}{4} \times 21\frac{5}{8}$ (77 × 55). Archive J. J. P. Oud, inv. nr. 50, Nederlands Architectuurinstituut, Rotterdam/Amsterdam. Photo courtesy Frank den Oudsten

155 Café de Unie, Rotterdam, reconstructed by Design Group Opera, 1985. Photo Paul Overy

PANAGGI, Ivan

117 Interior from Casa Zampini, Macerata, 1925-6. Photo courtesy Musei e Pinacoteca Comunale, Macerata

RIETVELD, Gerrit

4 Buffet, c. 1919, and High Back Chair, c. 1919. From *De Stijl* (vol. 3, no. 5) March 1920

5 Prototype Red Blue Chair, c. 1918-19. Unpainted wood, c. $34\frac{1}{4} \times 23\frac{5}{8} \times 23\frac{5}{8}$ (87 × 60 × 60). Photo courtesy Christie's, Amsterdam

47 Label from Red Blue Chair, 1930s. Photo courtesy Stedelijk Museum, Amsterdam

48 Child's High Chair, 1918. From *De Stijl* (vol. 2, no. 9) July 1919

49 Toy Wheelbarrow, 1923. Painted wood, c. $11\frac{3}{4} \times 31\frac{7}{8} \times 15$ (30 × 81 × 38). Stedelijk Museum, Amsterdam

50 Furniture in model living-room, c. 1923. Photo courtesy Centraal Museum, Utrecht

51 Price list for furniture in model living-room, c. 1923. Coloured crayon and pencil on paper, $25\frac{5}{8} \times 9\frac{7}{8}$ (65 × 25.2). Photo courtesy Centraal Museum, Utrecht

56 GZC jewellers, Kalverstraat, Amsterdam. From *L'Architecture Vivante* autumn 1925. Photo courtesy Frank den Oudsten

57 2 Military Chairs, 1923. Painted wood, each c. $15\frac{3}{8} \times 20\frac{1}{4} \times 35\frac{7}{8}$ (39 × 52 × 91). Photo courtesy Christie's, Amsterdam

58 Berlin Chair, 1923. Painted wood, $41\frac{3}{4} \times 27\frac{1}{2} \times 21\frac{5}{8}$ (106 × 69.9 × 54.9). Photo courtesy Christie's, Amsterdam

59 Zig-Zag Chair, c. 1932-4. Wood, c. $14\frac{3}{4} \times 16\frac{7}{8} \times 28\frac{3}{4}$ (37.5 × 43 × 73). Photo courtesy Christie's, Amsterdam

61 Crate Chair, 1934. Wood, c. $23\frac{5}{8} \times 24\frac{3}{8} \times 25\frac{5}{8}$ (60 × 62 × 65). Stedelijk Museum, Amsterdam

71 Furniture in an interior, c. 1930 (textiles by Van der Leck). From *Mobilier et Décoration* July 1930. Bibliothèque Nationale, Paris

75 Surgery for Dr Hartog, Maarssen, 1922 (now destroyed). Photo courtesy Stedelijk Museum, Amsterdam

76-8 Furniture in maquette for exhibition room, Berlin, 1923 (colour design by Huszár). From *L'Architecture Vivante* autumn 1924. The British Architectural Library, RIBA

80 Furniture for music room for Til Brugman, c. 1924 (colour design by Huszár). Photo courtesy Stedelijk Museum, Amsterdam

81 Music room for Piet Ketting, c. 1927. Coloured paper, ink and pencil on paper, $6\frac{5}{8} \times 8\frac{1}{2}$ (16.7 × 21.7). Centraal Museum, Utrecht

82 Music room for Piet Ketting, c. 1927. Photo courtesy Centraal Museum, Utrecht

93 Schröder house, Utrecht, 1924-5, photographed c. 1925. Photo courtesy Frank den Oudsten

94 Schröder house, Utrecht, 1924-5. First-floor interior, photographed c. 1925. Centraal Museum, Utrecht. Photo courtesy Frank den Oudsten

95 Schröder house, Utrecht, 1924-5. Plans of first floor

96 Schröder house, Utrecht, 1924-5, restored 1985-7. Ground-floor study, photographed c. 1987. Photo Frank den Oudsten

98 Schröder house, Utrecht, 1924-5, restored 1985-7. First-floor interior, photographed c. 1987. Photo Frank den Oudsten

114 Chauffeur's house, Utrecht, 1927. Photo courtesy Nederlands Architectuurinstituut, Rotterdam/Amsterdam

115 Housing, Wiener Werkbundsiedlung, Vienna, 1930. Photo courtesy Centraal Museum, Utrecht

SANT'ELIA, Antonio de

118 Casa a Gradinate. Drawing. From *De Stijl* (vol. 2, no. 10) August 1919. Photo courtesy Stedelijk Museum, Amsterdam

TAEUBER-ARP, Sophie

146 Tea-room, Aubette, Strasbourg, 1926-8. Photo courtesy Fondation Arp, Clamart

VANTONGERLOO, Georges

38 *Composition* 1918. Oil on canvas, $78 \times 62\frac{1}{4}$ (198 × 158). Musée national d'art moderne, Centre Georges Pompidou, Paris

45 *Composition starting from an Oval* 1918. Painted mahogany, $6\frac{1}{2} \times 2\frac{1}{2} \times 2\frac{1}{2}$ (16.5 × 6.5 × 6.5). Copyright Vantongerloo Archive, Zurich

46 *Construction of Volume Relations* 1919. Sandstone, $8\frac{7}{8} \times 5\frac{3}{8} \times 5\frac{3}{8}$ (225 × 137 × 137). Tate Gallery, London

WILS, Jan

53 Dressing table, early 1920s. Archive Jan Wils, inv. nr. 1721, Nederlands Architectuurinstituut, Amsterdam/Rotterdam. Photo courtesy E. M. van Ojen, The Hague

74 Alcove, window seats and freestanding furniture, Berssenbrugge photographic studio, The Hague, 1921 (colour by Huszár). Nederlands Architectuurinstituut, Rotterdam/Amsterdam. Photo courtesy Frank den Oudsten

87 De Dubbele Sleutel, Woerden, 1918 (demolished 1970s). Nederlands Architectuurinstituut, Rotterdam/Amsterdam

88 Daal en Berg estate, The Hague, 1920-21.

Nederlands Architectuurinstituut, Rotterdam/ Amsterdam. Photo courtesy Frank den Oudsten
90 Cricket Clubhouse for Olympic Games, Amsterdam, 1928. Photo courtesy Nederlands Architectuurinstituut, Rotterdam/Amsterdam
ZWART, Piet
89 Presentation drawing of Wils's Daal en Berg estate, The Hague, 1919–21. Ink on paper, $8\frac{1}{2} \times 11\frac{5}{8}$ (21.6 × 29.5). Nederlands Architectuurinstituut, Rotterdam/Amsterdam. Photo courtesy Frank den Oudsten

Miscellaneous illustrations

10 Tomb of Midas, illustrated in Gottfried Semper *Der Stil in den technischen und tektonischen Kunsten* 1860–63
13 Gerrit Rietveld and assistants outside his furniture workshop in Adriaen Ostadelaan, Utrecht, *c.* 1918. Photo courtesy Centraal Museum, Utrecht
14 Portable electric machines. From *Het Bouwbedrijf* 1 October 1926. The British Architectural Library, RIBA
15 Canal houses, Amsterdam, 17th century
18 Cover of *Wendingen* July 1918
20 'First de Stijl Manifesto' (English version). From *De Stijl* (vol. 2, no. 1) November 1918
52 Drawing of components of Rietveld's Red Blue Chair
60 Metz catalogue, *c.* 1935. Centraal Museum, Utrecht
79 Music room for Til Brugman, before 1924. Photo courtesy Stedelijk Museum, Amsterdam
84 Construction of Bienert interior (83), Pace Gallery, New York, 1970. Formica on wood, 120 × 144 × 168 (304.8 × 365.8 × 426.7). Photo courtesy The Pace Gallery, New York
119 Nelly van Doesburg dressed as I. K. Bonset. From *De Stijl*, Tenth Anniversary issue, 1928
120 Hans Richter's *Filmmoment*, illustrated in *De Stijl*

(vol. 6, no. 5) 1923
121 Poster for Kurt Schwitters and Theo van Doesburg's Dada tour in Holland, 1923. $24\frac{3}{8} \times 33\frac{1}{2}$ (62 × 85). Dienst Verspreide Rijkscollecties, The Hague
123 Models constructed from Meccano. From *De Stijl* (vol. 5, no. 5) May 1922
129 Kasimir Malevich's *Black Square* illustrated in *De Stijl* (vol. 5, no. 9) September 1922
130 Cover of *Merz* (no. 1) January 1923. Courtesy of the Board of Trustees of the Victoria and Albert Museum, London
131 El Lissitzky's *Proun* article (first page) and illustration in *De Stijl* (vol. 5, no. 6) June 1922
136 The International Collection of Modern Art, Museum Sztuki, Lodz, 1932. Photo courtesy Museum Sztuki, Lodz
138 Cornelis van Eesteren and Theo van Doesburg with model of Maison particulière, 1923. Rijksdienst Beeldende Kunst, The Hague. Photo courtesy Frank den Oudsten
139 Rosenberg exhibition 'Les Architectes du groupe de Stijl', Paris, autumn 1923. Rijksdienst Beeldende Kunst, The Hague. Photo courtesy Frank den Oudsten
147 Page from *Cercle et Carré* (no. 3, Paris) 1930. Fondation Arp, Clamart
152 Alfred Barr, Jr *De Stijl 1917–28* 1951, p. 12. Library, The Museum of Modern Art, New York. Offset, printed in black, 10 × 8 (25.4 × 20.3). © 1961 The Museum of Modern Art, New York
156 Various objects with De Stijl motifs. Photo Eileen Tweedy

Works by the following artists © 1991 BEELDRECHT: Bart van der Leck, Piet Mondrian, J. J. P. Oud, Gerrit Rietveld
Work by César Domela © 1991 ADAGP

Index